ROME AS A GUIDE TO

THE GOOD LIFE

Rome

AS A GUIDE
TO THE
GOOD LIFE

A Philosophical Grand Tour

Scott Samuelson

THE UNIVERSITY OF CHICAGO PRESS

Chicago and London

The University of Chicago Press, Chicago 60637
The University of Chicago Press, Ltd., London
© 2023 by The University of Chicago
Color illustrations © 2023 by Lauren Nassef, with color work by Isaac
Tobin.
Published 2023
Printed in Canada

32 31 30 29 28 27 26 25 24 23 1 2 3 4 5

ISBN-13: 978-0-226-82626-4 (cloth)
ISBN-13: 978-0-226-78004-7 (paper)
ISBN-13: 978-0-226-82625-7 (e-book)
DOI: https://doi.org/10.7208/chicago/9780226826257.001.0001

Library of Congress Cataloging-in-Publication Data

Names: Samuelson, Scott, author.
Title: Rome as a guide to the good life : a philosophical grand tour / Scott
 Samuelson.
Description: Chicago : The University of Chicago Press, 2023. | Includes
 bibliographical references and index.
Identifiers: LCCN 2022045650 | ISBN 9780226826264 (cloth) |
 ISBN 9780226780047 (paperback) | ISBN 9780226826257 (ebook)
Subjects: LCSH: Philosophy, Ancient. | Rome—Description and travel. |
 Rome—Antiquities. | Rome (Italy)—Biography.
Classification: LCC DG31 .S26 2023 | DDC 937.001—dc23/eng/20220926
LC record available at https://lccn.loc.gov/2022045650

♾ This paper meets the requirements of ANSI/NISO Z39.48-1992
(Permanence of Paper).

A voice, different from any I had ever known, fell on my ear: "Even the stones of Rome speak," it said, "come with me, and I will tell you what they say."

JOSEPH MULLOOLY

CONTENTS

10

MAKE A GOLDEN ASS OF YOURSELF

The Metamorphoses in Agostino Chiti's Villa

167

V · MAKE A PALACE OF YOUR MEMORY

11

BE THE CONVERSATION

The Philosophy of Raphael's *School of Athens*

187

12

UNLOCK THE SOUL IN YOUR SOUL

Giordano Bruno in the Campo de' Fiori

203

CONCLUSION

What Resists Time Is What's Ever Flowing

225

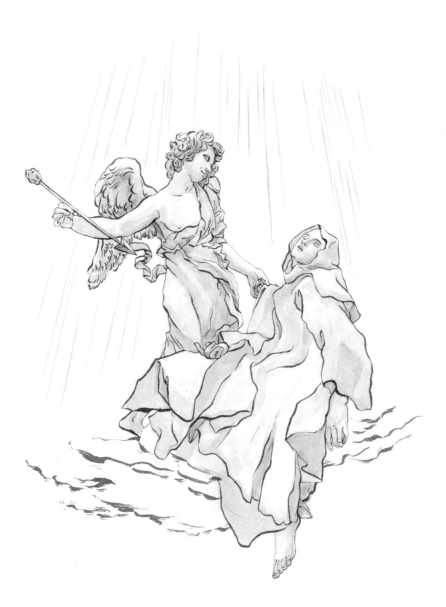

FIGURE O.1 · Gian Lorenzo Bernini, *Ecstasy of St. Teresa* (1645–52), Cornaro Chapel, Santa Maria della Vittoria. Teresa of Avila writes of her experience of God, "The pain was so great that it made me moan; and yet so surpassing was the sweetness of this excessive pain, that I could not wish to be rid of it." Teresa of Avila, *The Life of St. Teresa of Avila*, trans. David Lewis (New York: Cosimo Classics, 2011), 226.

PHILOSOPHY AS A GUIDE TO *LA DOLCE VITA*

In individual mirrors, Rome rediscovers all the forms and all the aspects of the soul.

CARLO LEVI

Why go to Rome? It's easy to be cynical about the city's tourists. Their wealth and freedom seem to have been purchased at the steep price of their holiness and nobility. They just want to brag, "Been there, done that." They gripe about the unbearable first leg of the transatlantic journey (nine hours in a reclining chair with personal movies), get their selfies in front of the Pantheon (or is it the Parthenon?), dine near the Trevi Fountain on what they'll boast is the best pasta ever (limp noodles with bacon bits and European ketchup), note the cultural differences of the McDonald's in Termini (McTiramisù), and splatter photos of their "Rome in Two Days" tour on social media (next up, Venice!). I suspect most of us have a certain amount of ugly tourist in our makeup. I know

I do. But there's more to us—all of us—than the cynical interpretation captures. Our age may be doing its damnedest to turn us into zombies with roller bags, but our holiness and nobility aren't undead yet! Under layers of greed and distraction, pasta and circuses, there's a hunger to live a better life, what the ancient Roman philosophers call the *vita beata*—the blessed life, the good life. We sometimes go to Rome in search of our own humanity. We want more than a change of scene. We want a change of soul.

Part of this deep desire to see Rome, preceded as are all deep things by shallowness, comes from vague associations with *la dolce vita*: the sweet life of good wine, fresh vegetables, sharp clothes, ancient monuments, cobblestone streets, and charming company late into the Mediterranean night. It's often awakened by movies, like those of Federico Fellini, who called Rome "the most wonderful movie set in the world."[1] Part of it has to do with our suspicion that there is truly great art in Rome, a hunch that can't be wiped out even by weapons-grade versions of consumerism and postmodernism. Part of it has to do with our awe at the dominance of the Roman Empire in its heyday—not just our crass admiration for power, though definitely that too, but our appreciation for commanding expressions of who we are, good and bad. But part of it, like all deep desires, is mysterious. We're looking for something intangible. In my experience, even when Rome gives us our heart's desire and then some, we still don't quite know what it is. All that business about gods and angels isn't totally crazy.

A long-standing reason to travel to Rome is religious. It's one of the prime spots of Christian pilgrimage. In some ways it's more the home of Christianity than Bethlehem or Jerusalem, such that Dante can speak of "that Rome where Christ is a Roman."[2] Judea, where Jesus lived and preached, was a Roman province. Peter, the "rock" on whom the church was built, was crucified on Rome's Janiculum Hill during the reign of Nero and buried under what was to become St. Peter's Basilica. Christianity spread through the world that Rome conquered and unified. The Catholic Church

continued that dominance by taking Roman culture to the four corners—and four rivers—of the earth, and carries it on to this day in ubiquitous churches and schools. There's a reason it's called *Roman* Catholicism. Before modernity created tourists, the church created religious pilgrims. From the Middle Ages to today, they've come to Rome not exactly in search of the good life but in search of gracing their spiritual life. They sought—and still seek—things like a papal blessing of a rosary, a saint's relic, an especially holy version of a holiday, communion with the global body of Christ, and, like all travelers, something novel, unexpected, extraordinary—for instance, in the Middle Ages, the dragon that was said to dwell in the Forum right next to the mouth of hell.

Another historically significant reason to visit Rome is educational. Even more than medieval religious pilgrims, the great forerunners of modern tourists to Italy were the upper-class young men, and occasionally young women, primarily British, who went on the Grand Tour from the seventeenth through the nineteenth century. After completing an education suitable to their nobility, involving the mastery of language through Latin literature and the knowledge of history through ancient Roman politics, these teens and twenty-somethings made the bumpy, flea-ridden, bandit-threatened, months-long carriage ride to Italy to experience firsthand the basis of their classical studies, admire masterpieces, brush up on their Italian, mingle with the continental elite, be seduced and horrified by the excesses of Catholicism, flirt with Roman beauties, have their portraits painted in romantic ruins with their dogs, and consolidate their social standing in Europe.

After obsessing over art books in high school, learning Latin in college, and studying Italian philosophy in graduate school, I stumbled into Rome for the first time in my midthirties, over a decade ago, invited along as a faculty helper on a subsidized study abroad trip for working-class college students. In two weeks, I, a so-called teacher, learned more than I had in the previous two decades. I've been lucky enough to go back on that trip every summer since,

with the sad exception of the pandemic years. There's plenty to hate about dirty, bureaucratic, decadent Rome, which, according to James Joyce, makes its money "like a man who lives by exhibiting to travellers his grandmother's corpse."[3] Following in a long line of wide-eyed small-town boys, I experience Roma as a living being and am sometimes guilty of romanticizing a city I probably couldn't live in full-time. But aren't cities made of our desires and fantasies? Why not err on the side of adoration, particularly when it comes to the city that supplies the etymology of the word "romanticize"? It didn't help that a few years ago, in the Mithraeum under the Basilica of San Clemente, I fell head over heels for an art historian and tried her patience with poetry until she married me.

Is Rome a guide to the good life? Yes and no. It's certainly not so simple as that the city embodies wisdom and happiness! Sure, if you're in search of the beautiful best of humanity, Rome will give you jolts of gelato and Borromini capable of momentarily redeeming the tragedies and stupidities so characteristic of the rest of our lives. But if you're looking for evil sufficient to condemn Western civilization, humanity, or the belief in the goodness of God, the history of Rome will furnish you with several airtight cases. And there's everything else too, including loads of trinkets, pickpockets, idiots, and tourists. That's just it. In the beginning of Plato's *Republic* (nota bene: we still use the translated Latin title for Plato's *Politeia*), Socrates says that if you were trying to read a text with minuscule print, you'd be grateful to find a large-print version. Likewise, he says, if you want to understand the individual soul, it helps to have the soul writ large, which is what a city is: a bustling text of all aspects of our character.[4] Rome is *the* city, the place where our humanity is writ large. I don't know of any education in the soul more efficient and exciting than reading Rome.

I've often had an experience common to travelers in Rome: a sensation of all the senses firing at once, where the body feels itself glistening like the lit-up mosaic in the Basilica of Saints Cosmas and Damian. The sunlight is clearer than usual. The terracotta buildings

look like warm flesh. People's souls are visible. The artistic device of halos starts to make sense. You feel like declaiming Byron: "Rome! my country! city of the soul! / The orphans of the heart must turn to thee!"[5] It's a feeling of being as large as possible in your humanity while still feeling human. The sensation is linked to immersion in what we call the arts and humanities: painting, sculpture, architecture, history, literature, religion, philosophy—cuisine and fashion too. It often follows on an afternoon negroni.

I distill the elements of the experience into two fundamental traits of Rome: audacity and self-knowledge. By "audacity," I mean the bigness of its monuments and passions, its frankness about sexuality and violence, its openness to beauty and transcendence, its straightforwardness with food and emotion, its pride in its nature and culture. One of the many etymologies of the city's name is the Greek word *rhome*, meaning "strength," which is suggestive of how the city's nature is to overwhelm.[6] By "self-knowledge," I mean the city's awareness of itself in its contradictory overwhelmingness. All municipalities rely on water and sewers. But what other city so trumpets that elementary truth with its fountains? All nations have histories pieced together from murder and plunder. But what other city is so clear-eyed and unflinching about the violence shot through from its origins? Each of us is a walking paradox of soul and body. But what other city so scrambles spirituality and sensuality that you're left confused about which is which and wondering if both are both—like in Titian's painting *Sacred and Profane Love* in the Galleria Borghese where the two allegorical figures are modeled on the same woman, and the come-hither naked one is supposed to be the sacred one? A wit in Santa Maria della Vittoria once quipped about Bernini's *Ecstasy of Saint Teresa*, a sculpture of a young woman in the throes of divine ecstasy, "If that's the experience of God, I know it well."

This is a philosophical guidebook to Rome. It sketches the city's great philosophical tradition, explores the meaning of various sites, and reflects on how the philosophy and the sites enrich each other.

In a way, it's a synthesis of religious pilgrimage, the Grand Tour, and contemporary tourism. While religious pilgrimage is alive and well, many of us nowadays are only thinly connected to the organized spiritual life, if not utterly alienated from all religion. Even those who are faithful often suffer from a lack of meaningful direction. The Grand Tour also survives in a weird way, mostly in the form of study abroad programs. While we professors like to grumble about the ignorance of kids these days ("We once taught advanced Latin in high school and now teach remedial English in college!"), I suspect that the ratio of reading great books to guzzling cheap wine hasn't changed all that much since the so-called age of reason. And though I think that tourism needs to be reconceived, given the environmental and cultural degradations that accompany it, I'm glad it shapes people's dreams and aspirations, given the personal and cultural blessings that also accompany it. If anything, I'd like to see the privilege of traveling extended to more people, as I've seen over and over with my students just how life-changing it can be.

The problem with contemporary travelers — pilgrims, students, tourists — is the same one that Lucretius noted over two thousand years ago about his fellow Romans fleeing the city for the country: we're really fleeing from the self we've gotten stuck with, though our escape attempt is thwarted by our inability to let go of that very self. A philosophical grand tour is the concerted effort to understand why we want to get away and where we ought to be getting to. Guided tours, study abroad programs, and even religious trips often bracket the profound questions raised by Rome. Does all this art about God really signify anything? Should I really be blown away by these places built on the slaughter and domination of others? What does all this strange history tell me about who I am? How can I find the good life I feel blazing in me? A philosophical grand tour is a way of welcoming such wonderments and seeing where they lead. Back in the days of the Grand Tour, the local guide was called a "cicerone," a light-hearted reference to the orator and

philosopher Cicero. Well, why not have Cicero and company for our cicerones—not just to the Eternal City but to the good life?

Before his execution, Socrates says that philosophy is a rehearsal for death, the intellectual equivalent of your soul leaving your body. It is indeed beautiful when you get so wrapped up in thought you forget for an hour or two that your feet hurt and you haven't had lunch. But one of the things I've come to see while exploring Rome is that philosophy can also be a practice embodied in a place, a merging of soul and site. A nice example of what I'm talking about is a graveyard (we're about to begin our philosophical grand tour in the Protestant Cemetery), where even visitors disinclined to philosophy are likely to muse among the epitaphs about the meaning of life. A more unusual case is a site like the Colosseum, which inclines us to explore our own experiences with sadistic spectacles while giving us the historical distance to see ourselves and our violence afresh. Encounters with works of art are yet another occasion for the embodied practice of philosophy, as art has the power to distill human experience—our whole intricate complex of perception, thought, and emotion—into goose bumps. Maybe the best example of all for my purposes is travel itself, which lifts you out of your normal routine, predisposes you to rethink what you take for granted, and invites you to change your life.

What follows is an eclectic guide to culture and happiness, one that blends history and philosophy. While I have no intention of papering over injustice, my aim here is to see how much our souls can be enlarged by the best of what the likes of Seneca and Raphael have given us. Though I hope this book (along with a more thorough guidebook) can serve as a vade mecum for Rome, it's also intended to be engaging to those whose only road to the Eternal City is mental flight. Our journey winds through some predictable sites but also detours through some places off the beaten path of the tour buses. Following my own fascinations and lingering over what moves me most, I make no apology for skipping over many

things of interest and beauty. In fact, I recommend it as a strategy for visiting any museum or city. My focus is on the philosophers and the places that startle me into thinking about dying well and living better. So, let's blend the sacred awe of the religious pilgrim with the free-wheeling curiosity of the grand tourist. Let's convert the museums back into temples. When we travel to Rome, or even dream of traveling there, our imaginations play softly with questions of the good life. Let's turn up that experience.

I

Build Not
Thereon

Original! Rome is quite beyond that.
C. DAY-LEWIS

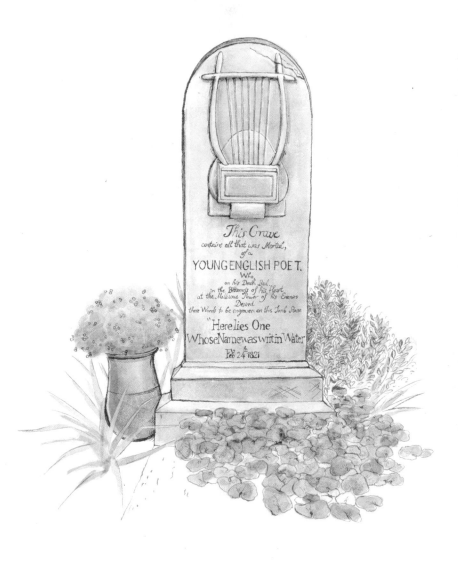

This Grave
contains all that was Mortal,
of a
YOUNG ENGLISH POET.
Who
on his Death Bed
in the Bitterness of his Heart
at the Malicious Power of his Enemies
Desired
these Words to be engraven on his Tomb Stone
"Here lies One
WhoseNamewas writin Water
Feb 24 1821

FIGURE 1.1 · Grave of John Keats, Protestant Cemetery. Keats died in obscurity in his apartment on the Spanish Steps, where in his suffering he heard the burbling of the Fontana della Barcaccia. It made him think of lines from the Jacobean play *Philaster*, "As you are living, all your better Deeds / Shall be in Water writ, but this in Marble: / No Chronicle shall speak you." *The Works of Mr. Francis Beaumont and Mr. John Fletcher* (London: J. & R. Tonson and S. Draper, 1750), 160.

1

DIE ON YOUR JOURNEY

The Question of Rosa Bathurst's Tombstone

> Indeed, there are some we should count not even as
> animate creatures but as corpses. A person is alive when he
> is of use to many; he is alive when he is of use to himself.
> Slackers who hide out at home might as well be in the
> tomb. Go ahead and write it in marble above their door:
> PRECEDED IN DEATH BY THEMSELVES.
> SENECA

Beautiful as it is to be buried where you were born, there's some-
thing distinctively human about being buried where a journey took
you. All cemeteries have the power to stir us to philosophy, but it's
that air of questing that makes Rome's Protestant Cemetery the
most moving graveyard I've ever visited. Eleanor Clark says of the
place, "This quiet garden keeps the dignity of human grief. . . . It
would be hard to find a [visitor to it] so stupefied as to come away
without a mellower sense of life."[1] It's an ideal spot for us to begin
a philosophical journey.

The more accurate term for the Protestant Cemetery is the Non-Catholic Cemetery (Cimitero acattolico): there are Muslims, Jews, Marxists, and classicists buried there too. But I'm fond of the older term "Protestant Cemetery" because it carries in its semantics the protest of humanity against the strictures and corruptions it's born into—a protest repeatedly expressed in the graveyard's epitaphs, from triumphant declarations over accidents of birth like Horace Belshaw's "SCHOLAR EDUCATOR AND INTERNATIONAL SERVANT WHO LEFT HIS NEW ZEALAND HOME TO BEFRIEND THE RURAL PEOPLES OF ALL NATIONS" to heartbroken sighs like John Keats's "This grave contains all that was Mortal of a Young English Poet Who on his Death Bed, in the Bitterness of his Heart at the Malicious Power of his Enemies Desired these Words to be engraven on his Tomb Stone: Here lies One Whose Name was writ in Water." It's a gathering of souls who, for better and worse, sought out a good life and met death on an odyssey—or, to use a more accurate term, an "aeneid," for Odysseus's journey brings him back to where he started, whereas Aeneas, the Trojan hero and begetter of what becomes Rome, dies on his destined journey, far from the home destroyed by Odysseus's ruse.

Let's have a look at my favorite epitaph in the Protestant Cemetery—by an English mother for her teenage daughter.

Beneath this stone are interred the remains of Rosa Bathurst, who was accidentally drowned in the Tiber on the 14th of March, 1824, whilst on a riding party, owing to the swollen state of the river, and her spirited horse taking fright. She was the daughter of Benjamin Bathurst whose disappearance when on a special mission to Vienna some years since, was as tragical as unaccountable: no positive account of his death ever having been received by his distracted wife. He was lost at twenty-six years of age. His daughter who inherited her father's perfections, both personal and mental, had completed her 16th year when she perished by as disastrous a fate. Reader, whoever thou art,

who may pause to peruse this tale of sorrows, let this awful lesson of the instability of human happiness sink deep in thy mind. If thou art young and lovely, build not thereon, for she who sleeps in death under thy feet, was the loveliest flower ever cropt in its bloom. She was everything that the fondest heart could desire or the eye covet, the joy and hope of her widowed mother, who erects this poor memorial of her irreparable loss. Early, bright, transient, chaste as morning dew, she sparkled, was exhaled, and went to heaven.

How much life—life in the beauty-adventure-tragedy-mystery-grief-love-death sense of the word—brims over in that single paragraph! Having made a point of regularly visiting the tombstone in its breezy setting of pines and cypresses ever since first discovering it, I've yet to read it without choking up. In fact, my obsession with unearthing its mysteries, both factual and metaphysical, is what led me to write this book.

Rosa, the middle of three children born to Benjamin and Phillida Bathurst, was staying in Rome with her aunt and uncle, Lord and Lady Aylmer. Another of Rosa's aunts, Tryphena Bathurst (later Thistlethwayte), who heard the story directly from Lady Aylmer, writes a letter about Rosa and the Aylmers on the tragic horseback ride. If we add to Tryphena's letter an account by Mrs. Hugh Fraser, a diplomat's wife and chronicler of Rome's gossipy stories, who got the goods from Rosa's sister in her old age, we can piece together what likely happened.[2]

The Duc de Montmorency, the French ambassador and family friend to the Bathursts, asked his servant to lend his horse to Lord Aylmer. The riding party agreed, fatefully, to meet up with the Duc's man, once he'd secured another horse, at the Ponte Milvio. "How often it is that the smallest causes produce the most signal results," Mrs. Hugh Fraser observes.[3] On that sunny spring day the Tiber was roaring with the meltwater of the heavy winter snows in the Apennines. Taking a shortcut to their meeting point, the party

found themselves on a narrow path between a vineyard and the river. Rosa's horse spooked and immediately slid into the swift waters. She cried out, "Save me, Uncle!" Lord Aylmer made two valiant efforts to rescue his niece and nearly drowned in the process. In the aftermath, a sizable reward was offered to anyone who could find the body swallowed by the Tiber—to no avail. "I can dwell no more on this fatal event," Tryphena abruptly ends her letter, "Kind love to Henry and the children."[4]

Some of the pathos of the epitaph's language derives from the power of the unsaid. Benjamin Bathurst, Rosa's father, could have a riveting costume drama / spy movie made about him. He was sent in secret to Vienna with the purpose of persuading Emperor Francis I to join England in its war against Napoleon. With his "perfections" of character, Benjamin won over the Viennese. His success led to tragic results: the Battle of Wagram, a costly but decisive victory for Napoleon and the triumphal entry of France into Austria. Benjamin followed the Viennese court to Hungary where he met up with Metternich to encourage Emperor Francis I not to surrender. This time his perfections were insufficient. The Treaty of Schönbrunn was signed on October 9, 1809.

Benjamin Bathurst is now atop Napoleon's hit list. After agonizing how to get back to England, he decides to go through Germany, traveling by night. His letters home bristle with suspicion of strangers and friends, all of whom are would-be assassins. The next piece of evidence we have of his fate is discovered by two old peasant women on a road by the woods near Magdeburg: some of his clothes ripped with bullet holes and soaked in blood, in the pants pocket a letter to his wife begging her not to take another husband if he should die. The hastily penciled note also warns of a French spy, the Comte d'Entraigues.

At this point in our drama, we pick up the story of the epitaph's author Phillida Bathurst. She writes a letter to Napoleon asking for permission to travel on the Continent in search of her husband but decides against sending it, fearing the emperor's refusal.

Instead, under her maiden name, she strikes off with her brother for Berlin to talk directly to the powerful ambassador there. When they arrive, they're shocked to find that the ambassador already has passports for them issued by Napoleon himself. "How," she gasps, "can His Majesty have possibly known that we were coming to Berlin, for I have told nobody of my change in plans but my brother here?" "It is peculiar, isn't it?" the ambassador says with an insinuating smile, "but there it is."

They make use of the passports to travel around Germany for clues. They find the bloody clothes and the foreboding note. She hears a rumor that a well-known Saxon lady, shortly after Benjamin's disappearance, was dancing at a ball with the governor of Magdeburg when he let slip, "All this fuss about this English ambassador, but what if I told you I had him under lock and key in my castle?" So Phillida heads straight to Magdeburg and harangues the governor for two hours straight, "entreating, threatening, calling down the Divine Anger upon him for his concealment of the facts."[5] He assures her that, though he did have an English spy locked in his castle, it wasn't her husband. In fact, he claims, the man in question, Louis Fritz, has now gone off with his wife to Spain. Fed up, Phillida goes to Paris to confront Napoleon himself, who assures her on his honor that he knows nothing of her husband's fate.

The heartbroken sleuth returns to London—and to three young children who had been left in the care of family and servants. A card is mysteriously brought to her from the Comte d'Entraigues, a name she recalls with a shudder from her husband's letter. She arranges a meeting with the French spy at which he tells her that her husband is dead. Excusing Napoleon of any knowledge of what happened, he claims that Benjamin Bathurst, after having been kidnapped, had indeed been locked in the governor of Magdeburg's castle and was eventually executed under orders of Fouché, a French official. If all that's not enough for a movie, the Comte d'Entraigues and his wife are then both found murdered in their carriage one day after the meeting. According to subsequent newspaper reports, not only was

the Comte d'Entraigues a French spy, but Madame d'Entraigues was a double agent, on the payroll of both the British and the French!

A shred of evidence supports the spy's story: no Louis Fritz was ever registered in the secret service department of the British Foreign Office. Plus, it does seem like the governor of Magdeburg was lying. But the fact is that we, like Phillida, are still in search of the truth about her husband, which is as "tragical" and "unaccountable" as life itself.

As for Rosa, known as "the angel girl," she was the toast of Rome, especially among the sizable British population there. Just a decade younger than John Keats, who died three years before her in his apartment on the Spanish Steps, she was an embodiment of Keatsian Romanticism: endowed with adventurousness by her father, raised to be original and free by a self-possessed mother, and scarred by tragedies throughout her brief, intense life. Her charms inspired admirers to poetry, including Walter Savage Landor, who, according to an old copy of *Lippincott's Magazine of Popular Literature and Science*, "has made his moan over [Rosa's] tragedy in more than one tear-spotted page of verse."[6]

The epitaph's language trembles not only with Rosa's vibrancy but with her mother's anguish. A German forest had swallowed up Benjamin. Now an Italian river had swallowed up Rosa. In the rawness of her grief, Phillida didn't even have the consolation of bodies to bury. Seven months after her drowning, in late October, one of Rosa's admirers, Charles Mills, was strolling across the Ponte Milvio. The sun was setting, and he seized the moment to wander down by the banks and bask in the loss of the angel girl. There he saw two peasants poking at something in the shallow water: a piece of fabric exactly the blue of Rosa's riding-habit. He ordered them to get shovels, and together they dug up the body. Thus it came about that her mother could erect a tombstone in the Protestant Cemetery over the remains of her daughter.

The story of Rosa's disappearance into and reemergence from the Tiber makes the epitaph's last sentence particularly arresting:

"Early, bright, transient, chaste as morning dew, she sparkled, was exhaled, and went to heaven." Her mother's language distills from water's savage indifference its tender loveliness: Rosa was like morning dew. The screaming, drowning, and coughing-up of a teenager are verbally transformed into the sparkling, exhaling, and evaporating of her soul. You can see why this epitaph was the favorite of the master wordsmith Henry James, who puts his finger on its unusual power: "an old-fashioned gentility that makes its frankness tragic."[7]

As juicy as the story behind the epitaph is, the greater mystery is philosophical in nature. "Reader, whoever thou art, who may pause to peruse this tale of sorrows, let this awful lesson of the instability of human happiness sink deep in thy mind. If thou art young and lovely, build not thereon, for she who sleeps in death under thy feet, was the loveliest flower ever cropt in its bloom." *Build not thereon.* After the rest of the epitaph has conjured an alluring drama of escapades and splendor, three words cancel it all and open a huge emptiness. Build not on youth and beauty. Build not on earthly existence. It's all too disastrously unstable. Build not your life on—life! But like so much of the spirituality in Rome, this rich memorial seduces with what it shuns: the loveliness of an intelligent young woman on her horse, the high-spirited riding party among the fragrant flowers, the intrigues of the mission on the Continent, the implied romance between the dashing Benjamin and the fierce Phillida, the inner life of the grieving mother, the quest to the Eternal City. "Build not thereon"—it's as much a cry of anguish as a piece of advice.

It's hard to read the epitaphs of any cemetery and not start wondering what your own life could be worth. The Rosa Bathurst tomb is a profound sermon, but instead of pushing a moral it poses a question, the central question of this book, which spans the wondrous space between life's impossibility and its necessity. How should we live? Whereon should we build? So much of Rome is noisy hustle-bustle, but the Protestant Cemetery is quiet enough

for this question to register. Cypresses and violets are interspersed among monuments that whisper not only in Latin, Italian, and English, but in German, French, Czech, Lithuanian, Bulgarian, Slavonic, Japanese, Russian, Greek. Towering in the background of the angel girl's grave is the Pyramid of Cestius, a tomb built for a Roman official sometime between 18 and 12 BC, during a fad for Egyptian monuments. Percy Bysshe Shelley once wrote of the cemetery's beauty, "It might make one in love with death, to think that one should be buried in so sweet a place."[8] It's hard not to feel here what the ancients meant by "mortality"—namely, that we have such unique lives that when our bodies give out something priceless disappears forever. We don't just perish—to be replaced by those who come after us. We *die*. You and I echo, but we don't repeat. There will never be another Cestius, John Keats, Rosa Bathurst, or anyone else here, or anyone else anywhere. The journey is all about becoming *who*—as opposed to *what*—we are.

By the way, just a few graves away from Rosa Bathurst's is Shelley's, with an epitaph from Shakespeare: "Nothing of him that doth fade / But doth suffer a sea-change / Into something rich and strange."[9]

DETOUR ON THE JOURNEY

Before we continue our journey through the Protestant Cemetery and our other Roman sites, let's take a brief detour through the word "journey." Cousin to the Italian words *giorno* and *giornata*, it comes from the Old French *journée*, which refers to the length of a day—and by extension to a day's work, and by further extension to how much can be traveled in a day. The word "journal" retains this sense of dailiness.

Journée derives from the Latin *diurnus*, meaning "of a day." We still use the word "diurnal" to refer to plants or animals active during the daytime. *Diurnus* is derived from *dies*, the straightforward word

for "day" in ancient Rome. One of the most famous phrases of Latin poetry is *carpe diem*, often translated "seize the day," though I prefer "reap the day." Since days are where we live, could it be that a journey is whereon we must build?

The beauty of traveling is that it's a freely chosen journey. But part of what makes a trip worthy of being chosen is that there's a lot about it you don't get to choose. You can't go on a real journey without detours. Hans Blumenberg says, "In the strictness of its exclusions, the supposed 'art of life' that takes the shortest routes is barbarism."[10] The goals of quests and pilgrimages, which are types of journeys, are largely an impetus for run-ins, mix-ups, sojourns, and discoveries. You can't predict what will be memorable about a journey, for its nature is to transform the you who's making the predictions. The best parts are inseparable from the worst parts. Sometimes the best parts *are* the worst parts. The barbaric version of tourism is the idea that traveling should be a straight comfortable trek to a selfie in front of a monument. How much can be traveled in a day is properly measured not by miles or sites but by frustrations and stories, boredoms and epiphanies.

Scholars theorize common roots for words in the Indo-European language family. The root of the various words for "day," like *dies*, is thought to be *dyeu-*, which means "to shine," for day is the time of shining. It's also linked to the various words for "god," like *deus*, for the gods are the shining ones. A related Proto-Indo-European root *bha-* also means "to shine" and gives us the Greek verb *phainein* ("to bring to light"—the root of "epiphany"), which appears in the lyrics of the Seikilos epitaph (second century AD), the oldest musical composition that comes down to us complete.

> While you live, shine (*phaínou*)—
> have no grief at all.
> Life exists but a little while,
> and Time demands his due.

Emerson says, "No one suspects the days to be gods."[11] Given the similarity between *dies* and *deus*, we probably should.

Reap the day. Honor the gods. Take a detour. Have an epiphany. Shine. According to the etymologies, it all comes to a head in the word "journey." If I were called in to construct a salutation, it would involve wishing folks a good sojourn through the time we have. *Buongiorno*!

THINGS TO SEE AND CONSIDER: ROME AS THE MYSTERY OF BUILDING A LIFE

The memorial to **Olivia Anderson** on her family's crypt reads, "OUR DREAM OF A CITY FOR ALL NATIONS DEDICATED TO THE CREATIVE SPIRIT OF GOD IN MAN WAS OUR HOPE AND PRAYER IN LIFE." If your soul is stirred by that hope and prayer, you'll feel like you're among friends in the **Protestant Cemetery**. After you find the tomb of **Rosa Bathurst**, with its reliefs by the English sculptor Richard Westmacott Jr., it's best to wander and wonder aimlessly. The graveyard is the resting place of many remarkable women whose lives are suggestive of what more the angel girl might have done with her dreams. Not far from Rosa's grave is buried **Elizabeth B. Phelps** (1813–94), who with her "profound and alert intellect" worked tirelessly for women's suffrage and Cuban independence. Her ambition in death was to be buried near Shelley. Another nearby tomb is that of **Malwida von Meysenbug** (1816–1903), a German writer and feminist who invited her friend Friedrich Nietzsche to Sorrento, where he wrote *Human, All Too Human*, the wisest of all his books. In 1869 von Meysenbug published the first volume of *Memories of an Idealist*, a book that earned her a nomination for one of the first Nobel Prizes in literature. She came to Italy in 1860 with her Russian friend Olga Herzen, the daughter of Alexander Herzen, and died in Rome. Also near Rosa's grave, with a tombstone marked by a broken statue of a goddess, is the legendary English beauty **Belinda Lee** (1935–61),

who acted in a number of movies, first in England, then in France, Germany, and Italy. She had an illicit love affair with the papal prince Filippo Orsini. They each attempted suicide—sleeping pills, slashed wrists—unsuccessfully. The pope punished the prince by removing the Orsini family's hereditary title. Lee ended up dying in a car accident between Las Vegas and Los Angeles. The Italian documentary *Women of the World* (*La donna nel mondo*), released shortly after her death, bears this dedication: "To Belinda Lee, who throughout this long journey accompanied and helped us with love." The poet and novelist **Sarah Dana Loring Greenough** (1827–85) is commemorated with a statue of Psyche becoming an immortal. The epitaph cries out, "Her loss was as that of the key-stone of an Arch." You might also find the grave of **Constance Fenimore Woolson** (1840–94), a fiction writer and poet originally from New Hampshire. After her mother's death, she moved to Europe, where she developed a close friendship with Henry James. (The complexities of their relationship have inspired several recent novels.) At the end of her life, she lived in an apartment over the Grand Canal in Venice and either jumped or fell to her death from her fourth-story window. If you look along the wall of the cemetery, you can see a plaque for "African American Abolitionist and Physician" **Sarah Parker Remond** (1826–94). Born free in Massachusetts, she began making her first antislavery speeches when she was just sixteen, the age Rosa was when she died. Reminiscent of Rosa's father, Remond traveled to England to lobby for support for the Union during the Civil War. She then went to Florence, studied medicine, became a practicing physician, and married an Italian. The last decade of her life was spent in Rome. You can also find the graves of **Gregory Corso**, **Antonio Gramsci**, **Percy Bysshe Shelley**, and **John Keats**, whose place on the **Spanish Steps** (Piazza di Spagna), next to the **Fontana della Barcaccia**, is also well worth visiting. Whereon shouldst thou build? The question can engagingly accompany you not through just the Protestant Cemetery, where the dreamers sleep, but all of Rome, where some of the dreamers are still awake.

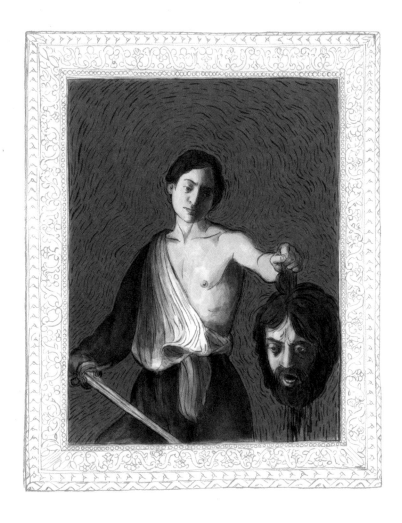

FIGURE 2.1 · Caravaggio, *David with the Head of Goliath* (ca. 1609), Galleria Borghese. "H·AS.O.S" is inscribed on the sword's blade, an acronym of a phrase from Augustine, *"Humilitas occidit superbiam"* (Humility slays pride), in a commentary where the philosopher notes that David's defeat of Goliath is like Christ's defeat of the Devil: "David represented Christ, as Goliath represented the devil, and when David laid Goliath low he prefigured Christ, who crushed the devil. But what is Christ, who cut down the devil? He is humility, the humility that slew pride." Augustine, *Expositions of the Psalms 33–50*, trans. Maria Boulding (Hyde Park: New City Press, 2000), 16.

2

BUILD ON TRAGEDY

The Humility of Caravaggio's
David with the Head of Goliath

Rome alone could conquer Rome.
SEAMUS HEANEY

What moment would you select if you were a painter or a sculptor charged with depicting an image from the great underdog story of David slaying Goliath? If you were a Baroque master, you'd look for the moment of maximum energy, as in Bernini's sculpture where David coils himself to sling the stone, biting his lip in concentration. Would you choose the obvious moment when the projectile strikes the giant? Would you focus on Goliath's shock or David's hopeful anticipation—or both? Maybe the dazed moment right after Goliath has fallen? Maybe the gruesome act of hacking off the dead warrior's head? Whom would you use as models? If you were a Renaissance master, you'd likely avoid the action altogether and disrobe a young man of flawless physique, as in Donatello's bronze or Michelangelo's marble. Not far from where Rosa drowned is the

Galleria Borghese, where you can see *David with the Head of Goliath*, Caravaggio's curious choice of how to depict the Old Testament tale. Among the many reasons to examine it is that it deepens our mystery of whereon to build a life.

Like so many who add a chapter to Rome's story, Michelangelo Merisi (1571–1610)—known to the world as Caravaggio, after the town outside of which his father owned property—wasn't born a Roman. He spent his first years in Milan and, when that city was ravaged by the plague, moved with his family to the country at the age of five—a bit too late: his grandparents, uncle, and father all fell shortly to the Black Death. In 1584, after his mother died, Caravaggio commenced four years of study with the Mannerist painter Simone Peterzano. When his apprenticeship was complete, he made his way to Rome and ate it up, hanging out with prostitutes and *bravi*, the city's sharply dressed street fighters. After a few lean years, his anti-Mannerist paintings, with their fusion of stark naturalism and emotional intensity, began to capture the imaginations of the city's key players. You get a sense of his early virtuosity in *Self-Portrait as Bacchus* (1593), commonly called *Sick Bacchus* (on the same wall in the Borghese as *David with the Head of Goliath*), a work that appears to romanticize a hangover. The rest of Caravaggio's life was a blur of brawls, prison sentences, and masterpieces. In 1606, in a dispute over a tennis match, he murdered a man. Even his powerful patrons couldn't protect him. He fled Rome for Naples, then Malta, then Sicily, then Naples again. After finally securing a papal pardon, he died trying to sail back to Rome—perhaps of syphilis, perhaps of malaria, perhaps at the hands of his enemies—"no positive account of his death ever having been received," so to speak.

In *David with the Head of Goliath*, we see the young warrior examining the hacked-off head of his enemy. As in so many of his paintings, the drama of this late work emerges out of darkness, as if a cinematographer's flood-light shone on method actors in a gritty setting. (The analogy runs deep: Caravaggio exerts a direct

influence on modern cinema.) Goliath's face still wears the moment of disbelief. Veins dangle from his neck. An exquisite shirt covers half of David's torso. Is there a skein of fabric in the upper right corner? Are we in the tent of Saul? David's expression, suspended somewhere between horror and compassion, is a mystery.

Like so much in Rome, the painting is an amalgam of sex and violence. Caravaggio's art, like the artist himself, doesn't have much time for the attractions of the female form but is superb with young men's beauty. The model for David looks to be the same one depicted in Caravaggio's *Saint John the Baptist*, also in the Galleria Borghese—the sexiest, least saint-like image of the ascetic you could imagine. Some scholars believe that he is Cecco del Caravaggio, the painter's assistant and lover in Rome. The placement of the sword in *David with the Head of Goliath* is—let's say—*suggestive*, though the painting's strong hint of sadomasochistic eroticism is mellowed into tragedy by the looks on its subjects' faces.

Alongside the profound naturalism and intense drama of his paintings, what makes Caravaggio's art great is a virtue I've dubbed in a different context "blues-understanding," by which I mean the ability to understand our humanity on both sides of suffering.[1] Blues-understanding involves compassion but also treats gently our infliction of suffering. It's easy, albeit repugnant, to celebrate our power at the expense of others. It's understandable, albeit inadequate, to vilify oppressors. It's rare to be clear-eyed and open-hearted about both the abuser and the abused. It's rare to have an undivided understanding of our divided humanity. We all inflict suffering and suffer unjustly, but Caravaggio transforms his intense personal experiences with violence, as both abuser and abused, into images perched on the knife edge of tragedy. *David with the Head of Goliath* is about the victory of an underdog (the perennially attractive fantasy of having our cake of justice and eating our cake of domination too), but the painting refuses any triumphalism in the Hebrew's triumph while also denying us sentimentalism over the

Philistine's downfall. We see the unvarnished truth of the situation: the horror of being reduced to an object and the horror of having taken a life.

If you've just come from Rosa Bathurst's epitaph, it's natural to read Caravaggio's David as saying, "Build not thereon." The young warrior is staring down at an "awful lesson of the instability of human happiness." Triumph shall become defeat. Youth shall become age. Beauty shall become ugliness. Life shall become death. Build not thereon! At minimum the young warrior seems to be wondering, "If I continue down this path, will an upstart someday lay me low?" But maybe he's sensing a worse tragedy, his actual destiny, that he'll live to old age and have to witness his son suffer Goliath's fate, that he'll be forced to cry out, "O my son Absalom, my son, my son Absalom! Would I had died instead of you!"[2]

The first time I saw the painting in Rome, in my midthirties, I identified with the young warrior. I felt horror and tenderness for him. I felt horror and tenderness through him. Over the past decade I've felt my sympathies shifting closer to what Caravaggio must have felt about the image. The hacked-off head that David holds in his hand is Caravaggio's self-portrait. Painted sometime in the shadow of his crime and exile, it's unmistakably the older face of the dashing, sickly-green Bacchus on the wall beside it. Though a few art historians date it to right after his commission of murder in 1606, many conjecture that David with the Head of Goliath is one of Caravaggio's last paintings, completed in 1609, the final year of his life, shortly after he was brutally beaten on his way out of a seedy bar in Naples.[3] If this view is right, the wound on Goliath's head didn't require much artistic license on the painter's part, nor the shocked look of horror at being laid low. Scholars also have evidence that the painting was sent to Cardinal Scipione Borghese, the shrewd patron whose art collection furnishes the Galleria Borghese. Caravaggio's hope was that the painting might secure him a pardon from Scipione's uncle, Pope Paul V. It's worth noting that one of the penalties for murder in the Papal States was decapitation.

One of the recurring themes in Roman history is that part of living the good life involves reading ourselves into the great stories. By self-projecting into myths, we expand our inner possibilities, add panache to our projects, and achieve a measure of self-knowledge—often heart-rending self-knowledge. We also enrich the myths. The art historian John Spike reasonably speculates that Caravaggio's projection of himself into the slain Goliath was a "confession that he would die enslaved by sin without seeing the light of grace." Spike sees Caravaggio's David as the artist's portrayal of Christ looking down at "those souls excluded from his kingdom."[4] The charged image is a symbol of capital punishment, an act of contrition, a plea to be forgiven, and a cry that life itself is to be built whereon we shouldn't build.

But connected to Caravaggio's admission of his spiritual failure is his pride in his artistic success. The painting imitates nature—not just in its depiction of flesh but in its evocation of soul. Caravaggio's deep realism is his insistence on seeing human nature, particularly his own human nature, as it is and not as he wishes it would be. The artwork is an accomplished physical representation and an achieved piece of self-knowledge, an image that embodies Pascal's observation: "Man knows that he is wretched. Thus he is wretched because he is so, but he is truly great because he knows it."[5]

Life is tragic, and not just in the sense that bad things happen to us. We're tied into the knot of David and Goliath. Not only do we suffer bad things, we inflict them too. But our lives have the potential for dignity, even for greatness, insofar as we're realists of our condition. We can't really cultivate our humanity without facing our fundamental moral and psychological ambiguities. Caravaggio's blues-understanding, which is also Rome's, puts us in good stead. The point isn't to be free of troubles but to be liberated into the deep values of compassion, humor, gratitude, forgiveness—those David-like virtues of humility that somehow defeat our moralism and pride. We build on tragedy, or else we never really build at all.

THINGS TO SEE AND CONSIDER:
ROME AS TRAGIC FOUNDATION

The highest concentration of Caravaggio's paintings anywhere is in the **Galleria Borghese**, one of the world's most extraordinary museums, where you can see not only *David with the Head of Goliath* but also *Self-Portrait as Bacchus* (1593), *Boy with a Basket of Fruit* (1593), *St. Jerome* (1606), *St. John the Baptist* (1610), *Portrait of Pope Paul V* (1605–6), and *Madonna of the Palafrenieri* (1605–6). After your visit to the Galleria Borghese, you might wend your way through the lovely park that is the Borghese Gardens to the **Basilica of Santa Maria del Popolo**, where you can be enveloped in what I call the "Caravaggio sandwich." In a side chapel, his painting *The Crucifixion of St. Peter* (1601) faces his painting *The Conversion of St. Paul* (1601). Peter requests to be crucified upside down, as he does not want to presume a martyrdom in imitation of Christ. Awkwardly shifting his body as his cross is being hoisted, he stares across the chapel at Saul (soon to be Paul), who has been knocked off his horse by the blinding appearance of God. In return, the divine light reflecting off the horse's haunches streams across the chapel onto the violence to which Peter is being subjected. Saul's servant and horse, as well as the workmen diligently crucifying Peter, support W. H. Auden's thesis that the old masters are never wrong about how suffering "takes place / While someone else is eating or opening a window or just walking dully along."[6] There are several more Caravaggios scattered throughout Rome (after the Borghese, the next highest concentration is found at the miraculous **Palazzo Barberini**): all of them are well worth seeing, though a few—alas—aren't accessible to the public. Though tragedy obviously pervades Roman history and art (isn't the fundamental Christian symbol the crucifix?), it's overwhelming to try to see the world through Caravaggio's eyes, where a homeless lady is Mary's mother and John the Baptist is a male prostitute, where suffering shines so transparently we're moved almost beyond compassion. The last act of the otherwise

pious hero in Virgil's *Aeneid*, which is the first act of what is to become Rome, is a gratuitous death-blow to his enemy Turnus. I wish Caravaggio had painted that scene!

DETOUR TO THE ORIGIN OF THE ORIGIN OF THE ORIGIN OF ROME

Our mind just can't escape making contradictory demands on itself. For instance, we crave an origin to ground history, yet we can always ask, "But what was the origin of the origin?" "Build not thereon" is the meaning of whatever foundation our story builds on.

Rome has at least two origin stories: an origin and an origin of the origin. The first is the story of twins raised by a she-wolf. They argue over which hill to build a city on. Romulus ends up killing Remus, and the city on the Palatine is named Roma instead of Remora.[7] The origin of the origin pertains to how the Trojan warrior Aeneas escapes his burning city, goes on the adventure narrated in Virgil's *Aeneid*, and eventually wins the hand of a Latin princess, starting a bloodline that issues in Rhea Silvia, the mother of Romulus and Remus.

But wait, how did it come about that the well-fortified city was sacked? The origin of the origin of the origin of Rome is depicted in *Laocoön and His Sons*, an ancient sculpture dug up in the Renaissance that's on display in the Statues Courtyard in the Vatican Museums.[8] Laocoön is the Trojan priest who, when his people are presented with a great wooden horse, says, "I fear the Greeks, even when they're bearing gifts," and hurls his spear at the hollowed-out wood. The gods, having preordained that the Greeks should conquer the Trojans, discredit the skeptical priest's true surmise by sending sea-serpents to kill him—and, for good measure, to massacre his children too. The magnificent sculpture depicts the moment of maximal cosmic injustice. One of the priest's innocent sons lies dead among the looped beasts; the other, still struggling, looks accusatorily at his father who writhes against the serpents in utter

agony. We see the original paradox of not just Rome but human life. Had Laocoön been successful, Troy wouldn't have burned. Had Troy not burned, Aeneas would never have fled. Had Aeneas not fled, Romulus wouldn't have been born. No murder of Laocoön, no Rome. No tragedy, no civilization. No unjust suffering, no humanity.

But wait, how did the Trojan War come about? Well, that's another story.

3

PUT DOWN ROOTS IN THE UPROOTED

The Piety of Bernini's
Aeneas, Anchises, and Ascanius

and if the City falls and one man survives
he will carry the City inside him on the paths of exile
he will be the City

ZBIGNIEW HERBERT

Whereon should we build? The literal sense of that question is central to Rome. The long-standing problem is erecting something new in light of previous construction. "Build not thereon" is whereon the Romans have been building for a few millennia. The solution, well known to Americans, of getting rid of what's there and building afresh is less common in the Eternal City. A more popular solution is to build around or on top of what's already there. My favorite church in Rome, which we'll visit in a later chapter, is the medieval Basilica of San Clemente, which is built on a much earlier Christian basilica, which is built on an older sanctuary of an imperial mystery cult, which is built on a burned-down

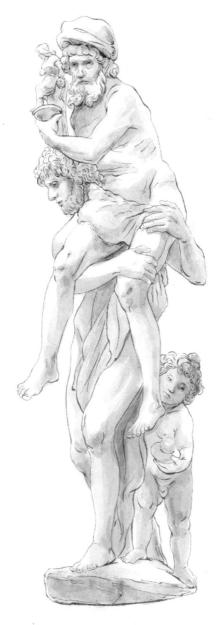

FIGURE 3.1 · Gian Lorenzo Bernini, *Aeneas, Anchises, and Ascanius* (1618–19). Galleria Borghese. Virgil has Aeneas say to his father, "Hoist yourself on my shoulders: the weight won't weigh on me. / Whatever happens, it will be the same for us both: / a shared risk, a shared salvation." Virgil, *Aeneid* 2.708–10.

republican-era house, which seems to have been built on yet an older structure. Another strategy is to make use of spolia (recycled fragments, "spoils" in Latin) to outfit the new building, as in various churches around Rome, including San Clemente, that have mix-and-match columns from various pre-Christian temples. Rome is built on Rome, out of Rome.

The question of whereon to build is also spiritually crucial to Rome. The king? The people? The emperor? The military? The gods? The cross? The pope? The past? The nation-state? *Il duce?* The tourist industry? The centrality of spiritual building is made clear in Jesus's pronouncement inscribed in giant letters around the dome of St. Peter's: "TU ES PETRUS ET SUPER HANC PETRAM AEDIFICABO ECCLESIAM MEAM" (You are Peter [the Rock], and on this rock I will build my church). Rome's approach to the spiritual question of whereon to build is much like its approach to the architectural question of whereon to build. It's a mishmash. Arguably, all Western history since Constantine is the attempt to build on the never-quite-stable rocks of religious authority and political power. Aren't our individual lives also unreconciled mishmashes of various value systems? "Rome wasn't built in a day"—I've come to realize that this old saying doesn't just mean that a project takes time, but that a project must be worked up, fall apart, and be put back together with pieces of its ruins.

Rosa Bathurst's epitaph and Caravaggio's late painting of David portray the tragedy at the foundation of humanity. Is there a way of honestly portraying the possibility of civilization? What image could show the paradox whereon human life and its buildings are practically founded? I recently came across a photograph of a Yazidi refugee carrying his blind father on his shoulders through the desert.[1] The determined slump of the son and the resigned humiliation of the father echo a famous statue in Rome, Gian Lorenzo Bernini's sculpture of Aeneas carrying his father Anchises out of Troy, another great work that can be found in the Galleria Borghese, in a room near Caravaggio's *David with the Head of*

Goliath. It had never fully sunk in until I laid eyes on this photo that the founder of Rome is a refugee. Like the fate of the Trojans after the Greeks laid waste to their people and city, the Yazidi have endured displacement and sex slavery after their genocide at the hands of ISIS. The photograph's protagonist—his name is the almost Roman-sounding Dakhil Naso—hoisted his disabled father on his shoulders and struck off into the unknown, equipped only with what the two of them could carry in their pockets. Likewise, Aeneas put lame Anchises on his shoulders and fled a burning city with no more than a tiny statue of their household gods. When I now see pictures of the desolation and wherewithal of refugees, I experience more than the second-rate emotion of pity. I think, "The City is on the move."

Virgil's *Aeneid*, the foundational epic of ancient Rome, composed under the reign of Caesar Augustus, tells how a small band of Trojan survivors goes on a journey that culminates with their victorious battle for control of Latium, the land in central western Italy that eventually gives birth to Rome. In book II of the *Aeneid*, the hero Aeneas, trying to escape his burning city, comes across Helen, the cause of the whole fiasco. He wants to kill her. But Aeneas's mother, the goddess of love, appears and encourages him instead to escape with his family. When Aeneas finds his father amid the slaughter, Anchises pleads to be left to die. Aeneas picks Anchises up, grabs his son Ascanius by the hand, and leads them determinedly through the flames, assuming his wife Creusa is right behind them. Once they reach their rendezvous point, he realizes in horror that she's gotten lost. Aeneas rushes back into the ruined city only to find his wife's ghost, who tells him to take care of their son and gives him permission to find another wife. When he tries to embrace her one last time, his arms slip through the dream image. It's a scene that's been replayed millions of times over the centuries, most recently in places like Afghanistan, Iraq, Yemen, Sudan, Congo, Syria, Nicaragua, Ukraine.

The artist who sculpted the memorable image of Aeneas is Gian

Lorenzo Bernini (1598–1680). Here I use the term "artist" in the most encompassing sense. As a sculptor, Bernini fashioned statues, tombs, busts, and various fountains, including the Fountain of the Four Rivers in the Piazza Navona. As an architect, he built churches such as Santa Bibiana and Sant'Andrea al Quirinale, and he presided over the construction of big chunks of St. Peter's, including its baldachin and the massive piazza and colonnade in front of it. He was also a painter, an actor, a director, and a stage designer. Many of his best-known sculptures—*Apollo and Daphne, David, Hades and Persephone, Truth Unveiled by Time,* and *Aeneas, Anchises, and Ascanius*— can be found in the Galleria Borghese. When they were installed there, Scipione Borghese bragged that his visitors hardly wanted to look at anything else. The Rome we now visit is, in certain regards, Bernini's town.

Like Caravaggio, whose imaginative intensity inspired him, Bernini was one of those artists whose turbulent energies are hard to contain except in their art. Born in Naples, he moved to Rome when he was seven and spent his whole long life there, with only a brief stint in Paris, when Louis XIV asked him to redesign the Louvre. "Stern by nature, steady in his work, ardent in his wrath" was how Bernini's son summed up his character.[2] His mind-boggling output speaks to his sternness and steadiness. For that bit about his wrath, one well-known story involves Costanza Bonarelli (Bernini's bust of her—my favorite work of his—is in the Bargello in Florence). Married to one of Bernini's collaborators, she and Bernini had a wild love affair. When Bernini discovered his brother was also having an affair with her, he attempted to kill his brother and hired a servant to slash Costanza's face with a razor.

Aeneas, Anchises, and Ascanius (1618–19) was completed when Bernini was just twenty years old. It portrays three generations, each bearing something crucial to Rome. Aeneas holds his father. Anchises, in a Phrygian cap, holds a statue of the household gods sitting atop a vase containing the ashes of their ancestors. Aeneas's son Ascanius trails along behind, carrying the Eternal Flame of

Vesta, which will find a home in the center of the Forum. Together they carry family, religion, and home. Together they unify past, present, and future.

You can see in this early work the style of the young artist being built out of a mishmash of images and forms glimpsed in Rome. Aeneas's head hearkens back to Bernini's father's sculpture of John the Baptist in Sant'Andrea della Valle. The composition draws heavily on Raphael's Renaissance fresco *Fire in the Borgo* in the Vatican. The pose of Aeneas—Bernini's most brilliant borrowing—derives from Michelangelo's sculpture *Risen Christ* in Santa Maria sopra Minerva (right outside of which you can see Bernini's sculpture of an elephant bearing an obelisk). Not only is Bernini's homage to Michelangelo an artistic inquiry into where his greatest predecessor left off; it's an ingenious allusion, fusing Aeneas carrying his father with Jesus carrying the cross. Bernini's sculpture wasn't built in a day!

Virgil's epithet for Aeneas is *pius*, usually translated as "pious" or "dutiful." *Pietas* involves a channeling of our energies toward higher ends and is expressed in a loyal commitment to family, community, strangers, and ultimately the gods. Piety, in this sense, allows us to transform fury and lust into honor and devotion. It's a virtue most vividly seen in our lowest, hardest moments, as in Aeneas's ability to overcome his desire for vengeance in order to save his family and the rudiments of Trojan culture. In the moment of utter destruction, he has a choice: to feed the furnace of hatred or to serve and preserve what matters most. By being able to uphold what's most important under the worst conditions, Aeneas proves himself worthy to found civilization. Bernini's sculpture captures this great piety that upholds all healthy culture. (Admittedly, a cynical reading is also quite plausible: the work serves to rationalize as filial piety the blatant nepotism of Pope Paul V and his nephew Scipione Borghese.)

An idiocy of our age is that we frame a choice between ethnic rootedness and rootless cosmopolitanism, both of which are men-

aces. Without roots we're shallow, while a clinginess to blood and soil unleashes some of our worst demons. As human beings we're wanderers as well as dwellers—and, more fundamentally, a crossing of both polarities. We're rooted, for sure. But we're also uprooted. Circumstances compel us to move; one of our central features is the ability to change and cope. Plus, there's often something exciting and liberating about moving. Never completely at home anywhere on this planet, we're in search of finding or founding something better, regardless of whether we stay put or hit the road. The truth is that we don't really know what's given to us until it's been put to the test—thus, the quip that there are only two plots in literature: a person goes on a journey and a stranger comes to town.[3]

I find Bernini's sculpture and the story behind it especially poignant now, as the upheavals of climate change and global capitalism usher in an age of the refugee. One common response to these disruptions, among those lucky enough to have all their journeys be trips, is to tighten borders, shut out refugees, purge immigrants. Another common response is to want (usually someone else) to welcome the stranger among us in the fond hope that nothing much has to change. It's like half of us are blind to the refugee in Aeneas, and the other half are blind to his household gods. How should we think about our identity in a time of flux? Who's the *real* Roman? Bernini's sculpture reminds us that Aeneas is a foreigner, a refugee, a loser, as well as an explorer, a conqueror, a founder. Uprooted, he carries his roots with him. He bears the past on his shoulders and leads the future by the hand. He brings with him a transformative piety. He reminds us of the ruins out of which lives and societies are made. The story of the journey and the story of the stranger are the same story in Rome.

Whereon should we build? One lesson I draw about the good life, both in the personal and political sense, is that we should seek out images, stories, and ideas grounded in our border-blurring paradoxes. We should be wary of straightjacketing our character in stupid nationalisms, bland universalisms, or any other facile

identities. We inhabit an age where gross simplifications of our humanity are aggressively marketed and depressingly common. Build not thereon! The goal is for the city to come alive in us, and for us to come alive in the city. The foundation is *pietas*, the faithful devotion to serving and preserving what matters most. As Phillida Bathurst suggests with her daughter's epitaph, we're richer and more connected than we think, and we should stay true to our vast ambiguous humanity, because none of us knows how long we have. What would it mean to live our lives and rebuild our buildings on the complexity of who we can be?

THINGS TO SEE AND CONSIDER: ROME AS THE FOUNDATION

You'd have to work hard to be a tourist in Rome and miss Bernini's works. His sculptures, buildings, and fountains are the quintessence of the Baroque's passionate dynamism, giving body to the Counter-Reformation's spirit of refounding Rome as the world's spiritual center. His theatrical design of **St. Peter's Square** (Piazza San Pietro) reaches out and embraces the masses with a great colonnade of saints. In the **Piazza Navona** his magnificent *Fountain of the Four Rivers* (*Fontana dei Quattro Fiumi*, 1651), where the jetting water buoys up the massive marble gods like beach balls, allegorizes how the Catholic Church is established across the entire planet. We see his fascination with foundations in his charming *Elephant and Obelisk* (1667) by the Basilica of Santa Maria sopra Minerva. In St. Peter's Basilica we see it in the breathtaking *Baldacchino* (1623–34) with its swirling columns that seem to build themselves upward out of Peter's tomb, as well as in the *Tomb of Alexander VII* (1671–78) with its allegory of virtues and its skeletal Death with an hourglass. Bernini also has a fascination with sex and violence, our psychological foundations. Even if we leave aside masterpieces like the chopped-off head of *Medusa* (ca. 1640s) in the Capitoline Museums (Musei Capitolini), or the *Ecstasy of St. Teresa* (1647–52) in Santa

Maria della Vittoria and the *Blessed Ludovica Albertoni* (1674) in **San Francesco a Ripa** (in both of which mystical experience is portrayed as orgasm), and just focus on his works of sex and violence in the **Galleria Borghese**, we find the disturbing *Rape of Proserpina* (1621–22), the exquisite *Apollo and Daphne* (1622–25), the moving *Aeneas, Anchises, and Ascanius* (1618–19), and the inspirational *David* (1623–24), the head of which is a self-portrait. Bernini isn't a particularly profound artist, but his works overflow with dramatic energy and are unsurpassed in technical bravado. What they show is essential to Rome: the unrelenting dynamism that rebuilds life *ab urbe condita* (from the founding of the city).

DETOUR BY THE FOUNTAIN OF
THE SINKING SHIP

What's the foundation of civilization? According to Ron Weber, my friend and colleague on the study abroad trip, it boils down to "good water in, bad water out." With their magnificent system of aqueducts, the ancient Romans were so adept at moving water that they were able not only to keep a million citizens hydrated and clean but to create air-conditioning systems atop the Palatine, where water was spritzed through thin pipes to cool the wealthy. The mythic version of Ron's point involves the story of the ancient king Numa Pompilius, Romulus's successor, who married the water nymph Egeria and visited her sacred grove every night. The advice she whispered in his ear became the law of the land and led to decades of peace and prosperity. Whereon should we build? Civilization springs from springs! (Ron applies his same formula to study abroad. It's all about water bottles and knowing where the bathrooms are.)

I would simply add to my friend's point about water that civilization is also about fountains, for life isn't quite life until its essentials are transformed through play. As anyone into sports or chess will tell you, play is generally the most serious thing we do. A spirit

of playfulness permeates all really successful activities, regardless of their usefulness. The ancient Romans, generally a practical people, imported much of their playfulness from Greece in the form of poetry, philosophy, wine, and art. I'm fond of Kenneth Burke's advice: "When in Rome, do as the Greeks."⁴ But Rome's native genius for playfulness gushed out in fountains of tremendous virtuosity. Though the 1,212 fountains recorded to exist in Constantine's time were dismantled when the aqueducts crumbled in the Middle Ages, Roman fountains have had a renaissance since the Renaissance. Their ubiquity, grandeur, and all-round charm are central to the city's appeal. What's better than a fountain? It allures all five senses, soothes us whether we're happy or sad, inspires creative reveries, and wets our whistles.⁵ It converts what killed Rosa Bathurst into a thing of beauty.

In his novel *ABBA ABBA*, Anthony Burgess imagines John Keats in his final ailing days listening to the Fontana della Barcaccia, a playful depiction of life as a sinking ship by Pietro Bernini (the father of the more famous Gian Lorenzo Bernini): "John stood a while by Bernini's broken marble boat, listening to the water music. He tried to identify himself with the water, to be the water, to feel the small sick parcel of flesh that was himself liquefy joyfully, joyfully relish its own wetness and singing clarity."⁶ Maybe it dawned on Keats that Rome itself is writ in water.

II

Remember Death

The melancholy of the antique world seems to me more profound than that of the moderns, all of whom more or less imply that beyond the dark void lies immortality. But for the ancients that "black hole" is infinity itself; their dreams loom and vanish against a background of immutable ebony. No crying out, no convulsions—nothing but the fixity of a pensive gaze. Just when the Gods had ceased to be and the Christ had not yet come, there was a unique moment in history, between Cicero and Marcus Aurelius, when man stood alone. Nowhere else do I find that particular grandeur.

GUSTAVE FLAUBERT

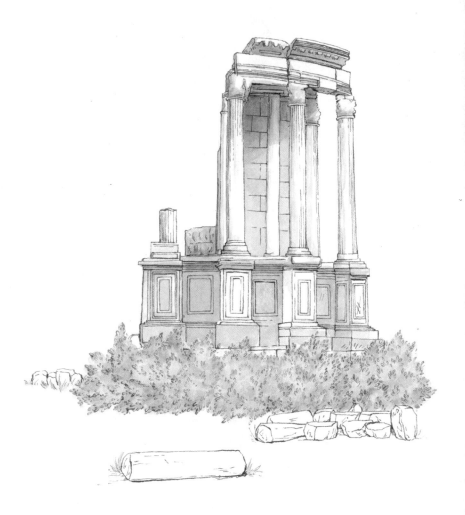

FIGURE 4.1 · Temple of Vesta, Roman Forum. Because Roman philosophy flourished after the republic collapsed, and Christian theology took shape after the Visigoths sacked Rome, and the Renaissance was discovered in broken statues, and the Baroque was forged after Protestantism attacked Catholicism, and Romanticism was animated by flowers springing from the cracks of fallen temples, and Neorealism invented modern cinema by training its cameras on the devastation left by World War II, my conjecture is that Rome is about the self-knowledge of living in the ruins.

4

BE NOT FOR YOURSELF ALONE

Cicero in the Ruins of the Forum

One would need a Cicero to sing Cicero's praises.

LIVY

What's most important about the Forum is what isn't there. Even its ruins are in ruins. If you try to find the *rostra*, the speaker's platform where, for instance, Mark Antony delivered his "Friends, Romans, countrymen" speech, you're likely to wander in a general area until you read in your guidebook that it was destroyed and rebuilt under Caesar Augustus, and even that later version is long gone. If you want to see the senate house where, for instance, Cicero gave blistering speeches against Mark Antony, your initial awe at the curia, one of the Forum's few intact buildings due to its conversion to a church in the seventh century, is likely to dim when you discover that the structure, which had already been remodeled in Cicero's lifetime by his enemy Julius Caesar, was totally destroyed in a fire and rebuilt almost five centuries later—oh, and its roof, rear facade,

and upper side walls are twentieth-century reconstructions. The
Temple of Vesta, where the eternal flame of the city burned awhile,
looks glorious and original: its ruins—yes, its ruins—were rebuilt
under Mussolini. I've had students take home a keepsake rock from
the Forum that's likely a piece of gravel quarried circa AD 2000.

Is it comforting or depressing that when Cicero looked out
at the Forum over two millennia ago, he was also struck by what
wasn't there? Though its architecture was still in decent shape, he
felt that its humane purpose was in ruins. In a dialogue addressed
to Marcus Brutus, who stabbed Julius Caesar shortly after the work
was composed ("*Et tu, Brute?*"), Cicero laments that one of the funda-
mental crimes of the would-be dictator is the demolition of public
discourse: distracting the citizenry, playing fast and loose with the
truth, undermining authority. After reporting that his friend and
mentor Hortensius died "when the Republic could least spare him,"
Cicero says,

> Were Hortensius alive today, he would doubtless have occasion,
> along with other good and loyal citizens, to mourn the loss of
> many things; but one pang he would feel beyond all others with
> few, if any, exceptions: the spectacle of the Roman Forum, the
> great theater where he used to exercise his genius, robbed and
> bereft of that accomplished eloquence worthy of the ears of
> Rome or even of Greece. For me too it is a source of deep pain.[1]

The note that Cicero strikes here is a common one, especially
among Roman ruins: the feeling of greatness lost. But what I love
most about his philosophy is how it works through nostalgia to
seek wisdom in the ruins: the ruins of politics, the ruins of philos-
ophy, the ruins of loved ones, the ruins of the body, and the ruins
of the so-called Eternal City. Not only does Cicero point us to the
finest purpose of the Forum; he helps us to understand what all its
shattered temples and lonely columns are trying to tell us. He makes
sense of what's there and helps us to live with what isn't.

Though Marcus Tullius Cicero (106–43 BC) is sometimes referred to in English as Tully, we mostly know him as Cicero. John Adams, who aspired to be an American Cicero, said of him, "All ages of the world have not produced a greater statesman and philosopher united."[2] The usual path to the prestige necessary for a Roman political career was military distinction. But Cicero won his *dignitas* with his rhetorical skills, successfully arguing cases and making speeches in the Forum. Having passed through the *cursus honorum* (the sequential order of offices for politicians), he was elected consul (like president or prime minister) in the year 63 BC and famously thwarted a conspiracy against elected officials—and eventually against Rome itself—led by a charismatic rich egomaniac named Catiline. Asked by Julius Caesar in 60 BC to join his partnership with Crassus and Pompey, Cicero turned him down, fearing that they threatened the existence of the republic. Due to political pressure, Cicero was forced into temporary exile. After Caesar was assassinated and Cicero returned to Rome, he and Mark Antony became the leaders of opposing factions: Cicero standing for republicanism, Antony for Caesarism. When Octavian, Lepidus, and Antony formed the Second Triumvirate, they declared Cicero an enemy of the state and had him executed.

"My education," Cicero says in *On the Orator*, "was the Forum."[3] The paradigm for most city squares in the Western world, the Forum was originally a neutral meeting point between the Romans on the Palatine Hill ruled by Romulus and the Sabines on the Capitoline Hill ruled by Titus Tatius. It naturally developed into an open-air market. As people mingled and shopped, they began to argue about politics and thus created a public space that became a site for speeches and trials, where human reason could be exercised. Temples were erected: first, to the precivilized gods of Vesta (goddess of the hearth) and Saturn (the god of agriculture who ruled over the Golden Age), then to the gods of the city like Castor and Pollux (the mythological twins who magically appeared to defend the infant republic) and Concordia (the goddess of peace in mar-

riages and public life), and ultimately to Romans themselves like Julius Caesar and Caesar Augustus (who were each declared *divus*—"divine" in the sense of becoming part of the permanent memory of the people) or Titus and Septimius Severus (whose triumphal arches at each end remind us that the Forum was the site of military parades). When your sandals crunch down the Via Sacra, you're not just seeing the Forum's columns and rubble. You're experiencing a public space that once combined commercial, political, legal, and religious activities such that a unique way of life could be sustained.

The Forum raises fundamental philosophical and political questions. In a town or a village, your identity can be more or less fused with the standard traditions and activities of getting by. In a big city like Rome, it's no longer possible for you simply to be someone who does your labors, prays to your tribe's gods, and enjoys the fruits of your labors. In the bustling Forum, who *you* are becomes a pressing question. What's the point of your labors? What should you buy? Which temple should you visit? How are you to occupy your free time and navigate the city's wide-openness? Who should have power? The city is a space not just of strangers but of strangeness: curious people doing, thinking, and saying crazy things. What the Forum teaches Cicero has something to do with the surprising possibilities that show up in relation to how others are exercising their rationality and exhibiting the range of their uniqueness. Not only does this quintessence of public space raise the great questions of who we are and how we are to live together, it provides a forum—in the most original sense of the word—for Cicero and his fellow citizens to answer those questions together.

Vesta, the goddess of hearth and home, is commemorated at the center of the Forum, for you can't have a decent public life without a protected private life. As Cicero says, "The most sacred, the most hallowed place on earth is the home of each and every citizen. There are his sacred hearth and his household gods, there the very center of his worship, religion, and domestic ritual."[4] But the point of a private life for Cicero is largely to empower the public life that

buzzes around the Temple of Vesta in the Forum. The centripetal energies of home serve the centrifugal energies of the city. Though he celebrates the hierarchical bonds of the family and is keenly aware of the class structure of Roman culture, including the institution of slavery, Cicero believes that our nature is best expressed in relationships with an element of equality, where we can strike up a debate on the steps of a temple or cast a ballot at the *comitium*, the assembly grounds where the thirty districts of the city met to record their votes for legislation and magistrates. Only when what Cicero calls "liberty" is widely available can we have a real public life. He says (in a moment of idealism's triumph over reality), "Nothing can be sweeter than liberty. Yet if it isn't equal throughout, it isn't liberty at all."[5]

How do we make the most of living together with a wide variety of people? At the heart of Cicero's moral philosophy is the idea of *decorum*, which in Latin means something like "fittingness" or "appropriateness." We still use the word "decorum" in roughly the same way in English. But our concept comes nowhere near the magnificence of the Ciceronian ideal. Unlike the principles of morality, religion, or ideology (all of which, Rome teaches us, come and go), decorum can't be codified: it's about the adjustments necessary to enhance relationships in any given situation. We recognize it as we do physical beauty, for it combines natural social traits in a musical way. In a sense, decorum is a more aesthetically oriented form of prudence. Not only does decorum proportion the virtues to the situation, it knows what virtue to apply when. Those who wield it master the grammar of social life to enhance human well-being. It means being polite when politeness is called for, but it also means being fun when politeness isn't called for.[6] Besides the general kind of decorum, in which we treat our fellow human beings, regardless of their creed or station, with grace and good humor, Cicero recognizes a heightened kind of decorum, powerfully expressed by the Stoics, that involves a life in accord with nature, where we ride the rhythms of being alive in a way becoming of free people.

The idea is to treat the ups and downs of existence with grace and good humor. It's the height of human achievement to treat death itself with decorum.

According to Cicero, human nature is inherently relational: "We aren't born only for ourselves: our country and our friends have a claim on a portion of our existence . . . people are born for the sake of people, to be able to benefit one another."[7] The best of our relationality doesn't just involve public service and social grace. The most rapturous of all his works is *Of Friendship*, which describes "the kind of companionship that provides everything men regard as worth seeking: integrity, glory, tranquility of soul and joy. When these are present, there is happiness, too; without them, it cannot exist."[8] True friendship, where we spontaneously seek the best for our friends and naturally express the full range of our personality in conversation with them, satisfies us more than even active participation in the life of the city. Though Cicero struggles with how to reconcile the potentially competing claims of friendship and politics, he insists that those who have a purely instrumental sense of relating to others, in which power is inescapable, are dead wrong: "They might as well steal the sun from the heavens as remove friendship from life!"[9]

How should the city be organized and regulated so that its citizens flourish? Cicero's political philosophy is built on the insight that power, even in the best hands, will eventually be abused, and so good government must involve checks on its natural tendency to degradation. Drawing on Plato's *Republic*, Cicero's *De Republica* initially lays out three types of regimes: the rule of one, the rule of the few, and the rule of the many. None of these is all that great. According to the main interlocutor of the dialogue, based on the famous general Scipio Aemilianus, the best would be the rule of one: a good leader who is respected by the people as a judicious parent. However, the possibility of ever getting a wise and selfless monarch is small, and the populace plays too little role under even a halfway decent monarchy. Plus, the good rule of one swiftly degrades into

the bad rule of one, a tyranny, the worst of all forms of government. The second best of these forms would be the rule of the few, an aristocracy, when reasonably noble and wise people are looking out for the common good. The problem here is that the masses are deprived of decision-making under an aristocracy. Plus, an aristocracy inevitably degrades into the second worst form of government: an oligarchy, where the rich wield their power to enrich themselves further. When this degradation happens, it's common for the disgruntled masses to overthrow the oligarchy and establish the least good and the least bad of the three simple forms of government: a democracy, the rule of the many. The upside of a democracy is that it opens public happiness to the masses. But there are at least two downsides. First, the masses often don't know what they're doing. Second, a democracy's otherwise admirable commitment to political equality blinds people to the true hierarchies of culture: the overarching standards of truth, beauty, and goodness necessary for us to flourish. As Cicero says, "Equality itself is unequal, since it acknowledges no degrees of merit."[10] Thus, democracies lapse into populism, an ignorant form of rule that eventually becomes so dysfunctional the mob clamors for a strong man to reestablish order and greatness. Populism and tyranny are the best of friends.

After skeptically analyzing the types of political rule and their evil twins, the main character of Cicero's dialogue endorses another form of government: republicanism. This involves a mixed constitution that balances what's best in the other forms of government and, more importantly, tries to prevent the degradation into their worst versions:

> A state should possess an element of regal supremacy; something else should be assigned and allotted to the authority of aristocrats; and certain affairs should be reserved for the judgment and desires of the masses. Such a constitution has, in the first place, a widespread element of equality which free men cannot long do without. Second, it has stability; for although those

three forms easily degenerate into their corrupt versions . . .
and although those simple forms often change into others, such
things rarely happen in a political structure which represents
a combination and a judicious mixture—unless, that is, the
politicians are deeply corrupt.[11]

Cicero's vision of the mixed constitution, which owes a lot to
Plato, Aristotle, and Polybius, has been the inspiration for almost
all decent Western political systems. In Cicero's Rome, it basically
involved two consuls each serving a one-year term (two citizens
shared a temporary form of "regal supremacy"), the senate (a body
of politically-experienced Roman aristocrats), and the assemblies
(the direct democracy of ordinary citizens, which was guided and
checked by the senate). It's a good system—"unless, that is, the pol-
iticians are deeply corrupt."

Besides the mixed constitution, the other crucial feature of
Cicero's political philosophy is a commitment to freedom as "non-
domination"—to use the expression of Philip Pettit, the great con-
temporary philosopher of republicanism.[12] One way of conceiving
of freedom is doing what you want. But liberty in the republican
sense means not being under anyone's thumb. It means being able
to walk through the Forum and look people in the eye. It creates
the possibility of real friendship—not just alliances of convenience.
Though it doesn't mean the absence of power imbalances, which is
impossible, it keeps those imbalances from becoming absolute to
either party's identity in the relationship. To draw a clear distinc-
tion between freedom as free rein and freedom as nondomination,
Pettit likes to use the example of Henrik Ibsen's nineteenth-century
play *A Doll's House*, which portrays a woman in the confines of
a patriarchal marriage. Even though Nora's liberal-minded husband
Torvald gives her free rein to do and say as she pleases, Nora still
isn't *free* in the republican sense, because her leeway comes at his
mercy. The "freedom" she has is the result of her domination. She's
still a doll in a doll's house. Similarly, we could live under a wise,

kindly dictator who makes us happy and safe (though good luck with that), but we'd be missing the freedom crucial to human flourishing. To achieve this kind of freedom, Cicero emphasizes the rule of law: "We are all slaves to the law so that we can be free."[13] What he most fears from Caesarism is that it replaces the rule of law with the will of an individual.

Cicero regards his political vision as a guiding light. Because we are born for each other, not for an abstraction, it's important to put people and their immediate realities above even our best ideals. Decorum is especially needful in politics, where it often takes the form of compromise. Cicero's many political zigzags, the wisdom of which people continue to debate two millennia later, demonstrate his refusal to allow ideas to defeat realities. As much as he admires Cato the Younger's firmness and integrity (Cato eventually kills himself rather than participate in Caesar's tyranny), Cicero sees Cato's unbending virtues as incompatible with the ingenuity and flexibility necessary to live well with others. In a letter to his dear friend Atticus, Cicero writes, "The fact remains that with all [Cato's] patriotism and integrity he is sometimes a political liability. He speaks in the Senate as though he were living in Plato's republic instead of Romulus' cesspool."[14] (The Forum really is a sewer. If you look closely, you can still see the Cloaca Maxima, originally installed in the sixth century BC, which by draining the otherwise often-flooded Forum allowed Rome to develop into a great city.)

Because our calling as citizens is to participate in political life and guard the public good, and our greatest pleasures as rational animals are thought and friendship, the highest virtue of all is eloquence, which doesn't simply mean being a persuasive speaker, much less using language acrobatically. Though it requires skills of grammar and logic, it involves knowing the audience, distinguishing truth from falsity, understanding and serving the virtues, having a good sense of humor, and relishing linguistic pleasure—though never more than the clear communication of what matters. As Nicola Gardini says of Cicero's vision, "To speak well is a philosophy: it is

the practice of justice and the creation of happiness. To speak (or write) well is to be good at heart; it is to defend the highest values of our shared existence; it is freedom itself."[15]

It's an art to achieve the freedom of eloquence. In fact, it requires several arts, which Cicero calls the *artes liberales* (the liberal arts), the education of free people. We should learn things like literature, history, philosophy, and a foreign language to expand our sense of human plurality, sharpen our thinking, and serve our mother tongue. These are the disciplines that illuminate and ennoble our humanity. But he recognizes that the *studia humanitatis* (the study of the humanities), another Ciceronian coinage, is dysfunctional when it privileges learning skills to get ahead in life over learning ideas and sensibilities that enlarge the soul. He worries about "the absurd and unprofitable and reprehensible severance between the tongue and the brain."[16] His model for the educational ideal of unifying tongue and brain (and heart) is Socrates, who, in Cicero's words, "was the first to call philosophy down from the heavens and establish it in cities and bring it into people's homes, compelling it to ask questions about life and death and good and evil."[17]

In the twilight of the republic, Cicero writes, "I began to renew [my philosophical work] in order to relieve my disappointment in the best possible way and benefit my fellow citizens however I could. For in these books I have, in effect, proposed legislation, debated before the people, and used philosophy as a substitute for the guardianship of the public good."[18] When political life is half-way decent, philosophy serves to focus us on the virtues, sharpen our logical skills, and cultivate the tolerant and relaxed attitude necessary for getting along with others. But when the living possibility of even decent politics vanishes, philosophy becomes necessary to guide us to the good life. According to Cicero, philosophy is *the* way of living in the ruins.

Cicero, perhaps uniquely in the whole ancient world, seems to have had a special sensitivity to ruins. In the *Tusculan Disputations*, he tells of being in Syracuse and trying to find the grave of the

mathematician and inventor Archimedes. The Syracusans denied it even existed. But Cicero, who knew a sphere and a cylinder were inscribed on the tomb, somehow managed to track it down in a tangle of brambles and thorns. Irked and saddened by the grave's sorry state, he sent for help in clearing the site and was overjoyed by reviving the thinker's memory: "So one of the most famous cities in the Greek world, and in former days a great center of learning as well, would have remained in total ignorance of the tomb of the most brilliant citizen it had ever produced, had a man from Arpinum not come and pointed it out!"[19]

We could even say that Cicero's philosophy dwells in the ruins of the ruins, because he believes that the philosophical project of having knowledge of the good ultimately fails. His training in rhetoric and logic, where arguments from every side must be considered and rebutted, as well as his feel for the plurality of life in the city, leads him to doubt that any single doctrine, no matter how subtle and complex, can comprehensively contain the truth. What are we to do in the rubble of human attempts to find wisdom? Cicero's approach is sometimes classified as eclecticism—namely, the blending of various philosophical schools without adopting any theory wholesale. The best we can do is a mixed constitution of the good life. (The mix-and-match architecture of Rome can be seen as an object lesson in Ciceronian eclecticism.) His commitment to improving society and living fully propels him to seek out the most reasonable ideas, though always recognizing their provisional nature in light of our fundamental ignorance. Such philosophical eclecticism is the highest expression of a rational animal's freedom in the Forum: "I live from day to day. Whatever strikes my mind with its probability, I say, so I alone am free."[20]

Many historians argue that by Cicero's time the republic was beyond saving. Their idea is that Rome, after centuries of military conquests, had become too big: the voting system was too centralized to be useful to its many territories; a small group of amateurs at politics could no longer be expected to take on a range

of specialized administrative duties; a growing number of soldiers had become increasingly dependent on ambitious generals who could exploit them; the growing wealth inequality had made the poor dependent on the largesse of the rich; and so on.[21] Essentially, a culture of management and domination had become so pervasive that ideals like rational persuasion and political participation rang increasingly hollow. Maybe these historians are right (though inevitability is only ever inevitability in retrospect). Cicero himself compares the republic of his day to "a magnificent picture now fading with age."[22] But I think it'd be a mistake to hold that he was quixotic in his defense of republicanism, let alone his defense of humanity. The central task of politics is to defend the possibility of politics. The central task of humanity is to defend the possibility of being human—even when the conditions are difficult, even if the task is impossible. Every time we use language clearly and truthfully, every time we stand up for the dignity and liberty of others, every time we admire what's worthy of admiration, every time we learn or teach the liberal arts, every time we enjoy the glory of friendship, we are defenders of the city without end.

At the end of Cicero's *De Republica* (we're missing big chunks of it—it too is in ruins), the main character relates a dream vision that carries him light years into the Milky Way to the cosmic concert hall where disembodied souls can finally enjoy the music of the spheres over the racket of earthly affairs. Scipio learns that what we call life is really a relentless ruination, whereas what we call death is really a spiritual life beyond all ruins. When he looks far down at Rome, Scipio realizes that earthly life's glories and failures are all vanishingly unimportant. What matters is striving to do what's right. What matters, even more than preserving Archimedes' tomb, is activating our minds as Archimedes once activated his. When we're seeking what's good or true, we're tuning ourselves to a music beyond all ruin. Like any good skeptic, Cicero goes back and forth about the reality of the afterlife. But he insists that a dream such as

Scipio's should be kept close to our hearts, because it motivates and fortifies what's best about who we are.

Many of Cicero's philosophical works were written in the particularly ruinous year of 45 BC. He'd just divorced his wife of thirty years. The republic was in the midst of civil war. The theater of accomplished eloquence had turned into a circus of manipulative blather. It was increasingly hard to hear the music of the spheres. In one of his letters Cicero laments, "My house, you say, *is* the Forum. What do I want with a town house at all if I can't go to the Forum? Atticus, everything is over with me, everything, and has been for long enough, but now I admit it, having lost the one link that held me."[23] Most painful of all, his daughter Tullia, the apple of his eye, died in complications from childbirth. Cicero immersed himself in philosophical works about grief: "When I am alone all my conversation is with books; it is interrupted by fits of weeping, against which I struggle as best I can. But so far it is an unequal fight."[24] The challenge of the good life involves living in ruins even more heart-rending than degraded politics.

Cicero worked through his grief by retiring to his country estate and writing books of philosophy from sunup to sundown. The most humane of these masterpieces, where the music of the spheres comes fully down to earth, is *Of Old Age*. Using as his mouthpiece the Stoic sage Cato the Elder (the great-grandfather of Cato the Younger), Cicero sings the praises of living in the ruins of life itself. In old age we're to keep our minds sharp by regularly exercising them, to insist on gathering with loved ones for conversation over food and wine, to take up gardening (because the bank account of the earth "never refuses to honor a withdrawal and always returns the principal with interest"), to exercise our well-earned authority, and to maintain a little naughtiness and gusto ("Just as I approve of a young man with a touch of age about him, I applaud an old man who maintains some flavor of his youth").[25] If we've devoted ourselves to the liberal arts, we'll be able to stay fresh and happy

by teaching others: "No one who provides a liberal education to others can be considered unhappy even if his body is failing with age."[26]

Carrying on the long-standing philosophical tradition of *memento mori*, Cicero insists on the value of regularly remembering that each of us will die. There are two extremes to be avoided: the blasé sense of always having more time, which makes us squander our talents and treat others poorly, and the morbid doom-scrolling through all that could go wrong, which fills us with anxiety and erodes our ability to act decorously. The point is to remember our limited time so as to empower us to make the most of it, to make the most of even the loss of it. By keeping in mind that our days are numbered, we up the odds of having nothing to resent when it's our turn to be put in the tomb.

Can't ruins serve as a *memento mori*—not in the gloomy modern sense of fetishizing fragments but in the healthy ancient sense of awakening us to what really matters in light of our fleeting time here? Cicero reminds us not only to preserve the history under our feet but to prize the best of what that history embodies. We should see the ruins of the Forum as a reminder to make eclectic use of our traditions, to prize relationships over rickety principles, to treat the living with dignity and good cheer, and to use language to value and pass on what's lastingly important.

Cicero eventually got his chance to demonstrate the extent to which he'd learned his own lessons about facing death. Octavian, despite having been briefly taken under Cicero's wing, could no longer restrain Antony, who sent soldiers to assassinate the orator who so unforgettably belittled him in the senate after Caesar's assassination. When the soldiers found him, Cicero looked up from reading Euripides's tragedy *Medea* and, stretching out his neck, said, "There's nothing proper about what you're doing, but at least make sure that you cut off my head properly." Now that's decorum! Cicero's hacked-off head and hands were then brought back to Rome and nailed to the rostra where he had so often commanded

attention in the Forum. Antony's wife Fulvia amused herself by yanking out the tongue and sticking her hairpin through it.

DETOUR INTO GOETHE'S CAREFREE CROWD OF MASKERS

Philosophers like Cicero encourage us to reflect on our mortality so that we remember to take care of our souls. For similar reasons, the city's churches taunt us with bones and skulls, like Bernini's tomb for Alexander VII in St. Peter's where a veiled bronze skeleton holds a tilting hourglass, or the crypt in Santa Maria della Concezione where the walls are decorated with the actual skeletons of over three thousand Capuchin friars. Almost all the figures in Michelangelo's *Last Judgment* either stare nervously at Jesus or fret about the mechanics of their salvation or damnation. But the skull-face of Death stares icily out at us. He's all that stands between us and the ultimate reality of what's depicted on the wall.

In his *Italian Journey*, reporting on Rome's Fat Tuesday in 1788, Johann Wolfgang von Goethe describes a merrier approach to confronting death. Where philosophy and religion have traditions of *memento mori* (remember you will die), Carnival has the tradition of *sia ammazzato* (be killed).

> It becomes everyone's duty to carry a lighted candle in his hand, and the favourite imprecation of the Romans, "Sia ammazzato," is heard repeatedly on all sides. "Sia ammazzato chi non porta moccolo—Death to anyone who is not carrying a candle." This is what you say to others, while at the same time you try to blow out their candles. No matter who it belongs to, a friend or a stranger, you try to blow out the nearest candle, or light your own from it first and then blow it out.[27]

This comedy of playacting both the tyranny of death and the tenuousness of life isn't simply a reminder to live well: it's a lot of fun

itself. "*Sia ammazzato*," Goethe notes, "becomes a password, a cry of joy, a refrain added to all jokes and compliments."[28]

The essence of Carnival is to turn the world upside down and give it a good shake. Like all great humor, Carnival depicts tragedy and magically releases us from it. Goethe describes how Carnival acts as a grotesque reminder of the whole human journey. Because we're conceived after a funny-looking act of passion, someone dressed up as the great hook-nosed clown Pulcinella publicly mimes sex acts. Because we pop out between our mother's legs, someone dressed up as the Earth Goddess's foul-mouthed old maid Baubo grabs her crotch and cracks jokes about giving birth. Because our identities are squeezed into social roles, everyone wears masks. Because we often bear the burden of being oppressed and some-times bear the burden of being in charge, social roles are inverted and mocked. Because pleasure is fleeting and chancy, it's a time of horse racing and gambling. Because we die, there's the sport of blowing out people's candles. In the swirl of revelers, Goethe sees the Via del Corso, one of Rome's main drags, as "the road of our earthly life" where we are all "both actor and spectator."[29]

Saturnalia, ancient Rome's version of Carnival, was held during the winter solstice. It was a crazed realization of liberty and equality. Slaves were released from domination, and happiness belonged to everyone in a temporary restoration of Saturn's golden age, which is why Catullus called Saturnalia "the best of days" and Platonists read it allegorically as the return of souls to their immortal state.[30] Ever since the medieval era, after being muscled out by Christmas, *Carnevale* has been celebrated right before Lent (*carne-vale* means "goodbye, meat"). The church, at least in its wisest moments, under-stood that for all its raucous leveling of hierarchies Carnival is a way of helping us to live with the status quo. By periodically relieving us of the burdens of social and political life, Carnival lets us take them up again refreshed. Because it holds nothing sacred, Carnival is a form of holiness. Especially if the revelry is followed by a period of fasting and prayer.

Unfortunately, the festival has lost some of its craziness since Goethe's time, though its spirit survives in all anarchic comedy about the quirks of bodily existence and the absurdity of civilized life. May we never blow out its candle! Not only is Carnival a needed relief from the workaday shuffle; a little of its topsy-turvy dream should accompany us in whatever we do, for we should never lose sight of the ambiguity, chanciness, and relativity of being human. Goethe concludes, "Knowing that life, taken as a whole, is like the Roman Carnival, unpredictable, unsatisfactory and problematic, I hope that this carefree crowd of maskers will make [you] remember how valuable is every moment of joy, however fleeting and trivial it may seem to be."[31]

THINGS TO SEE AND CONSIDER: ROME AS THE QUESTION OF RUINS

When I take students on a hot summer day to the piles of gravel, almost-randomly erected columns, and mess of dirt and tourists that goes by the name the **Roman Forum** (Foro Romano), I translate Horace's *"pulvis et umbra sumus"* (we are dust and shadow) to "we're all dusty—and where's some shade?" World-historical as it is, I advise travelers with only a few days among the riches of Rome to skip it. If you long for impressive ancient ruins, the **Baths of Caracalla** (Terme di Caracalla) is considerably less dirty and crowded. Plus, you can get a picturesque view of the Forum from the lovely **Palatine Hill** or the **Capitoline Museums** (you have to go up a set of stairs when you're in the underground passageway between the two sides of the museum—when you ascend to the other side of the museum, you'll find the bust of Cicero in the **Hall of the Philosophers**). The **Palazzo Massimo alle Terme** has the **Boxer at Rest**, one of Rome's most moving ancient statues—of a body in ruins. Sitting down after a bout, the battered pugilist looks up at us and wordlessly poses all the questions of suffering. What is a ruin, anyway? Should Rome's ancient sculptures be considered ruins, even those

whose parts aren't missing? Most of them were once coated with dazzling colors. Plus, every single one has been dislocated from its original site (a gem of a museum that highlights this point is the **Centrale Montemartini**, where ancient busts and friezes are displayed among diesel engines and steam turbines in Rome's first electrical power station). What about a more recent sculpture like the charming *Monument to Goethe* in the **Villa Borghese**, which shows the poet towering over his literary creations? More than once the head of Mephistopheles has been stolen and recovered. It's not a ruin, is it? What about the **Pantheon**, which has been remodeled over and over for centuries? It raises the famous Ship of Theseus quandary in metaphysics, which asks how many parts of a ship can be replaced while still remaining the same ship. To what extent should ruins be repaired or repurposed? When should they be demolished and built over? Should we cherish ruins like the moderns? Should we be disturbed by ruins like the ancients? What Rome seems to say is that people who think there are simple answers to these questions are kidding themselves. There's also the question of what a ruin should teach us.[32] My favorite lesson can be found in a prose poem by Yehuda Amichai. He recalls a time that he was coming home from the grocery store and a guide used him as an impromptu marker for his group of tourists: "You see that man with the baskets? Just right of his head there's an arch from the Roman period." The poet reflects that redemption will come only when the tour guide says instead, "You see that arch from the Roman period? It's not important: but next to it, left and down a bit there sits a man who has bought fruit and vegetables for his family."[33]

5

TAKE THE VIEW
FROM ABOVE

Marcus Aurelius in the Saddle

> It is to philosophy Marcus Aurelius owes his good standing
> to this day, since this discipline proved to be more durable
> than the Roman Empire.
>
> JOSEPH BRODSKY

Rome is a colosseum of massacred art. I'm not just talking about
the well-known case on Pentecost Sunday 1972 when an Austra-
lian tourist—shouting, "I am Jesus Christ! I have risen from the
dead!"—stormed into the side chapel of St. Peter's Basilica, assaulted
Michelangelo's *Pietà* with a geologist's hammer, and succeeded in
knocking off Mary's arm and nose. (While a few brave tourists
wrestled him away from the masterpiece, others seized the oppor-
tunity to pocket pieces of Renaissance marble. If you look closely,
you can see where the arm has been mended. The Mother of God's
nose is still missing in action. The nose we admire, now behind

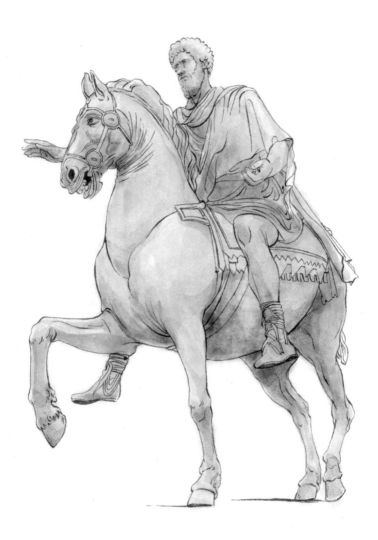

FIGURE 5.1 · Equestrian Statue of Marcus Aurelius (ca. AD 175), Capitoline Museums. Henry James writes, "I doubt if any statue of king or captain in the public places of the world has more to commend it to the general heart. Irrecoverable simplicity—residing so in irrecoverable Style—has no sturdier representative." Henry James, *Italian Hours* (New York: Penguin Books, 1995), 127.

a wall of bulletproof glass, was restored with a chunk from her back.) I'm also thinking of all the cases of predecessors' monuments destroyed by new regimes. For instance, bronze sculptures of heroes on their horses, once ubiquitous in imperial Rome, were all remade into coinage and cannons by early Christians who enjoyed watching pagans melt.

The sole exception is the Equestrian Statue of Marcus Aurelius. Well, there was one other long-surviving equestrian bronze, but it was destroyed in 1796 by the Jacobin Club, who in their revolutionary delirium considered it nothing more than a symbol of monarchy. Marcus Aurelius was preserved throughout the Middle Ages because he was misidentified as Constantine, the first Christian emperor. This mistake is so obviously wrong I wonder if it wasn't originally a savvy official's way of preserving a masterpiece. Yet even this statue has been assaulted. In 1979 a terrorist set off a bomb to destroy Marcus Aurelius—or at least the Roman government he symbolizes.[1] Nobody was killed, and the bronze was fine. But a subsequent investigation of the sculpture uncovered erosion from the elements, so it was moved for better preservation from outdoors into an airy well-lit room in the Capitoline Museums. What now stands on the piazza designed by Michelangelo is a copy. As usual, the great terrorist is time.

Charmingly, the emperor who would have cared least about the destruction of his monument is the only one whose monument has survived. Marcus Aurelius says with typical incisiveness, "What is it to be remembered forever? Nothing but vanity . . . Everything is ephemeral—not just the rememberer but the remembered as well."[2] He understands that time is a terrorist only insofar as we let ourselves be terrorized. His masterpiece the *Meditations* reconciles us to ephemerality and goes a long way toward explaining the look of calm strength radiating from his face atop Rome.

In the words of Edward Gibbon, "If a man were called to fix the period in the history of the world, during which the condition of the human race was most happy and prosperous, he would, without

hesitation, name that which elapsed from the death of Domitian to the accession of Commodus."[3] Marcus Aurelius Antoninus (AD 121–80) was the last in this relatively happy run of what's known as the Five Good Emperors (after Nerva, Trajan, Hadrian, and Antoninus Pius). I emphasize the *relative* happiness, as most of Marcus's twenty-year reign was marked by what his Stoicism would regard as challenges, though souls with less philosophy might see them as downright evils. He put down violent insurrections to the east and in the north, and his last fifteen years as emperor involved leading Rome through one of history's worst pandemics: the Antonine Plague. Yes, one of the world's greatest natural disasters takes the family name of a Stoic: Marcus Aurelius *Antoninus*.

Probably a form of smallpox that began in the Far East, the disease spread through the world globalized by the Roman Empire, demanded the cancellation of big gatherings, and wiped out ten to twenty million people over its horrible tenure. The philosophical emperor put Galen, the most famous physician of the ancient world, in charge of studying and understanding the disease. Marcus confiscated money from the rich and auctioned imperial treasures to replenish the government's budget and, when two thousand people a day were dying in Rome, to help pay for funerals. His *Meditations* can be productively read as reckoning with all that a plague reveals: death, pain, loss, virtue, vice. Prior to living through a pandemic myself, I'd always read the work's explicit reference to the virus as a standard mind-over-body thing:

> It takes quite an accomplished man to leave the world without ever having tasted deceit or any kind of dissembling, and without having indulged in luxury and vanity . . . Corruption of the mind is far more pestilential than any kind of noxious spoiling of the air we breathe. For the plague affects living creatures in their animal nature, but corruption of the mind affects human beings in their humanity.[4]

After witnessing how lies, motivated reasoning, greed, and self-absorption spread a pandemic and ravage the body politic, I've come to see that reflection as an urgent meditation on leadership and citizenship in a time of crisis. Of the two well-known versions of Marcus Aurelius's last words, one is: "Don't weep for me: mourn for all who died of the plague." The other is: "Look to the rising sun, for I am setting." Both possibilities suggest the horizons of his humanity.

Cicero, in the twilight of the republic, puts philosophy in service of politics. Marcus, in the heyday of the empire, sees philosophy as far superior to the administration of the state. In both cases, the goal of a good life is the same, but certain conditions are far less accommodating than others for flourishing in the political arena. The emperor never dodges his imperial duties, but the philosopher engages in a daily struggle not to allow "politics"—in the sense of power plays—to warp his humanity: "Beware of becoming Caesarified, dyed in purple. It does happen . . . Strive to be and remain the kind of person philosophy would have you be."[5] The "purple" is the Tyrian dye that colors the emperor's toga and refers by extension to the office itself. The trick is not to become Caesarified—even if you're Caesar. In the *Historia Augusta* it's said of Marcus Aurelius: "Toward the people, he behaved exactly as if he were acting in a free state."[6] If you're thinking that treating everyone with equal dignity is relatively easy for the emperor, you should know that he learned it from the Stoic philosopher Epictetus (ca. AD 50–135), who was born and raised in slavery. In the moving opening of Marcus Aurelius's *Meditations*, which is simply a list of all the things he's thankful for having inherited and learned, he lavishes particular gratitude on his teacher Junius Rusticus for having given him Epictetus's *Discourses*.[7]

Marcus Aurelius's book, composed on one of the emperor's last military campaigns in Germany, is a strange and lovely thing: a philosophical diary. Though Latin was Marcus's native language,

he wrote the *Meditations* in Greek, probably because it was the idiom of *philosophia*, rich in specially-loaded terms and careful distinctions. Though countless seekers over the centuries have treasured the *Meditations*, it seems to have been intended for Marcus alone. In *The Inner Citadel*, Pierre Hadot shows that the work should be read as a set of philosophical exercises meant to open its author to a new perspective and build the spiritual muscles to make the most of his fleeting time. Much modern philosophy is an attempt to rig up the best possible theory of knowledge, ethics, beauty, or the universe itself. Ancient philosophy, even as it engages in theoretical work, is primarily about the artistic shaping of the soul. As Plotinus enjoins, "Never cease sculpting your own statue."[8]

The central issue of ancient philosophy, including the *Meditations*, is how to sculpt the soul in the face of death. A big problem with death is that it disrupts our plans and connections. Because our minds are future oriented, we want to see the product of whatever we're working on and maintain our connections indefinitely. Not only does death mean that it's always *possible* we won't see the finished product; we'll *never* see the conclusion of all we care about. Even if we're lucky enough to see our grandkids, we'll miss out on our great-grandkids or our great-great-grandkids. Even if we're inspired and diligent enough to write ten books, we won't finish the eleventh. Plus, did we ever once say what we really should have said? It's rare, and I'm not sure if it's even desirable, to say goodbye to a life in which all projects and relationships have been brought to perfection. To come to terms with death means to face our limits and rethink what we mean by success.

It's not that we shouldn't undertake projects. If anything, Stoics are always embroiled in big projects. But we should engage them with a reserve clause: "I will do X—provided nothing out of my control prevents me." The key is to shift our goals from finishing a project to working on it. For instance, rather than thinking, "My happiness depends on finishing this book," much less, "My happiness depends on the success of this book," I should think,

"My happiness depends on writing this book to the best of my abilities." Happiness is now or never. Our sense of well-being switches from the never-arrived future to the always-here present, from the sculpture to the sculpting. The Greek philosophical term for this kind of well-being is *areté*, which we translate as "virtue," though it's closer in its technical meaning to our sense of virtuosity—an active performance of ourselves at our best. The Stoics believe that virtue is synonymous with being in accord with nature in its fire-like activity.

Our normal future-oriented sense of happiness is ego-filled. My judgments of things depend on if they go my way. My very vision of things is stained by these judgments. The pile of money *looks* good. The rash *looks* bad. Well aware of how hard it is to break out of this ego prison, Marcus often advises himself, as a spiritual exercise, to switch from a subjective perspective to an objective description, from a personal opinion to a view from above. The stack of money *is* a pile of rags and copper. The rash *is* a skin eruption caused by a disease. Such descriptions take on the perspective of nature itself and embody the essence of rationality: the harmony of the mind with the order of things.

Not only does the regular adoption of this objective viewpoint wear down the walls of the ego prison; it can also awaken wonder at existence. Take even Marcus's notorious view-from-above description of sex as "the rubbing of an organ and the spasm-induced emission of a little slime."[9] Marguerite Yourcenar, in her novel *Memoirs of Hadrian*, has Hadrian rebuke Marcus,

> The short and obscene sentence . . . about the rubbing together
> of two small pieces of flesh . . . does no more to define the
> phenomenon of love than the taut cord touched by the finger
> accounts for the infinite miracle of sounds. Such a dictum is
> less an insult to pleasure than to the flesh itself, that amazing
> instrument of muscles, blood, and skin, that red-tinged cloud
> whose lightning is the soul.[10]

The rebuke to Yourcenar's Hadrian is that Marcus isn't propounding a theory. His meditation is an exercise for him—and us—to resist the desire to expulse slime when it's unworthy and to reveal the astonishment of the friction when it is. His "short and obscene sentence," after all, is part of what inspires such eloquence as "that red-tinged cloud whose lightning is the soul" from the novelist.

Another exercise of the view from above is to see all of history as if from a point outside of time—which isn't that hard to do while wandering through Rome's historical layers.

> Take the time of Vespasian, for example, and you'll see the same old things: people marrying, raising a family, getting sick, dying, making war, celebrating festivals, trading, farming, flattering, acting in their own interests, being mistrustful, scheming, praying for their enemies to die, grumbling at their circumstances, falling in love, storing up wealth, longing for the consulship or sole rule. And now not a trace remains of that life of theirs. Then turn to the time of Trajan and it's the same all over again.[11]

When we set aside all that's superfluous, we embrace our present life. The view from above time is actually the view from within time, where we see the amplitude of history in the present moment. "Bear in mind how much is going on simultaneously in each of us, taking our bodies and minds together, at any given instant, and then you won't be surprised at the far greater number of events—in fact, the totality of events—that exist simultaneously in the single, comprehensive entity that we call the universe."[12] Our gift is to interact with everything that's happening right now. We're currently living in the time of Julius Caesar, the time of Marcus Aurelius, the time of Caravaggio, the time of Rosa Bathurst. Contrary to popular opinion, the latest scandal isn't unprecedented. The eternities are in the breaking news. To live well means coming to accept the facts and citizens of our bustling now.

At the start of the day tell yourself: I shall meet people who are officious, ungrateful, abusive, treacherous, malicious, and selfish. In every case, they've got like this because of their ignorance of good and bad. But I have seen goodness and badness for what they are, and I know that what is good is what is morally right, and what is bad is what is morally wrong; and I've seen the true nature of the wrongdoer himself and know that he's related to me—not in the sense that we share blood and seed, but by virtue of the fact that we both partake of the same intelligence, and so of a portion of the divine. None of them can harm me, anyway, because none of them can infect me with immorality, nor can I become angry with someone who's related to me, or hate him, because we were born to work together, like feet or hands or eyelids, like the rows of upper and lower teeth.[13]

I advise my students to be Stoic travelers in Rome, saying to themselves every morning, "I shall meet with wily pickpockets, ugly tourists, and late buses. Bring it on, pickpocket! My job is to protect my wallet, yours to pilfer it; if you win, hats off. Bring it on, ugly tourist! We're not so different, you and I. Bring it on, Bus 75! No matter how late you're running, you can't upset me, for I'm in Rome!" Travel's lesson about what happens to the best-laid plans is also Stoicism's lesson about life itself.

The more we bring our thoughts and desires in line with how things are, the more we're inclined toward three ideals. First, we act in service of the greater good, for we understand that we're active pieces of the great puzzle. Second, we don't overrate or undervalue the things we do: "It's essential . . . to remind yourself that the attention given to anything one does has its own value and proportion, because then you won't wear yourself out spending more time than you should on less important matters."[14] Finally, we act out of love for all human beings, for we understand that all people have the precious gift of rationality and do wrong only because

they're confused about what's truly good, just as we ourselves have often done wrong. Like all true moralists (to be distinguished from moralistic types), Marcus Aurelius holds himself to high standards, for his thoughts and actions are in his control. But he's forgiving of others, for what others think and do is not ultimately up to him. "If human beings exist to help one another, you must either instruct them or put up with them."[15]

When we stop assuming that we can put off doing what matters until tomorrow, when we really face the fact that we're going to die, and when we realize that we're part of a great natural order, we can start doing the things that matter today. At the very least we stop doing things we'll end up regretting. "Every time you do something, ask yourself: 'Do I find this acceptable? Might I not come to regret it?' Before long, I shall be dead and then 'away with everything.' If the work I'm currently engaged in is proper to an intelligent and social being, one who lives under the same laws as God, what more could I want?"[16] The daily goal is to make progress with our thoughts, desires, and deeds, whether in our personal or our public lives. Even a baby-step in the right direction is significant: "Don't expect to create Plato's ideal state, but be satisfied if you make even the slightest progress, and regard that in itself as no small achievement."[17]

As we make progress, we experience joy. Greek philosophy makes a distinction between *hêdonê* (the good feeling of things going our way) and *chara* (the good feeling of actively engaging the world). It's like the difference between seeing a favorite team win and playing a sport at a high level. What Rilke says in a letter may be helpful here: "The reality of any joy in the world is indescribable, only in joy does creation happen (happiness, on the contrary, is only a promising and interpretable pattern of things already existing); joy, however, is a marvelous increasing of what already exists, a pure addition out of nothingness."[18] We experience this joy when we're paying close attention to reality or developing our particular talents.

Joy is a kind of natural calm—the way a tree is calm, even in a storm. Stress is the result of not doing what we're meant to be doing. It's a funny thing: do the essential stuff, and time sprawls out before you; do the insignificant stuff, and you never have enough time even to do the insignificant stuff, let alone all you dream of. *Festina lente*, as the old Latin adage has it—hurry leisurely.

> If you separate from yourself—that is, from your mind—all that other people do or say, all that you yourself have done or said, all that disturbs your peace of mind as looming in the future, all the properties of the body that encases you . . . all that is to come and all that has gone . . . and train yourself to live the only life you have, that is in the present moment, you'll be able to pass what remains of your life, up until your death, with a mind that is tranquil in itself, kind to others, and at peace with your guardian spirit.[19]

What's translated here as "guardian spirit" is *daimon*, which refers to something like your true self. It's both your unique consciousness, with all its quirks and talents, and your particular point of connection to the whole universe, which is experienced as conscience or intuition, and which the ancients considered divine. As Marcus points out, the Greek word for leading a good life, *eudaimonia*, means literally having a good *daimon*.[20] The point of philosophy is nothing more or less than the care of your guardian spirit.

What I love about the Equestrian Statue of Marcus Aurelius is how it portrays this vision of *eudaimonia*. The plainly-dressed emperor-general, riding a spirited horse saddled with barbarian cloth, blesses us with a calm outstretched hand. It's been conjectured that the sculpture once included a conquered Sarmatian chieftain under the horse's drawn right leg. Are we seeing a monument to Roman imperialism? Sure, but not just that. The sculptor has taken the genre and imbued it with philosophy's insistence on ruling wisely and powerfully over oneself. Sometimes we think of Stoics

as cold and emotionless; in fact, they have powerful emotions, often more so than non-Stoics. It's just that they seek out ways of channeling them productively. Plato compares the nonrational parts of the soul to horses that rationality must master and ride. The statue actually gives us a horse, bristling with strength and energy, that has been brought under its rider's sway. I'm particularly struck by the visual echoes between the animal and the philosopher: their eyes look off in the same direction; the wrinkles in the horse's drawn neck mirror the folds in the emperor's plain tunic. We're looking at the Stoic unification of rationality and nature, symbolized by an experienced rider comfortably communicating physical messages back and forth with his horse.

Notice how the corners of Marcus's sculpted mouth droop in an unaffected way, how his facial muscles are relaxed but not slack, how his eyes cast a wide blessing. Here's what the *Meditations* has to say about the look of goodness: "Your face should be an open book. Honesty is immediately clear from the tone of voice and the look in the eyes, just as a loved one immediately knows everything from his lovers' glances . . . The eyes of a man who's good, sincere, and kind reveal what he's like, and you can't mistake him."[21] The philosopher's spiritual discipline is to achieve gentleness and simplicity: to make virtue look easy. In discussing the *Meditations*, Hadot speaks of a will so strong it overcomes itself as a will.[22] I'm not sure if anyone could come up with a better image of the paradoxical achievement of effort issuing in effortlessness than this sculpture. Compare it with other depictions of Marcus, and you'll see by contrast its sculptor's psychological subtlety and philosophical insight.

Am I going overboard when I see Stoicism in the old bronze itself? Marcus writes, "The by-products of natural phenomena have a certain charm and attractiveness. For example, in the process of baking bread, the loaf breaks open in some places, and although these cracks in a sense represent a failure of the baker's art, they do somehow catch the eye and, in their own way, stimulate the

desire to eat the bread."[23] (I love imagining the emperor seeing in the crust of fresh bread both the problem of evil and its solution!) Couldn't a similar point be made about his statue's patina, which adds a wabi-sabi beauty to the bronze? Like the work of the Stoic, the work of the sculptor is not only to make metal come to life but to submit metal to life.

While I'm horrified by the thought of someone melting down or blowing up this masterpiece, it's hard to look at things in Rome—think of Caravaggio's *David with the Head of Goliath*—and not appreciate the violence of rising generations. Freud builds his whole psychological theory on the desire to tear down our predecessors. Even though I myself don't go so far as the Oedipal complex, I can sympathize with revolutionaries toppling a gilded monument to a king, or activists taking a hammer to a self-aggrandizing statue of a general. But I think that we make a mistake when we see nothing in our humanity that transcends political power. Sure, art—very much including the bronze of Marcus Aurelius—has advanced the cause of countless regimes over the centuries. But the early Christians, in their zeal to erase injustice, destroyed more than just symbols of paganism when they melted down equestrian statues, much like certain moralists of our own day jettison more than just injustice when they throw out our all-too-human traditions. Don't dye your soul purple! In his essay "Animula," Zbigniew Herbert (whose great teacher Henryk Elzenberg was an expert on Marcus Aurelius) observes,

> Someone very rightly said that not only do we read Homer, look at frescoes of Giotto, listen to Mozart, but Homer, Giotto, and Mozart spy and eavesdrop on us and ascertain our vanity and stupidity. Poor utopians, history's debutants, museum arsonists, liquidators of the past are like those madmen who destroy works of art because they cannot forgive them their serenity, dignity, and cool radiance.[24]

THINGS TO SEE AND CONSIDER:
ROME AS THE VIEW FROM ABOVE

It's worth reflecting on Marcus Aurelius's discipline of taking the view from above, as you take your own view from above next to the replica of the **Equestrian Statue of Marcus Aurelius**. You're standing on the **Piazza del Campidoglio**, Michelangelo's ingeniously designed "square" commissioned by Pope Paul III to show off the renewed grandeur of Rome. The scare quotes are because the site isn't square at all; it's a trapezoid—sloping irregularly toward one side—formed by three palazzi and a steep staircase. Designing something so beautifully strange as the Campidoglio, under what are literally uphill conditions, is a mark of Michelangelo's genius. Could it also symbolize how the Stoics use the art of reason to fit themselves to the zigzags of life? While you're up there, you'll visit the **Capitoline Museums** to revere, among the countless treasures, the original bronze of the **Equestrian Statue of Marcus Aurelius** (ca. AD 175) in the **Palazzo dei Conservatori**. In an adjacent room is the so-called **Vignacce Marsyas** (ca. AD 100s) a recently found ancient sculpture depicting the satyr—after having lost a musical duel to Apollo—tied to a tree and flayed: the flesh where the skin has been removed is hauntingly rendered in red marble, and the remaining flesh in white marble. Among other things, this mesmerizing work can provoke debate about whether the Stoics are right that the sage can be happy even while being tortured (consider the **Hanging Marsyas** in the **Centrale Montemartini** by way of comparison). In the other section of the Capitoline Museums, the **Palazzo Nuovo**, you can see in the **Hall of the Emperors** the magnificent bust of **Young Marcus Aurelius** (ca. AD 140), which portrays something of the natural intensity and cultivated intelligence that caught Hadrian's eye. If you're the sort who worries that Stoicism makes you passive, you should correct yourself by examining the **Column of Marcus Aurelius** (Colonna di Marco Aurelio, ca. AD 193) in the **Piazza Colonna**, a tall Doric column with spiral reliefs com-

memorating the emperor's vigorous military campaigns against the Marcomanni (AD 172–73) and then the Sarmatians (AD 174–75). This memorial is modeled on **Trajan's Column** (Colonna Traiana, ca. AD 113), which, standing in the ruins of **Trajan's Forum** (Foro di Traiano), is called by Italo Calvino an "epic in stone, one of the most copious and perfect visual narratives in history."[25] To examine the details of either column would require a fireman's ladder and a permit. I've never understood how anyone ever followed their corkscrew narratives. If the gods didn't exist, we'd have to invent them as fit spectators. The view from above indeed! I strongly recommend binoculars. In his *Charon, or The Inspectors*, the satirist Lucian of Samosata (ca. AD 125–80), an almost exact contemporary of Marcus Aurelius, tells how the ferryman of Hades asks for a day off to see this thing called "life" that the dead are always pining for. After climbing a tall mountain, he takes his own view from above and observes, "If people realized from the beginning that they are mortal, and that, after a brief sojourn in life, they must leave it as they would a dream, and leave everything upon this earth, then they would live more wisely and die with fewer regrets."[26] The journey to Rome's seven hills, if undertaken thoughtfully, might yield a similar insight.

DETOUR FROM THE PARTY

Since the 1960s, Roman Catholicism has softened a bit on suicide, but the church long regarded it as a sin that condemns the sinner to eternal damnation. The ancient Romans had a more complex response. Though they mostly looked down on suicides of despair, like that of Mark Antony after the Battle of Actium over his doomed love for Cleopatra, they generally saw heroism in suicides done for the sake of honor, like that of Lucretia, who plunged a knife into her breast after exacting an oath of vengeance on her rapist, or Cato the Younger, who slit his stomach and pulled out his bowels to keep from living under Julius Caesar's thumb.

Cato was influenced by Stoicism, a philosophy with a particularly rich view of suicide. One of the Stoic metaphors is that life's a banquet. You should be affable with your fellow partygoers, savor the dish in front of you, and not spend your time wishing for what's already been passed or hoping for what's yet to be served. It's appropriate to stay until the party's over—with a few exceptions. The Stoics think it's acceptable, sometimes even honorable, to commit suicide

- if it cuts short a debilitating disease—as when the dishes at the party have spoiled;
- if it frees you from madness—as when you're getting too drunk;
- if it keeps you from doing evil—as when jerks crash the party; or
- if it preserves your community—as when a loved one calls needing your help.[27]

The contemporary world vacillates between the religious view that suicide is wrong because it throws away the gift of life and the utilitarian view that euthanasia should be a legal option to eliminate unnecessary suffering. Could Stoicism point to a third way, one that upholds the sanctity of life *and* shows mercy toward the afflicted?

Another Stoic metaphor is that life's a game. You should try your best, play fair, and remember—win or lose—it's just a game. Your parents signed you up for the team, but now it's your choice whether you stay on or quit. Not only should you remember that you will die; you should face the fact that you can choose to die. As Epictetus says, "Don't be more cowardly than children, but just as they say, when the game is no longer fun for them, 'I won't play anymore,' you too, when things seem that way to you, say, 'I won't play anymore,' and leave." But here's the kicker: "If you stay, don't complain."[28]

III

Reap the Day

Liberty of soul, freedom from all partial and misrepresentative doctrine which does but relieve one element of our experience at the cost of another, freedom from all embarrassment alike of regret for the past and calculation for the future: this would be but the preliminary to the real business of education—insight, insight through culture into all that the present moment holds in trust for us, as we stand so briefly in its presence.

WALTER PATER

FIGURE 6.1 · Arch of Titus (ca. AD 81), Roman Forum. Detail of a menorah taken from the Temple in Jerusalem. In the *City of God against the Pagans*, Augustine wonders, "Justice removed, what are kingdoms but great bands of robbers?" Augustine, *The City of God against the Pagans*, trans. R. W. Dyson (Cambridge: Cambridge University Press, 1998), 147 (4.4).

6

CONQUER YOUR FEAR

Lucretius versus the Roman Triumph

Venus defeats Mars.
MARSILIO FICINO

Roman triumphs were celebrations of military victories that trundled cartloads of booty and slaves from the Campus Martius outside the city gates, down the Circus Maximus, along the Via Sacra through the Forum, and up the Capitoline Hill to the Temple of Jupiter Optimus Maximus, where the honored general would offer a sacrifice. By the tail end of the republic, these military parades had "departed in every way from their ancient simplicity."[1] Pompey's famous triumph in 61 BC for his defeat of King Mithridates Eupator of Pontus displayed a solid gold throne, gold statues of gods, overflowing vessels of gold pieces, silver coins totaling more than the annual tax revenue of the whole Roman world, a pyramid festooned with animals made out of gems, a shrine of pearls, pile after pile of weapons, broken-off beaks

of ships, wagonloads of captives wearing pants rather than togas (a sure sign of "barbarians," examples of which you can see on the triumphal arches in and around the Forum), vanquished pirates in their native dress, paintings depicting Mithridates's downfall and execution, and Pompey himself atop a jewel-encrusted chariot in the ancient purple toga of Alexander the Great. There was even leftover booty, according to Plutarch, "quite enough to deck out another triumphal procession."[2]

It's common, especially in academia, to trace back sins like colonialism, consumerism, and environmental destruction to the culture on proud display in Pompey's parade. That's nothing new. Rome has always inspired disgust. Early Christians were horrified by its culture of rampant violence and grotesque spectacle. A millennium later, Martin Luther flatly declares, "If there is a hell, Rome is built upon it. It is an abyss from whence all sins proceed."[3] Protestants, along with other believers in a more modest faith than Roman Catholicism, continue to be scandalized by the city's marble churches, built with the sweat and pennies of the world's poor, which often strike them as looking more like dance halls than houses of worship. Even some Romans lining the Via Sacra back in the day were aghast.

One of them was Lucretius, a philosopher-poet of peace and moderation, who was likely present for Pompey's over-the-top parade. What afflicts us, according to Lucretius, isn't foreign armies, it's the savage tribes of greed and aggression in our own souls. The true hero isn't the general who brings back gold after the sack of a formidable foe but the philosopher who brings back wisdom after the sack of our barbarian desire to conquer barbarians. When I imagine Lucretius watching a triumph clang down the Forum, what I picture isn't his grimace at the celebration of excess: it's the smile that must have curled his lips when he realized he could use the military parade as a metaphor for the triumph of the Greek philosopher Epicurus, the least militaristic philosopher imaginable.

When human life lay groveling for all to see,
beaten into the dust by the crushing force of religion . . .
a man from Greece was first to lift his mortal eyes,
first to arise and take on the challenge, a man
undaunted by menacing rumors of the gods, undaunted
by bolts of lightning with their ominous rumblings—
not just undaunted, brightened and charged with courage
to be first to break the bolts and bars of nature's gates.
His mental mightiness won out: he marched off
and burned down the world's walls. He wandered
through the vast universe and earned a true triumph.[4]

Lucretius teaches us to read Rome against the grain. When he sees images of Venus and Mars, he thinks of the physical laws that bind and unbind atoms. When he sees a worn-down piece of bronze sculpture, he thinks of how everything is mortal. And when he watches a military parade, he subversively appropriates it to celebrate a hero who didn't need to leave his garden and his glass of wine to crush our true enemies—ignorance and anxiety—and bring back the booty of wisdom and happiness.

Lucretius (ca. 100 BC–55 BC) was born, wrote a poem, and died. That's all we can say with any confidence about his life. Is there anything more that needs to be said about his life? (Scholars dismiss as Christian propaganda the story, circulated four centuries after his death, that he drank a love potion, lost his mind, and committed suicide.) In dactylic hexameter verse, De Rerum Natura (On the Nature of Things) instructs a Roman politician by the name of Memmius in the thought of Epicurus (341–270 BC), whose philosophy is self-described as medicine for the soul. "Vain is the word of a philosopher by whom no human suffering is cured," the Greek master says.[5] Poetry, in Lucretius's famous image, is like the honey a kindly doctor slathers around the pill to make it go down easy.

The medicine itself is the "fourfold remedy" (tetrapharmakos),

which originally referred to a compound of wax, tallow, pitch, and resin, but becomes in Epicureanism a name for the philosophical principles we should remember and practice.

> Don't fear the gods.
> Don't worry about death.
> What's good is easy to get.
> What's bad is easy to endure.[6]

These principles were practiced and taught by Epicurus in a villa outside Athens, essentially a subsistence farm, which welcomed people with a sign, "Stranger, here you will do well to tarry... This garden does not whet your appetite, but quenches it."[7] Two centuries prior to Lucretius, Epicurus applied the balm of his philosophy to a group of friends, family, and slaves, male and female alike, treating all equally in his garden. One of his central lessons is that we must unplug from the craziness of society to achieve *ataraxia*, the freedom from disturbances that characterizes genuine happiness. Because Epicurus practiced what he preached, spreading his gospel proved difficult. It's hard to cure people if one of the main contagions to be avoided is the sick! A solution his students lit on was to circulate the master's image in statuary and on coins.[8] The bust of Epicurus, a statue from the third century BC, one of the most striking in the Capitoline Museums' Hall of the Philosophers, is an example of this kind of philosophical recruitment.[9] Lucretius's poem serves as yet another way of celebrating the doctor and popularizing his cure.

Overcoming the worry about death is the hardest of the fourfold remedy, and it's central to *De Rerum Natura*. The fact of death—unthinkable, inevitable, irreversible—is the prime difficulty of being an animal conscious of its end. Particularly excruciating for us is early death, which would have been a conspicuous feature of Lucretius's time. Though it isn't true, as my knowing-just-enough-to-be-dangerous students sometimes claim, that the

ancient Romans considered thirty-five to be old age (sixty was their line for senior citizenship: you were finally exempted from jury duty), thirty-five is a decent guess for their average lifespan—in fact, it could have been as low as twenty-five.[10] Only about half their children survived beyond the age of ten. Young men frequently died in military combat; young women in childbirth. Diseases regularly swept through and wiped out masses of the population. Though there were plenty of seventy-year-olds in togas, old age certainly wasn't considered anyone's natural right. The calamity of premature death was relentless.

It's not hard to understand why, in the centuries after Lucretius's own premature death at the age of forty-five, Christianity began to spread across the Roman Empire with its "good news" that we shall be resurrected in deathless versions of our bodies. As the republic was about to experience its own premature death, the issue presented itself to the human mind in all its bewildering rawness. Comparable to Christianity, there were mystery cults that reconciled a group of initiates to mortality by giving them the secret key to immortality. The mystery of these cults usually had something to do with a dying god. Lucretius makes the interesting observation that religion is often linked to violent sacrifice. There's something about the death of the innocent that calls forth hope for life everlasting. But until Christianity unveiled to all a similarly violent, hopeful mystery, many people had only a hodgepodge of legends and uncertainties. In moments of clarity, people feared their souls would end up in Hades, subject to eternal punishment or unrelenting boredom. In moments of hope, they imagined the ghosts of themselves and their loved ones retiring to heavenly pastures, like soldiers going back to family farms. Many simply lived with death as a great insecurity and thus, according to Lucretius, pursued their immortality in the form of wealth or glory, hoping at least that their names would survive their bodies. Such was the essence of the Roman triumph. Even in the stream of premature death, people found ways of losing themselves in distraction.

Though we're certainly not without the tragedy of early death, our medical technologies have made it just rare enough we sometimes delude ourselves into believing that living into our eighties is a right. We're a little less inclined than folks like Memmius to superstitions about the afterlife. We're a tad more inclined to superstitions about life itself. What Epicurus calls the "unnatural desires"—for money, glory, and power—don't just have their usual deep roots; our whole culture is an aggressive cultivation of them. We tell ourselves fairy tales about economic growth, even as our happiness wanes and our habitat burns. We make idols of celebrities, including those without talent or achievement. We fantasize about wars on crime and terror that others will fight for us. Like Midas, we touch priceless goods—relationships, art, education, politics—and turn them into money. Meanwhile, our science and technology are hellbent on extending life indefinitely and inventing new gizmos to numb us from meaninglessness. Lucretius points out that the torments we imagine in the underworld are actually what plague us in this world. For instance, he says that the story of Sisyphus, the ghost who must push a fallen boulder up a mountain only to have it fall down again in an endless vicious circle, doesn't describe a single crook's fate in Hades: it describes all the people in this world who seek illusory goals only to find that their success leaves them unsatisfied and ever wanting more.[11]

Has there ever been a vision of the universe so clear-eyed as Lucretius's Epicureanism? We're born. Our existence is unique. Life is chancy. We struggle to survive, ease our pains, find our pleasures. Though we tell ourselves fairy tales to allay our fears, we're going to die. I repeat: we're going to die. There's never been a golden age. We sometimes make things better. We often make things worse. We enjoy ourselves at times. We could do so more with a change of attitude. Did I mention we're going to die? None of this is bad news. If we just open our eyes and clear our minds, the universe appears as the great beauty it is. We're thirsty, and what we thirst for rains down from the sky. We crave companionship,

and there are billions of people to choose from. Our brief time in this iffy world means that our lives have value. Instead of obsessing about what we'll never experience, we should reap the day. Accepting our vulnerability not only isn't depressing; it's the very solution to living well.

Lucretius's poem is an elaboration and extension of the theory of reality that underlies the Epicurean vision. Our senses give us an imperfect, albeit roughly accurate, perception of the universe — one that can be corrected with a little clear thinking. The *natura* of things can be understood by considering both the solidity and divisibility of matter. If we had fine enough instruments, we could keep subdividing reality. But because things really are there, we couldn't subdivide forever. Eventually, we'd hit rock-bottom fundamentals, which Epicurus calls "atoms," and which Lucretius calls "the seeds of things." It's a theory shockingly in line with the poster of the periodic table in your high school science room: a limited number of types of tiny fundamental building blocks that combine to form everything.

Actually, there are a few basic principles of the universe. First, there's matter, which is made up of atoms. Second, there's the void, which is the empty space where the atoms do their thing. If the universe were all atoms (imagine a room packed full with sand), there could be no motion. Third, there's the swerve, which is basically a placeholder for all the physics unknown to Epicurus and Lucretius. Epicurus correctly intuits that objects falling through a vacuum move at the same rate despite their differing sizes. So how is it, he wonders, that these tumbling atoms ever interact to form all the weird and wonderful things scattered throughout the universe? There must be a swerve, something like a gust of wind in a rain shower, that makes the atoms bump against each other to shape and destroy the compounds we know as reality. The swerve also introduces an element of unpredictability, which we experience as free will. Epicurean physics isn't a tyranny: it's a republic.

Lucretius demonstrates with a lovely argument that the universe

is infinite. Imagine that you go to what you take to be its edge and throw a spear. Either the spear would hit something, in which case atoms are ahead, or the spear would keep flying, in which case the void is ahead. Either way, there's more. Zillions of atoms—zillions raised to the zillionth power—swerve endlessly, forming and reforming ever-surprising works of cosmic art. Worlds like ours and worlds unlike ours flourish and perish across the galaxies. This is infinity after all. There's no real rhyme or reason to the universe's creations other than creativity itself. It's all a trick of the swerve. You and I are among the sculptures in the current temporary exhibit. Our atomic organization includes minds capable of understanding what's going on and bodies capable of feeling happiness. We should take advantage of this great stroke of luck and enjoy the pleasures of being alive while we can.

Like everything else, consciousness is part of the physical world. It blinks into being in the course of our body's development. It changes as we grow. It can be modified by wine or a blow to the head. It wears down in old age. One of the images Lucretius uses to evoke the crumbling nature of all things, even consciousness, is a statue rubbed by the hands of many travelers. Rome still has such idols: I think of Arnolfo di Cambio's St. Peter, the bronze foot of which has so often been touched for good luck by pilgrims to St. Peter's Basilica that its toes have disappeared into a smooth mass. We like to imagine our minds as floating beyond the laws of the physical world, just as we like to imagine bronze sculptures as invulnerable to the flux of time. They're not. Someday our consciousness will be that foot.

Death is nothing to us—literally nothing. My daughter, when she was little, once asked me, "Where did our spaceship go?" After digging around in the wooden bin that contained our Lego creations in a colorful sea of loose pieces, I replied, "I think your brother took it apart and used some pieces to soup up his Batmobile. Your spaceship hasn't *gone* anywhere. It doesn't exist anymore, even though its Legos are still around. Given how weird

that thing was, I really don't see us recreating it." Asking where the spaceship went, by Epicurean lights, is basically the same as asking where the soul goes at death, when the physical structure necessary for consciousness comes undone. Death won't be anything for you, as *you* will no longer exist. From your nonperspective, it will be, Lucretius says, as it was before you were born. It makes no more sense to fear an afterlife than to regret a prebirth. The universe will find other uses for your Legos.

We should see death as it really is: the limit that gives form to our lives. It's both wrong and unhelpful to see death as a confinement, as an unfair stoppage of our projects. Things that go on endlessly lose their value. An Epicurean tip for getting through difficulties is to remember that pain comes to an end. Well, death is "this too shall pass" taken to its logical conclusion. Another Epicurean tip for getting through tough times is to remember the goods of life, like friendship and conversation. Well, death provides the shapeliness to time that makes these pleasures substantial. The sooner we stop thinking of death as a mere transition and come to terms with it as an absolute end, the sooner we can start enduring our temporary bouts of suffering and enjoying our precious encounters with beauty. Without a container, life could never be full, let alone overflowing.

When the spaceship is disassembled, doesn't my daughter have a right to lament its destruction? Can't we still miss people when they die? Of course. But like all pains, mourning can be endured. We should take comfort in the fact that the dead are utterly free now from disturbance. After the hurt of saying the permanent goodbye, our focus should move from lamenting the self that the universe no longer contains to cherishing the selves that it still supports. What's our other option? To those who wish things otherwise, Lucretius says, "Because you long for what isn't and disdain what's here / Life has passed you by, unfulfilled and unenjoyed."[12] Or, as Horace puts it a generation after Lucretius, we're all going to die one way or the other—

So you can spend all your time gloomy,
or you can treat yourself, lounging on holiday
in a secluded park, drinking that bottle of Falernian
from the depths of your cellar.[13]

Would the dead, before they were dead, really have wanted us to spend all our time gloomy? Don't you think they'd prefer it for us to have that bottle of wine?

The key to living well involves understanding our desires. A common delusion is that luxuries bring us the greatest pleasures. But luxuries don't give us the essentials: they give us the extras. There's nothing wrong with a bottle of Falernian now and again. But when we come to feel like we *need* the unnecessary, we begin our trip up Sisyphus's mountain. An even worse fantasy, generated from "needing" luxuries, is that money, power, or glory will bring us happiness. The problem with these "unnatural desires," as Epicurus calls them, is their endlessness: they can never be satisfied. As a child, I remember playing the game, "If you had three wishes, what would you wish for?" The standard answer was, "A million more wishes." Doesn't that answer reveal the nature of our boundless desire for money, power, and fame? We just want more. The irritating thing is that most of us have trouble coming up with three actual wishes, let alone a million. When you wish for unlimited wishes, you're wasting your limited life.

Lucretius notes how our sense of being victimized gives birth to unnatural desires. Why do we want more, more, more? Because we're afraid. We're afraid we might lose anything and everything. We get angry at the world for our vulnerability. We grow envious and desirous of whatever we don't have. War, which can make us temporarily feel like we have the power to inflict the death and destruction we fear, is the logical endpoint of our illogical refusal to accept our limited existence. Lucretius's poem is full of gruesome revelations of the brutality that the Roman triumph conceals.

Here's the real report: a chariot with scythes slices
limbs off enemies so fast the lopped-off parts can be seen
quivering on the ground, spasming in their warm blood.[14]

That's not bravery, according to Lucretius. It's what happens when
we can't conquer our fears.

The solution is to satisfy what Epicurus calls the "natural neces-
sary desires." When our atoms get what they crave, we have an ahh-
experience. Think of drinking a glass of cool water when thirsty,
having a riveting conversation with friends, reading a fascinating
book, making a good meal, playing a challenging game, sinking into
a soft pillow. Our natures don't miss luxuries

when friends lounge on the soft grass
by a babbling brook in a tall tree's shade,
refreshing their bodies on next to nothing.[15]

The truly rich are those who enjoy the abundant goods all around
them. Poverty isn't defined by the Epicureans solely in terms of
money; it describes the common state when we're in flight from
ourselves, pining after realities that don't exist while squandering
the one that does. The goal of Epicureanism is to reap the day, to
lounge on that soft grass by that babbling brook in that tall tree's
shade such that when death comes you can say, "Ah, I have lived."
For an Epicurean, three wishes are plenty: a stroll in the park, some
time with loved ones, and home cooking. That's real wealth.

Lucretius begins his poem with a prayer to Venus, asking that
his words have sufficient sweetness to make the medicine of our
mortality go down. It often strikes readers as peculiar, if not flat-out
contradictory, that Epicureans invoke the gods when they're so
vehemently opposed to religion and the supernatural. Epicurus rea-
sons that because we sometimes see them in dreams, and humanity
unanimously believes in them, the gods must exist in some atomic

form or another. Because they don't bother us, it's a waste of precious time to bother them with requests. Their tranquil lives in their secluded corners of the universe, free of anger and greed, should be an inspiration to us all. Tennyson's poem "Lucretius" contains this reworking of a passage in *De Rerum Natura*:

> The Gods, who haunt
> The lucid interspace of world and world,
> Where never creeps a cloud, or moves a wind,
> Nor ever falls the least white star of snow,
> Nor ever lowest roll of thunder moans,
> Nor sound of human sorrow mounts to mar
> Their sacred everlasting calm![16]

The gods in their cosmic gardens are good models of keeping their cool. But when it comes to the business of human life, they don't cause us any problems, and they're not going to provide us with any solutions. It's up to us to make things better.

The real problem, according to Lucretius, is religion, which stresses us out with unfounded principles and fills our brains with delusions of heavens and hells. By giving body to our unnatural desire for the infinite, religions—even religions of peace, maybe especially religions of peace—are intertwined with our unnatural desires for money, fame, and power. The ease with which later Christians would march into war under the sign of the cross wouldn't have shocked Lucretius in the slightest. Religions reinforce our sense that real value is elsewhere. When we commit to their principles, we become enemies of life. Their myths make it easier to talk people into killing and being slaughtered. War is never fought in the name of enjoying the simple things. It requires unleashing our immoderation. Lucretius's countercultural revulsion at Roman military triumphs must have fueled his even more countercultural hatred for Roman religion.

What Lucretius adds to Epicurean theology is that the primary

gods—Mars and Venus—aren't entities in the universe: they're the laws of nature. Here's how George Santayana explains the idea:

> The Mars and Venus of Lucretius are not moral forces, incompatible with the mechanism of atoms; they are this mechanism itself, insofar as it now produces and now destroys life, or any precious enterprise, like this of Lucretius in composing his saving poem. Mars and Venus, linked in each other's arms, rule the universe together; nothing arises save by the death of some other thing.[17]

Rome locates love and war at its origins: Aeneas is born of Venus, and Romulus is begotten by Mars. The Lucretian twist is that Venus and Mars are behind everything else too. The atoms swirl together in the universe's moments of joy and creativity and then break apart in its moments of pain and destruction. Tradition also has it that Venus and Mars are romantically entangled. In the prayer at the beginning of *De Rerum Natura*, Lucretius asks the goddess of creativity not only for help with his poem but for intervention in his city's turbulence in the twilight of the republic. When the god of destruction reclines on her lap, gazing up at her radiance, could she put in a good word for peace?

But the Roman triumph marched on. As Lucretius watched it wind down the Via Sacra, he must have felt pity for the victims and disdain for the celebrants. Probably also in the mix of emotions was pride in his own soul's fortifications against unnatural wealth. It's sweet, Lucretius says in a notorious passage, to stand atop the cliff and look down at a boat on the storm-tossed ocean. Life's a tragicomedy. It's out of this jumble of emotions—sadness and delight swerving into each other—that I imagine the poet formulating the topsy-turvy idea of Epicurus as a universe-conquering general who parades the wealth of philosophy.

Lucretius's subversive grin then perhaps turned into something else—a look of oceanic happiness, a smile of smiles, a *risus purus*. The

event he was observing wasn't just another example of human igno-
rance. It was a microcosm of infinity! Just as the universe is a river of
atoms breaking apart and coming together, so too the triumph was
a parade of bits and pieces of conquered civilizations being incorpo-
rated into Rome. Of course, like everything else in the universe, Rome
too would fall and be remade, its seeds staying roughly the same, the
whole changing utterly. After two thousand years of religious and
political remixing since the time of Lucretius, it's tempting to see
Roma, the offspring of war and love, as having grown into one of the
great divinities: a natural law of the cultural universe. But recall the
Lucretian big-picture lesson: we're only a blip of an organism in a blip
of a civilization on a blip of a planet in a Milky Way that is itself
a blip in infinity. It's not about conquering Pontus, nor even dominat-
ing several millennia. It's about enjoying this twinkling of life given
to us by the goddess who can conquer even our desire to conquer.

THINGS TO SEE AND CONSIDER: ROME AS
A SUBVERSIVE DOCUMENT OF BARBARISM

The modern materialist Walter Benjamin suggests that every doc-
ument of civilization is at the same time a document of barbarism.
Likewise, the ancient materialist Lucretius teaches us to recognize
barbarism in civilization—and then to rescue humanity from its
own barbarism. Military celebrations, commemorated in monu-
ments like the **Arch of Titus** or the **Arch of Septimius Severus** in
the **Roman Forum,** or the **Arch of Constantine** by the **Colosseum,**
should remind us that imperialism is idiotic and that philosophy
alone can conquer our fears. Statues like the colossal **Mars Ultor**
or the famed **Capitoline Venus** (both in the **Capitoline Museums**)
are repurposed as the physical laws that bind and unbind atoms.
The city of Rome in all its wild flux can be seen as a symbol of
the endless recombination of atoms where we must learn to find
our happiness. For Lucretius, the ultimate goal of unreading and

rereading Rome is to come to terms with death. On your way to see the bust of his master **Epicurus** in the Capitoline, you walk through an underground tunnel, where there are the remains of the records office of ancient Rome. The tunnel is now decked out with shards of tombs and sarcophagi. Before ascending to the bright **Hall of the Philosophers**, it's worth lingering underground with these homely epitaphs, which make blunt a human's permanent disappearance, to consider if Lucretius's Epicureanism is indeed powerful enough to dispel the pain of mortality.

> Mater [Mother] was my name, mother was not my future,
> for I must confess to having lived only five years,
> seven months, and twenty-two days.
> While I lived, I played. I was always adored by everyone.[18]

They come close to haiku.

> The bones
> of Pomponia Platura,
> Gaius's freedwoman.[19]

My favorite ancient epitaph, which expresses a kind of folk Epicureanism, isn't there, alas.

> He lived fifty-two years.
> To the spirits
> of Tiberius Claudius Secundus!
> Here he has all he needs.
> Baths, wine, and sex ruin our bodies,
> but baths, wine, and sex make life worth living.
> For her dear slave husband,
> Merope, slave of Caesar, erects this—
> as well as for herself and her descendants.[20]

Maybe such humble epitaphs are the true documents of civilization. After reckoning with mortality and rethinking your unnatural desires for glory, money, power, and eternal life, you might seek out one of Rome's many lovely parks where it's easy to be an Epicurean with a friend and your favorite beverage, as you "lounge on the soft grass / by a babbling brook in a tall tree's shade, / refreshing [your] bodies on next to nothing." Or maybe for your Epicurean triumph you want to go with the grain, so to speak, and refresh your body and soul with a plate of pasta.

DETOUR THROUGH FOUR PASTAS

My mentor Donald Phillip Verene, a profound philosopher and distinguished scholar of Italian thought, divides our approaches to food into two types: the Cartesian and the Vichian. Because René Descartes, the grandfather of modern technoscience, holds that custom and tradition are irrelevant to knowledge, and that our approach to life should be based on clear and distinct ideas applied for the sake of human improvement, the Cartesian approach to food emphasizes a continuum of values like nutrition, money, technique, and creativity. As different as they appear, health food, fast food, engineered food, and gimmicky food are all products of a technological Cartesianism that aims at novelty and progress. Because Giambattista Vico, the grandfather of the modern humanities, holds that human things are rooted in poetry and must be approached historically, the Vichian approach to food emphasizes custom, home, merriment, and tradition. It's about how Grandma did it and the aromas that wafted from her kitchen. Home cooking is the main form of the humanistic approach to food, but down-home restaurants like the bistro, the pub, the diner, and the trattoria are also Vichian institutions.[21]

Roman cuisine, like most Italian food, tends to be Vichian (Vico himself, though a great scholar of Roman tradition, was Neapolitan). Even the bad restaurants of the Eternal City (there are plenty),

let alone the good ones (they do exist), generally serve up at least a couple of the classic four Roman pasta dishes: *bucatini all'amatriciana* (a long pillowy pasta with San Marzano tomatoes, crushed red pepper, Pecorino Romano, and the pork-cheek bacon known as guanciale), *spaghetti alla carbonara* (spaghetti with the bacon known as pancetta, raw eggs, Pecorino Romano, Parmigiano Reggiano, and black pepper), *cacio e pepe* (usually bucatini with Pecorino Romano, cracked black pepper, and a little pasta water), and *pasta alla gricia* (rigatoni or another pasta with guanciale, Pecorino Romano, black pepper, and a little pasta water). As my teacher says, "A true dish, like a poem, musical composition, or work of art, can be enjoyed over and over. It has the power of repetition."[22] There's a charming episode of *No Reservations* where Anthony Bourdain visits a Roman trattoria (it's all filmed in the black-and-white style that he associates with Italian neorealist films), and an impassioned fight breaks out over whether a *carbonara* can accommodate zucchini flowers. That argument is the essence of tradition. The Italians have a saying, *A tavola non s'invecchia* (At table one doesn't grow old), perhaps because their practice of making food and eating together isn't consumed by time.

Verene's distinction can also be applied to wine. The Cartesian mindset regards it as an alcoholic beverage that's healthy up to a point but otherwise a source of addiction and disease, or else as an economic product to be scored and collected. The Vichian mindset understands it in terms of its place at the meal as well as how, where, and of what it's made. Should we think and drink according to health, economics, and rarity? Or should we think and drink according to festivity, sociality, and locality? Cartesians drink (or don't drink) wine because it serves a purpose. Vichians drink wine because wine is good.

The art of Italian cooking isn't about a pyrotechnic amalgamation of ingredients. It's about a discovery of the deep flavors of a few ingredients. It's about making the essentials shine by craft and contrast. It's about the conversing of the generations. The ultimate

goal, as with all great art (the blues, Caravaggio), is to go back to the tragic origin of things—in the case of a meal, the killing that's essential to living. Good food doesn't impress us. Good food breaks our hearts and reconciles us to our home on this earth. Think of the profundity of fresh bread with a sprinkle of olive oil or a grilled lamb chop with rosemary. Such tastes elicit a moaning sigh.

In *Marcella Says*, a cookbook that I wouldn't trade for a bookshelf of philosophical tomes, Marcella Hazan (she, though a great lover of Roman cuisine, was born in Cesenatico in Emilia-Romagna) puts her finger on art's essence with the Italian verb *insaporire*, which means something like "to draw out the flavors of," "to make tasty." The Roman pastas, all variations on simply combining cheese and pepper with a noodle, require the height of art to draw out their flavors. The simplest of them—*cacio e pepe*—is the most difficult to do well. The ingredients must be good. You have to have a sense of decorum in the Ciceronian sense of knowing feelingly what's right. You also have to have a balance of focus and nonchalance. The uptight never quite pull them off, though neither do those who don't pay the right kind of attention. When these dishes are lovingly and artfully prepared, there are few things simpler and more satisfying. They harmonize us with nature. They break our hearts. A good meal is not only fuel for reaping the day: it's the very essence of *carpe diem*.

Let me close with two quotations from my teachers about food and truth. First, Verene: "The everyday meal comes and goes, but it is part of what one is, in the sense that one is what one eats and how one eats. To cook what one eats and what others with whom we dine may eat is a rudimentary form of self-knowledge."[23] Second, Hazan:

> It is not my intention when I cook to provoke surprise at the
> family table, or to dazzle guests with my originality or creativity.
> I am never bored by a good old dish and I wouldn't shrink
> from making something that I first made fifty years ago and my

mother, perhaps, fifty years before then. I don't cook "concepts." I use my head, but I cook from the heart, I cook for flavor. Flavor must be more revelatory than exploratory. It wants to be disclosed rather than imposed; it is neither stylish nor pedantic, nor is it exhibitionistic. Like truth, it needs no embellishment. It is not the idea of the thing, but the thing itself. Flavor reaches into what may be our deepest source of pleasure.[24]

It's not about being an epicure. It's about being an Epicurean.

FIGURE 7.1 · Tellus Panel (9 BC), Museum of the Ara Pacis. The scholar Michael Putnam argues that Horace's "Song of the Ages" influences the imagery: "The panel's central figure has been variously interpreted as Terra Mater, Italia, and Pax as well as Ceres and Tellus, and no doubt aspects of all five would be discerned by the ancient viewer. Horace's words give particular voice to art's intimations not only of earth's generative ability but of the health that accompanies the Augustan peace." Michael C. J. Putnam, *Horace's* Carmen Saeculare: *Ritual Magic and the Poet's Art* (New Haven: Yale University Press, 2000), 68.

7

DARE TO BE WISE

Horace's View of the City

Does not a good person consider every day a festival?

PLUTARCH

The meaning of life isn't all that mysterious, though it's rare for anyone to talk its talk, let alone walk its walk. Even devotees of religion and philosophy are more likely to addle our brains with dangerous nonsense than to remind our souls of sound principles. Luckily, I know of at least one Roman who lays out the good life and lives it up: Quintus Horatius Flaccus (65-8 BC). Because he doesn't belabor a theory, Horace—as we know him—isn't usually classified as a philosopher. I myself subscribe to the dictum that you can't get drunk with the labels on the bottles. As Horace says in the letter known as the *Art of Poetry*, what matters in verbal work is that it delights and instructs us. Who cares whether we slap the label of philosophy on it or not?

Horace was born in a small town in the heel of Italy's boot.

Though we know nothing about his mother, his father was a freed slave who figured out how to make a decent living during the republic's most tumultuous years. Not wanting a slave's son to be belittled, he brought him to Rome, stretched the budget to dress young Horace in upscale clothes, and diligently walked him to and from the best available schools. Horace's education eventually took him to Athens where he fell in love with philosophy and poetry. "Captive Greece captured its captor," as he'd later write about the culture's influence on Rome.[1] In 42 BC, two years after the death of Julius Caesar, Horace joined the army of Brutus and Cassius to defend freedom. At the famous Battle of Philippi, when the army of Octavian and Mark Antony had decisively gained the upper hand, Horace threw down his shield and "was swiftly carried by Mercury/ in a thick cloud through enemy lines."[2] This is Horace's poetic way of saying he sweet-talked his way into the good graces of the victors.

After the war, Horace returned to Rome to find that his father had died and the family estate had been confiscated. He saw the writing on the wall: the reign of Octavian, now called Caesar Augustus, was the only way forward. He took a functionary-type job in the Treasury and composed the *Satires* and the *Epodes* in his free time. His friend Virgil introduced him to Maecenas, one of history's great patrons, who offered the budding poet the prize of being secretary to the emperor. Horace turned it down, managing— with Mercury's help—not only to stay in his former enemy's good graces but to earn Augustus's lavish praise. Maecenas set the poet up with a livable salary and a small farm in Tibur, now Tivoli, where Horace oversaw operations, worked the land, and perfected four slim books of the *Odes* and two volumes of the *Epistles*. When the spirit moved him, Horace went to Rome and took in the big city. When its hubbub got too much for him, he returned to his Sabine farm and poured himself a glass of local wine.

Here's my version, with brief annotation, of the Horatian decalogue, which I've abstracted from his works.

1. **Remember death.** When you put out of mind that you're going to die, you bank the goods of life rather than enjoy them.

 Pale Death pounds—he's not picky—at pauper's door
 and despot's tower.[3]

 Until he knocks, don't let your good luck go to waste.
 Remember your mortality, and "dare to be wise."[4]

2. **Reap the day.** If my students know only one Latin phrase, it's apt to be Horace's *"carpe diem."* Often translated as "seize," the verb is closer to "pluck," like picking a daisy or an apple. I've gone with "reap" to keep in mind that the time is ripe.

 You're in charge—
 and happy too—if every evening
 you can say, "I have lived."[5]

 Young people tend to interpret *"carpe diem"* as an exhortation to partying, but that's just because they can't really fathom dying. When you honestly face your death, reaping the day means savoring daily life, doing the things you're meant to do, and being grateful for this crazy world. OK, also a little partying.

3. **Cultivate relationships.** Horace calls Virgil "a chunk of my soul," for the soul is incomplete without a friend.

 When sane, I rank no joy above friendship.[6]

 But it's not just friendship you should cultivate. Horace is on good terms with pretty much everyone, from slave to emperor. The key is developing the virtues that put all folks at ease: etiquette appropriate to the situation, frankness about

important things, confidence in your abilities, a sense of fun. Don't be a glad-hander, as glad-handing at best establishes superficial connections.

4. *Work to the limit of your limits.* Horace often remarks that he's unable to write lyric poems of wild power like the Greek poet Pindar or epic poems like his soulmate Virgil.

Self-knowledge
keeps me from venturing beyond my strengths.[7]

But what's the sense in beating yourself up for what you can't do? Horace writes perfect poems within his limits and, by doing so, expands the limits of the lyric and the essay. When you do what you've been given to do as well as it can be done, you make your mark and—generally—sleep easy at night.

5. *Avoid what's popular.* Thinking the thoughts that everyone thinks is a form of slavery. Plus, the mob doesn't have your best interests at heart. Popularity, Horace says, is a set of footprints stampeding in the opposite direction of meaning and happiness—usually into caves of distraction and idiocy, from which the footprints never seem to return.

Virtue's not into what's in.[8]

One exception Horace makes to this rule is women's hairdos. He has a taste for the latest styles.

6. *Venus makes fools of us all.* The Epicureans warn against erotic relationships because they wreck your happiness. The Stoics frown on them because they make you temporarily insane.

Here's the ironclad law of Venus:
mismatched minds and bodies attracted
for maximum humor.[9]

But Horace ultimately departs from the philosophical schools.
Sex may often be an unnecessary desire, but you necessarily suf-
fer from it. Romantic love is indeed a kind of madness, but it's
a divine kind of madness. When it comes to your erotic nature,
the extremes to be avoided are priggish moralism and slavish
dissolution. The virtue to be aimed at is a joyful acknowledg-
ment of our common folly. (If you want a bit of gossip about
Horace, an ancient rumor has it that he lined his bedroom walls
with mirrors to enjoy sex from every angle.[10])

7. *Don't worry about what you can't control.* Life's a crapshoot.
 Getting worked up over twists of fate, much less possible
 twists of fate, is a good way to make yourself miserable.

 Who lives anxiously is, by my lights, never free.[11]

 Having survived a civil war, Horace knows that the dice could
 easily have come up his number. Rather than waste his time
 in worry and grief, he savors all there is to be savored.

8. *Wine helps.* The wise stay calm—well, mostly. Sexual desire
 makes fools of everyone. Politics too is hard to stay level-
 headed about. Oh, there's also toothaches, which elicit
 whining from even the Stoics. Let's face it: there's going to
 be a leftover of worry and grief in even the most rational
 rational-animal. Plus, isn't rationality a burden we need to lay
 down periodically? If only there were a delicious elixir that
 chased off worry, reconciled us to the moment, and glad-
 dened our hearts . . .

Yes, you, remember to forget,
with a smooth wine,
life's sadness, Plancus, life's burdens.[12]

9. *Practice moderation, but don't get uptight about it.* Moderation,
conceived as reining in wild passions, is a great thing. It keeps
you balanced and prevents your pleasures from running you
off the cliff. However, since passions need to let loose once
in a while, it's wise to moderate your moderation with the
occasional immoderation.

Mix a little madness into the plan:
frivolity is a necessary sweetness.[13]

By the way, let's not ascribe the virtue of temperance to those
who aren't much tempted. It's worth noting that the Latin
term for "moderation" is *mediocritas*, the root of our "medioc-
rity."

10. *Irreverence is worse than superstition.*[14] When Horace was a
student, he was, like all philosophical types at some point in
their journey, "a devotee of a crazy theory"—probably atom-
ism.[15] But he eventually recognizes the limits of the human
mind, moves beyond his zealous antizealotry, and opens him-
self to the veneration of the holy cycles—offering sacrifices,
praising the gods, participating in religious festivals.

O shining grace of heaven, who should always
be worshipped and always be cherished . . .[16]

So what if worship sometimes verges on superstition? Your
theory of the world will crumble in the future. Your atten-
tion to shining grace is more durable than bronze.

See? The meaning of life isn't all that complicated. It's basically a compendium of Stoicism and Epicureanism liberated from their metaphysical systems, tempered by common sense, and quickened by poetry. Now, as Horace says,

> Live, goodbye. If you have better guidance,
> I'm all ears. If not, you're welcome to mine.[17]

All that said, there actually is a mystery to the meaning of life, something that can't quite be stated in a formula or a decalogue. It's like trying to make Grandma's magic cookie bars. Even though you follow her handwritten recipe to the quarter-teaspoon, they just don't come out as good as hers. The secret has something to do with style.

It starts with learning how to do something well—something you believe in. Virtue takes virtuosity. In Horace's case, it's poetry, though it could just as well be cookie-making. Once you become superb at a vocation, you discover your powers and can deploy them powerfully. "Style," as Alfred North Whitehead says in what I take to be the best book on education, "is the last acquirement of the educated mind; it is also the most useful. It pervades the whole being."[18] It's marked by the ability to accomplish difficult things with grace and good judgment. Here's how Horace describes it in the *Art of Poetry*:

> I strive for poetry about common things so well-made
> people think they could pull it off, though they'd sweat
> and slog and come up empty-handed. It's the power
> in working with form. It's the beauty in what's common.[19]

The goal is freedom in the sense of powerful play: the ability to do as you wish—to play—with the forms of your craft. Think of the difference between the baker who knows only to follow the recipe

and Grandma who, when an ingredient isn't available, nonchalantly improvises. It's depressing that we make such a hard distinction nowadays between craft and art, because art is the blossoming of craft. Art is making it look easy.

Linger over practically any line of Horace, and you'll find the everyday alchemized into art. For instance, after his lover Pyrrha has just broken up with him, Horace asks the question that usually tortures the spurned, "Who's making love to you right now?"

> Quis multa gracilis te puer in rosa
> perfusus liquidis urget odoribus
> grato, Pyrrha, sub antro?

Here's a no-nonsense translation:

> What slender boy, drenched in cologne,
> is embracing you, Pyrrha, in your favorite haunt
> on a bed of roses?

Simple and beautiful in a heartbreaking way, right? (For what it's worth, Horace was chubby—thus the torturous fantasy of his slender replacement.) But let's look closer.

As an inflected language, Latin can tolerate practically any word order. In English, "Dog bites man" and "Man bites dog" have different meanings. But in Latin, either sentence, based on the inflection of man and dog, could have the other's meaning; in fact, you could say, "Vicious man bites bald dog," and, because of the endings of the nouns and adjectives, actually mean, "Vicious dog bites bald man." A word-for-word crib of Horace's lines, with no respect to English grammar (I use dashes to break up the grammatical pieces), would read:

> What—many—slender—you—boy—in roses—
> soaked—liquid—embraces—odors—
> pleasant—Pyrrha—in grotto?

This smear of words paints a dramatic picture. Horace's verse is as close as any in the Western tradition to Chinese poetry, which fuses language and visual art. Put together grammar and word order, and at the first line's center is the word "you" as a direct object (*te*), directly surrounded by the words "slender" (*gracilis*) and "boy" (*puer*); the subject and its adjective *embrace* the pronoun of Horace's ex (it's just the beginning of the poem's embraces [they work like parentheses within parentheses]). The couple themselves (*te puer*) are surrounded in the first line by "many" (*multa*) "roses" (*rosa*). The action of embracing (*urget*) is at the center of the second line, encircled by the "odors" (*odoribus*) of the lover "drenched in liquid" (*perfusus liquidis*—*liquidis* modifies *odoribus*). At the heart of the third line is the name "Pyrrha," over whom Horace is obsessing, and she's embedded between "pleasant" (*grato*) and "in the grotto" (*sub antro*). The semantics of what in English would be "What slender boy, drenched in cologne, is embracing you, Pyrrha, in the pleasant grotto on a bed of roses?" has been arranged in Latin to depict the obsessive fantasy at the core of the spurned lover's question. All of this is accomplished according to the strict rules of a complex meter, the Fourth Asclepiadean, developed not for Latin but for Greek. And that's just a few lines from what happens to be the first poem to awaken me to the artfulness of the *Odes*. When it comes to describing Horace's poetry, Nietzsche nails it, "This mosaic of words, in which every word—as sound, as locus, as concept—pours forth its power to left and right and over the whole, this minimum in the range and number of signs which achieves a maximum of energy of these signs—all this is Roman and, if one will believe me, noble *par excellence*."[20]

Horace's philosophical task is to apply this kind of play to life generally, which involves inhabiting natural emotions and cultural patterns with panache. The fact that his father was a freed slave may well be the most important biographical fact about Horace—he wasn't going back. It's not just that he didn't want to be an unpaid laborer or that he took up arms in defense of the republic. He didn't

want to be enslaved by party, by politics, by popularity, by job, by religion, by theory, by money, by anxiety. Living well means being free.

Freedom in this sense involves practical things that liberate you from want and fear, like Horace's Sabine farm and his regular income from Maecenas. But it also involves, paradoxically, not becoming reliant on those things.

> Though I don't praise poverty after a chicken dinner,
> I wouldn't trade my freedom for all Arabia's gold.[21]

Freedom also means being able to look all people in the eye: anything other than deep equality puts the manacles of a power dynamic on you. Though you bow your head in public when it's appropriate, your mind bows to no authority except the truth, and your soul bows only to what is greater than the soul: beauty, holiness, justice, love. In this way, freedom involves thinking for yourself, which doesn't mean thinking without anybody's help but rather pursuing the higher goods in dialogue with the best of the living and the dead. Likewise, freedom means mastering the art of language such that, with Mercury's help, you can speak truthfully without speaking offensively. It means the ability to be in Rome but not of Rome.

This deep freedom appears to be a radical independence. It is by certain standards. But the ultimate act of freedom is embracing dependence. The successful are prone to believing that their success is self-made. But independence can't be achieved without considerable help. Our lives are so woven of luck—good, bad, both— that it's impossible to disentangle our choices from all we haven't chosen: nature, nurture, encounters, detours. Refusal to see the chanciness of our existence, especially of our virtues and accomplishments, is dishonest and small, a state of untruth that keeps us in chains. Gratitude is a much greater virtue than independence. It's also more characteristic of the free soul.

Horace's poems radiate gratitude for the friends who nourish

him, for the wine that delights him, for the lovers who keep things interesting, for the muses who empower his poetry, for the gods who give him life, for the natural forces that sustain him, and for the father who blessed him with a liberal education. Horace offers his most frequent thanks to Maecenas. In part, this has to do with the etiquette of how to treat a patron. But Horace's praise of Maecenas never seems perfunctory. Grateful for being empowered by his patron to do what he loves, the poet finds ever-fresh ways of returning the favor.

> I'll pour us some cheap goblets of Sabine wine—
> nothing special, but I bottled it myself
> in Greek jars the day the theater gave you
> such an ovation—
>
> "It's the great lord Maecenas!"—that the booming
> echo made it seem like the Vatican Hill
> and the banks of your ancestral river had
> joined in your praises.[22]

Maecenas, who hangs out with the rich, is used to high-end wine. The poet's compliment is that Maecenas isn't so snobby he can't enjoy house wine in the Roman equivalent of mason jars. Since the cheap goblets are big two-handled goblets (*canthari*), Maecenas can infer that he's in for some serious imbibing. Horace offers his patron a unique experience: intimate conversation over a secret-recipe wine from the very estate the poet is thankful for, bottled on the auspicious day that Maecenas received a huge ovation on his outing to the theater after recovering from a bad sickness. The poem expresses the best kind of gratitude, the kind that enlarges both the giver and the getter of the gratitude, the kind that's down-to-earth, smart, and suffused with love. When Maecenas died, he left Augustus a proviso in his will, "Remember Horatius Flaccus like he were me."[23]

Horace got a chance to express a public form of deep gratitude when Augustus asked him to compose a hymn for the *Ludi Saeculares*, the Games of the Ages, a festival marking the end of one age (*saeculum*) and the beginning of the next. An "age" in this sense refers to a hundred and ten years, the longest it was believed a human could live. It's a very ancient Roman idea for a holiday: the marking of the regeneration of the greatest possible life-spans. The civil wars had prevented a celebration in 49 BC. With a little fancy footwork, the court historians recalibrated that the next festival should take place in 17 BC, a few years after Augustus had fully consolidated his power. After heralds fired up the citizenry by promising a spectacle "such as they had never witnessed and never would again," the weeklong celebration involved sacrifices to various deities, purification rituals, the distribution of free food, the performance of Greek and Latin plays, chariot racing, hunting, and lots of drinking. The highlight was the performance of Horace's hymn atop the Palatine Hill by two choruses, one of twenty-seven boys, one of twenty-seven girls.

Though Horace usually demurs when asked to write official poems, he agrees to compose the "Song of the Ages" because he doesn't want to disappoint the emperor but also, I imagine, because he knows it's the kind of official poem he can pull off: a thanksgiving for peace rather than a paean to war. Previous versions of the festival had been exclusively nocturnal, but Augustus wanted daytime celebrations too. Horace's song, with its principal deities of the sun-god and the moon-goddess, is bathed in brightness.

> Phoebus and Diana, mistress of the woods,
> O shining grace of heaven, who should always
> be worshipped and always be cherished, hear us
> this sacred moment.[24]

That second line contains the opposite of an eclipse. Phoebus (Apollo) and Diana cross paths and merge into a single "shining

grace of the heavens" (*lucidum caeli decus*). Throughout the poem, the two central gods blaze through their various powers. Diana is the chaste huntress who presides over nature, fertility, marriage. Apollo is the confident leader who oversees war, reason, healing. They serve as the sacred principles of cosmic complementarity we ignore at our peril. On no real evidence, I like to imagine the choreography of the boy and girl choruses as swirling, yin-yang-like, in imitation of the orbits of sun and moon.

The "Song of the Ages" takes inspiration from its performance site atop the Palatine, the hill where the Roman elite, including Caesar Augustus, lived. When we're on a hill, we're simultaneously up and down: we're above where we came from, and we look down on where we were and will be. We're up in the sky, but we also feel earthbound precisely because we feel the heights above us. "I can almost touch the clouds," we say. Welcoming us atop the swankiest of Rome's seven hills, Horace takes advantage of this ambiguous condition, inviting us both to look skyward and to enjoy a god's-eye view of the city.

> Life-giving sun gleaming on your chariot,
> who reveals day and hides it, newness again,
> sameness anew, may you see nothing greater
> than this city Rome.[25]

Like poetry itself, the celebration on the hill helps us to see everyday reality afresh. Our humdrum lives in our frantic culture nevertheless participate in the sacred cycles. The same old thing is a whole new day. Nowadays we think of secularism as the opposite of religiosity, but here the *saeculum* is precisely what's infused with holiness.

Horace prays for blessings on the human chain throughout the ages—strength in marriages, fruitfulness from couples, protection for mothers, good advice from fathers, attentiveness from children, care for the elderly—so that the festival of life's fullness can be

celebrated again and again. The poem is a far-reaching vision of marriage: not only of husband and wife, but of sun and moon, of culture and nature, of god and human, of virtue and sex. It's also a celebration of peace, but not in the sense that war is no more. The arrows of the gods are still present. When we do wage war, Horace sends up a prayer for the kind of victory that not only spares the defeated but wins over their hearts and minds. But the poet reminds his fellow Romans (and us too), particularly the politicians, that the point of life isn't an ever-running war machine.

> Now Faith and Peace and Honor dare to return—
> also ancient Restraint and ignored Virtue;
> and Abundance makes an appearance with her
> cornucopia.[26]

A few years after the performance of the "Song of the Ages," Augustus ordered the building of the Ara Pacis, the altar to the goddess Peace—one of the most magnificent ancient monuments to be seen in Rome. Scholars have argued for the Horatian hymn's direct influence on the Ara Pacis's reliefs, which also depict an intergenerational celebration of the golden age, overseen by a goddess who unifies various divine functions.[27]

So, what's the meaning of life? Horace's "Song of the Ages" suggests that it's festivity, the joyful marriage of our energies. I use the word "festivity" in part thinking of actual festivals, like the Games of the Ages, which lift us out of the workaday world into a sociality of freedom and fun that marks time and expresses gratitude. There's something about playing well that's rooted in working well. Sometimes *la dolce vita* is conceived as the party life. But partying gets boring or ugly without a sense of festivity. Partying is a break from work; festivity is the flowering of work. It's striking that most real festivals are religious (think of Christmas or Mardi Gras). The more these festivals get away from their holy function of thanksgiving, the more joyless or depraved they generally become (think

once more of Christmas or Mardi Gras—or, for that matter, of the triumphs of the late republic). Joy is always larger than the ego. Irreverence, I repeat, is worse than superstition.

But what I'm getting at by "festivity" goes beyond what happens at even the best festivals. There's a kind of festivity that permeates existence, that doesn't come and go with holidays. When you remember your mortality, do your work well, cultivate your relationships, prize your freedom, accept your vulnerability, and take your place in the human chain—when, in short, you reap the day—you keep in contact with the great beauty, the overwhelming "yes." It's that place of music where, to borrow what a theologian says about Mozart, "happiness outdistances sorrow without extinguishing it, and the 'Yes' rings stronger than the still-existing 'No.'"[28]

The performance site of Horace's "Song of the Ages" is one of the loveliest spots in Rome. Breezy, above all the hubbub, covered in gardens, littered with ruined palaces, lined with lemon trees, the Palatine inspires a feeling in me that is—well, palatial. When I look out from its bluff at Rome, I'm reminded of being on a little motorboat in the Pacific and seeing a humpback whale rise from the depths, leap as if in slow-motion into the air, crash back into the waves, and slip down into the shadows with one last wave of its colossal tail. Isn't that sort of like looking out and beholding Rome, where it always seems like we're seeing the giant tail of an even more massive history? Whale song, or so I've read, is a communal composition that a male humpback puts his own twist on—sort of like Horace with his "Song of the Ages." I've also read that whales' hearts are so strong they sometimes beat only twice a minute. Gazing down on the Forum or the Circus Maximus and imagining the time-lapse of history, I think of the *saeculum*, the fullest possible human life, as that huge heartbeat. Boom. Boom. Horace is just eighteen beats away.

Our age is prone to thinking of biology's prime objectives as survival and reproduction. Maybe whales and Rome and the fullest human lives are better thought of as principles of festivity, embod-

iments of the overwhelming Yes, which are indeed tied to survival and sex, and never exempt from the great "no" of suffering and injustice, but which are more completely realized in playfulness and freedom than in necessity and labor, better exemplified by the extravagant leap of the whale than by the nervous flight of the plankton, more clearly seen by a wine-loving poet than a victory-obsessed general. Maybe that deep whale song of the ages can even be accessed by a small-town kid who's somehow made it to the top of the Palatine.

DETOUR VIA SORRENTINO'S TRICK

The last words of Paolo Sorrentino's 2013 movie *The Great Beauty* (*La grande bellezza*) are the first words of its main character's long-awaited second novel.

> This is how it always ends. With death. But first there was life. Hidden beneath the "blah, blah, blah." It's all settled beneath the chitter-chatter and the noise. Silence and sentiment. Emotion and fear. The haggard, inconstant flashes of beauty. And then the wretched squalor and miserable humanity. All buried under the cover of the embarrassment of being in the world—"blah, blah, blah." Beyond there is what lies beyond. I don't deal with what lies beyond. Therefore, let this novel begin. After all, it's just a trick. Yes, it's just a trick.[29]

The movie is a love letter to Rome, a city full of tricks—like Andrea Pozzo's ceiling fresco in the Church of St. Ignatius of Loyola, which creates the illusion of an architecture that rises up into heaven itself (its "dome" totally fools your eyes), or Borromini's forced perspective corridor in the Palazzo Spada, which creates the illusion of a gallery almost five times longer than it actually is.[30] The Piazza dei Cavalieri di Malta, on the Aventine, has a door with a little keyhole that, when you peep through it, perfectly frames St. Peter's Basilica

in the distance. Its trick is that the largest church in the world is even greater for being fit into a keyhole!

In an extra on the DVD of *The Great Beauty* there's a scene where Jep Gambardella, the main character, is interviewing an old director who claims that in his thirty-two celebrated films he's never said anything important. Jep objects, "You've shaped the imagination of millions forever!" The director muses that people fail out of laziness to respect their curiosity. Is it possible, he wonders, to make a movie that would disinhibit them? Jep is suddenly all ears, as he wrote a celebrated novel as a young man but has been unable to compose any serious literature for the past four decades, in large part because he's immersed himself in *la dolce vita* of Rome. The director explains that the germ of his next film is about a girl whose eyes change colors every time she blinks: blue, green, black, blue again. Though she never speaks, everyone is enchanted by "just silence and those eyes." The director says that his inspiration came from deep in his youth, when his father hoisted him on his shoulders so he could see above the crowd the first traffic light installed in Milan. Though there was no traffic, everyone marveled at the machine's changing colors. As childlike wonder glistens through his wrinkled face, the old director muses, "*Que bellezza, que grande bellezza!*" (What beauty, what great beauty!)[31]

What's revealed by the likes of the eyes of the traffic light isn't a trick. The great beauty is real. The trick is to reposition ourselves to experience its undiminished enchantment. The old director's trick is to come up with an image—a girl whose eyes change colors every time she blinks—that revives the childlike clarity. We have all looked and looked. The trick is to see as if for the first time. The trick, as Jep learns over the course of the movie, is to reap the day.

Carpe diem means almost the exact opposite of how young people tend to interpret *carpe diem*. It doesn't mean, "Past and future be damned!" It certainly doesn't mean, "Stay relevant!" It means, "I'll make the most of today with its legacy backward and forward." It really is a trick to pull off, because we're so used to caring about past,

present, and future in their separate boxes. We dwell on memories of the past, because the present fills us with anxiety. We immerse ourselves in the distractions of the present, because we're hiding from the past. We worry about the possibilities of the future, because we have troubles being present.

A pivotal moment in Jep's odyssey is when he visits an exhibition of photographs in the Villa Giulia. The photographer, after having had a picture taken of himself every day for fifty-five years, has wallpapered the Renaissance villa with the countless Polaroids. Jep is moved to tears at the collective power of the otherwise mundane photos, which register every shade of emotion and remind him of how each moment is merged into a great living sequence that embraces our contradictions. Everything has grace and depth, even a selfie! What Jep comes to realize—the director's trick—is that he has to use the blessing of his imagination to see *la grande bellezza* simultaneously revealing and hiding itself, to understand the dialectic between the "blah-blah-blah" and our "haggard, inconstant flashes of beauty," to accept that all people are both shallow and deep, to reap the day by coming to terms with the past so as to move into a creative future. Rome isn't built in *a* day. It's built in *the* day.

On his rooftop porch, Jep casually remarks to his Roman pals that the best people in their city are the tourists. I'm not sure if that's true, but I take his point. To live somewhere is often not to see it. Tourists are more likely than Jep to take in the Colosseum, even though his porch overlooks it. But we tourists face a problem too. We often experience only what we're supposed to experience. Our phones often record more than our memories. All of us, whether as insider or outsider, face the challenge of overcoming imaginative blockages to wake up to the great beauty. The epigraph to the movie is from Louis-Ferdinand Céline's *Journey to the End of Night*: "Travel is useful, it exercises the imagination. All the rest is disappointment and fatigue. Our journey is entirely imaginary. That is its strength. It goes from life to death. People, animals, cities, things, are all imagined. It's a novel, just a fictitious narrative."[32] We

sometimes use the word "fictitious" to dismiss something as fake. But the idea of *The Great Beauty*, as well as the idea of Rome itself, is that we need "fictions" to inhabit reality. If our tricks aren't up to the tasks of loving and dying, if our stories don't gather up the great beauty, we're stuck with hypocritical religion, corrupt politics, stupid entertainment, pompous art, and endless distraction—all of which the movie documents with droll bemusement. *The Great Beauty* is a kind of tourist guidebook to Rome, not in the usual boring way, but in the sense of teaching us the trick to inhabit ourselves as imaginatively-charged travelers of the day. Everything flies off like a flock of flamingos, and it always ends with death. But first there is life.

THINGS TO SEE AND CONSIDER: ROME AS THE GREAT BEAUTY

In *Poets in a Landscape*, Gilbert Highet indulges in a Horatian fantasy, which also nicely describes Jep.

> [Rome] is often recognizably the same city [as it was in Horace's time]. As one wanders through its busy streets, one occasionally sees a plump little man strolling vaguely along, eyeing the shop windows, glancing at the pretty girls, pausing to buy a lottery ticket, reading the headlines in a newspaper-office window, and at last sitting down to drink a glass of bitter Campari and to watch, with apparent complacency, the noisy traffic swirling past. One puts him down as—well, what? . . . It is still possible that he may be an artist, a philosopher, or a poet.[33]

As you meander through Rome, keep an eye out for the god Mercury, who may reveal to you the secret of how to be in and out of Rome such that you find the great beauty. Maybe the secret can be found in the **Museum of the Ara Pacis** (Museo dell'Ara Pacis), dedicated to the Augustan altar that portrays a celebration of peace

in the spirit of the "Games of the Ages." You might also check out the inscribed pilaster in the **Piazza della Repubblica** that commemorates the performance. "Where else but Rome," Georgina Masson says, "could we stand looking at an inscription and know with certainty that it would have been familiar to our old friend Horace himself?"[34] If you're interested in Paolo Sorrentino's *The Great Beauty*, I'd say to begin your wandering, as the film does, on the **Janiculum** (Gianicolo), where you can observe the cannon firing at noon on the **Terrazza del Gianicolo**, wander by the **Piazzale Giuseppe Garibaldi**, admire the Renaissance perfection of Bramante's **Tempietto** where the child gets lost, and take in the stunning view of Rome that so overwhelms the Japanese tourist it causes him to fall over dead by the **Fontana dell'Acqua Paola**. If you survive the beauty of the vista, from there you might wend your way to the Tiber and stroll like Jep between the **Ponte Sisto** and the **Ponte Mazzini**, making a small detour to see the **Fontana del Mascherone di Santa Sabina**, where Jep washes his face after a night of partying. Borromini's **Sant'Agnese in Agone** in the **Piazza Navona**, where Jep seduces a rich fan of his novel, is also just a short walk away. Beyond that, the sites of the movie are scattered. You might visit the **Aventine Keyhole** like Ramona, scale the **Scala Santa** by the **Basilica of San Giovanni in Laterano** like the Saint, or bash your head against ancient stone like Talia Concept in the **Park of the Aqueducts** (Parco degli Acquedotti) outside the city. The **Baths of Caracalla**, where Jep sees an illusory giraffe, is well worth your time, as I've already mentioned. When you're by the **Colosseum**, look for Jep's apartment on the top floor of the orange building on the **Piazza del Colosseo**. One candidate for the great beauty can be found in **St. Peter's**: the statue of *Justice* in the **Monument to Pope Paul III**, the work of Guglielmo della Porta (ca. 1515–77). The personified virtue is said to be based on the pope's sister, known as Giulia Bella (Giulia the Beautiful), the lover of the pope's Borgia predecessor Alexander VI. *Justice* was originally naked, for justice should keep nothing hidden. But the sculpture was so erotic that a

later pope insisted on putting clothes on it to prevent embarrassing incidents (nakedness and clothing are also main themes of *The Great Beauty*). For instance, Giuseppe Belli, the vivid nineteenth-century poet of Roman life, tells how once an English lord was caught in front of *Justice* committing an obscene act with "bird in hand" (*l'uscello in mano*). Such a story is right at the center of the complex Venn diagram that is Rome, the overlap of justice, beauty, love, lust, virtue, vice, obscenity, religion, pragmatism, and travel—what Sorrentino calls *la grande bellezza*.

IV

Love and Do What You Will

A world you are, O Rome, but without love
The world would not be the world, Rome would not be
Rome.

JOHANN WOLFGANG VON GOETHE

FIGURE 8.1 · *The Flavian Amphitheater*, a.k.a. the Colosseum. Our word "fornication" derives from the Latin word *fornix*, which means "vaulted chamber," since prostitutes and illicit lovers often made use of nooks under arches.

8

HOLD HUMANITY SACRED

Seneca or Augustine versus the Colosseum

> Never, in its bloodiest prime, can the sight of the gigantic
> Colosseum, full and running over with the lustiest life, have
> moved the heart as it must move all who look upon it now,
> a ruin. God be thanked: a ruin.
>
> **CHARLES DICKENS**

Tourists in the Colosseum often wonder why ancient Romans killed people for fun. Because the place feels like a modern sports arena (am I the only one who gets hungry for an overpriced hot dog by its *vomitoria*?), we also wonder about violent spectacle in our society. Why do we cheer on the big hits in the NFL? Why are boxing matches, MMA fights, and violent video games so compelling? After snapping selfies in the iconic arena of carnage, folks who'd never dare wade into a book by Immanuel Kant suddenly find themselves knee-deep in the basic subjects of philosophy. Aesthetics: what's so enjoyable about bloodshed? Ethics: is it acceptable

to be a spectator of violence? Politics: what role should bread and circuses play in society? Human nature: what does the persistence of violence tell us about who we are? As my wife, who can't bear to enter a place so haunted by slaughter, often asks with noble exacerbation, "What's wrong with people?" Rome's famous site of concentrated killing is where the most philosophical questioning per capita happens in the world on any given day. That's my hypothesis, anyway.

If you're not careful, the questions keep ramifying. Wait, why am I here? How weird to be a spectator of spectral spectators of violence! Why am I drawn to visit a city with a legacy of conquering the world? Is it wrong for me to celebrate the art and architecture of a civilization rooted in colonization and slavery? What am I supposed to do with the part of me that lights up at the beauty? What am I supposed to do with the part of me darkly allured by the violence? Isn't Rome itself haunted by murder? Isn't my country? Isn't the world? Regardless of how you answer these questions, give the Eternal City credit for not shying away from them. The Colosseum and the triumphal arches rub them in your face.

Ancient philosophers looked down on the games but never called for their abolition. The Colosseum was another idiocy of the dominant culture from which they had to unplug. It wasn't until the rise of Christianity that a philosophical sensibility began to regard the games as evil—and not just the games, but a whole set of ancient Roman practices. For our tour guides through the philosophical maze of the Colosseum, I'm interested in two all-too-human philosophers, Seneca and Augustine, both of whose philosophies are marked by the experience of the games. The small but significant difference between Seneca's Stoicism and Augustine's Christianity speaks to a fundamental choice about how we're to hold humanity sacred in light of our destructive energies.

The construction of the Amphitheatrum Flavium (Flavian Amphitheater), as it was originally known, began in AD 72 under the emperor Vespasian in what had recently been the artificial lake

of the Domus Aurea, the gargantuan golden house that Nero built after the great fire of AD 64 wiped out a chunk of downtown. The Colosseum is a later name, probably from the Middle Ages, referencing the Colossus of Nero, a 98-foot-tall bronze statue of the vain emperor as the sun-god. The good sense of Vespasian was to give the masses a public works project after Nero's despicable reign and its subsequent upheavals. The money for the Amphitheater was raised from the Siege of Jerusalem. The menorah among the booty depicted on the nearby Arch of Titus, which commemorates the Roman victory, is a token of the massacre of hundreds of thousands of Jews and the destruction of the Holy City's five-hundred-year-old temple. To add insult to unspeakable injury, Titus had sex with a prostitute on a bed of Jewish scriptures in the Holy of Holies. Genocide and Desecration: the parents of the Colosseum.

The staggering arena probably held upward of fifty thousand people, could be flooded to simulate sea battles, had a retractable roof to protect patrons from the sun (it took non-Romans only until 1989 to figure out the SkyDome), and operated with an elaborate underground network, the *hypogeum*, for exotic beasts to spring up unexpectedly. Nowadays we're familiar with the gladiatorial battles (*gladiator* means "man with the sword"), but there were other spectacles, including circus performances, executions, and the "hunting" of rhinos, hippos, crocodiles, giraffes, elephants, gazelles, antelopes, jackals, hyenas, cheetahs, panthers, bears, boars, leopards, camels, wolves, horses, lions, and ostriches. To give you a sense of the scale of nonhuman carnage: the emperor Trajan hosted a single set of games in which eleven thousand animals were slaughtered. In 1855 Richard Deakin published *The Flora of the Colosseum*, an illustrated botanical that chronicled the exotic plants—some otherwise extinct by the nineteenth century—that grew in the soil of the arena's ruins, originally sprung from seeds carried in the animals' fur. As for the scale of human death in the Colosseum, the classicists Keith Hopkins and Mary Beard, doing speculative math on the piecemeal evidence, guesstimate eight

thousand fatalities per year in the Colosseum alone, not counting the many deaths in lesser amphitheaters across the empire.[1]

Though Lucius Annaeus Seneca (ca. 4 BC–AD 65) just predates the Colosseum, he's entangled in the building's history in a small way. Born to a prominent Spanish family in Corduba (now Córdoba), Seneca was sent to Rome as a boy to study rhetoric and philosophy. He embarked on the *cursus honorum*, and his considerable talents shot him to prominence. After dodging the wrath of Caligula, he was exiled by Claudius on trumped-up charges of adultery and then called back to Rome to tutor Claudius's twelve-year-old nephew Nero. Though Seneca periodically tried to free himself from Nero, the rest of his life was bound up with the famously bad emperor for good and ill—though I'm not sure if the good parts aren't the ill parts and vice versa, for, as Seneca says to anyone who's constantly lucky in life, "I account you unfortunate because you have never been unfortunate."[2] Nero's tutor-adviser ended up having to compromise and humiliate himself in the imperial court. He also made a fortune, composed some of the most influential tragedies of all time, and wrote a series of Stoic works that manage to be down-to-earth, suave, and humane. Long wanting to be known as the Roman Socrates, he got something of the chance when Nero finally forced him to commit suicide. Seneca's death went as messily as Socrates's execution went smoothly. Whereas the Athenian Socrates discoursed on the immortality of the soul and died of his hemlock after cracking a joke, the Roman Socrates slit his wrists to not much avail and then took a dose of poison that didn't work either. Finally, Seneca sat in a hot bath until his opened veins flowed long enough to do the trick. How is Seneca connected to the Colosseum? Maybe had the Stoic been a better teacher, Nero would never have dreamed up the Domūs Aurea. Maybe had the irritating palace never been built, there'd have been no pressing need to put the Colosseum in its place. In Seneca's defense, a faculty of Confucius, Buddha, Jesus, and Mohammed would probably have failed to reform Nero.

Regardless of the dates, Seneca was well aware of the kind of

thing the Colosseum was built for. Long part of Roman culture, the games exploded during the empire. Because the military had become professionalized, and the martial energies of the Roman populace no longer had a direct outlet, it was easy for emperors to play on their subjects' love of spectacle. (Something similar can be observed in American football, a beautiful sport that involves disciplined regiments led by an on-field general trying to protect their territory and invade their opponent's. Football gains in popularity during decadent imperial periods when nostalgia runs high for the good old days of fighting a successfully mythologized war.) In Seneca's day, morning and afternoon shows involved orchestrated fights, some between humans, some between animals, some between human and animal, some recreating military battles of yore, some acting out mythological scenes—for instance, a woman and a live animal reenacting the story of Pasiphae having sex with a bull. At lunch the artifice was reduced to a bare minimum: criminals were thrown into the ring and forced to kill each other. The crowd preferred the chaotic halftime show. Seneca acidly observes in a letter to his friend Lucilius, "And why not? There is no helmet, no shield to stop the blade. Why bother with defenses? Why bother with technique? All that stuff just delays the kill. In the morning, humans are thrown to the lions or to the bears; at noon, they are thrown to their own spectators!"[3] This point distinguishes tragic art from violent spectacle. It's one thing to be awed by artistic grace and feel mixed emotions about any violence on display. It's another thing for the primary thrill to be the violence itself. Foreseeing the argument that the victims, having been sentenced to death, deserve their fate, Seneca turns the tables, "What about you? What did you do, poor fellow, to make you deserve to watch?"[4]

In another letter on the games, Seneca writes, "The human being, a sacred thing for human beings, is now killed as a sport and entertainment."[5] The clause "a sacred thing for human beings" (*sacra res homini*) expresses the Stoic principle of cosmopolitanism, the idea that all people, by virtue of their rational consciousness, are

citizens of the universe who deserve our full moral attention. To use the children of God as disposable objects for our enjoyment is a grotesque violation of morality, but it's not the problem Seneca focuses on in his letter. Our delight in the gladiatorial games is linked to the tyrannical power that we experience when our individual voices merge into a roar with the power to tilt the emperor's thumb. Experiencing first-hand the pull of the games, he says, "I become more cruel and inhumane, just because I have been among humans."[6] His main advice to Lucilius for not desecrating humanity is to stay away from crowds.

The mob's thrill at making and breaking people is the same type of whimsical cruelty Seneca witnessed first-hand with Nero, an emperor so warped that he had his own mother murdered. There's an exchange from Seneca's tragedy *Thyestes* between King Atreus and a faithful servant that sums up the corruption at the core of tyrannical power. It doesn't take much imagination to read it as a transcription of an actual conversation between Nero and Seneca.

ATREUS

The best thing about being king
is making folks accept whatever you do,
and even praise it.

SERVANT

If you force praise by fear,
hatred and fear come back around to you.
True glory, true respect, come from the heart
not from the lips.

ATREUS

Even a low-born peasant
can get true praise. But only the powerful
can get false praise. Let them want what they do not want.

SERVANT

A king should want the good, his wishes match his people's.

ATREUS

If rulers can only do good things, their rule
depends on the people's consent.

SERVANT

If there is no honor,
no reverence for law, no trust, no faith, no goodness,
the kingdom cannot stand.

ATREUS

Trust, faith, goodness,
are merely private goals; kings follow their own way.[7]

As twisted as it is to want false praise, it makes sense if you're in love with power. Anything less than false praise risks having an object higher than the ego. "Let them want what they do not want" (*Quod nolunt velint*): that phrase expresses the dehumanization of both the tyrant and those who void their character under his spell.

There was a time in my life when I found it odd that certain Roman emperors performed in the games. Why would the most powerful man in the world, I used to wonder in my innocence, humiliate himself just to get people's attention? Nero, for instance, engaged in chariot racing (at the encouragement of Seneca, who by that point was secretly wishing the perilous sport would take him out) and also sang and acted on stage, forcing his audience to act the part of enthusiastic spectators. Emily Wilson, in her biography of the philosopher, coolly observes, "Theatricality was the dominant mode of the age."[8] Experience has finally taught me the essential link between the whimsy of the dictator and the roar of the crowd. The medium where they join together offers an easy mysticism,

where the limited self merges with a corporate dominance. The ogre blathers on, and you look in vain through his crowd for a worried expression. In our own age of theatricality, the appeal of what we know as reality TV, rallies, and social media not only doesn't surprise me anymore—it strikes me as the very essence of tyranny.

What's the opposite of the viciousness embodied by the Colosseum? For Seneca, it's the virtuousness symbolized by the Three Graces, the muse-like goddesses depicted naked or in translucent gowns who dance in a row with entwined hands. Seneca interprets them as allegorizing the nature of gift-giving at its finest: "Some people advance the view that one of them stands for giving a benefit, one for receiving it, and one for returning it. Others hold that they represent three kinds of benefactors: those who confer benefits, those who return them, and those who accept benefits and return them at the same time."[9] They represent the circle of reciprocity at the opposite pole of our delight in destruction. The *Gratiae* (*Grazie* in Italian) are still honored in certain Romance languages every time a benefit is received.

Seneca's analysis of gift-giving is a startling prefiguration of a seminal book of anthropology, Marcel Mauss's *The Gift*, which also shows how gift exchanges bind people together with three interconnected obligations: to give, to receive, and to reciprocate. Our modern sentimental view, formed in response to selfish marketplace economics, is that giving is a selfless act. The truth, as Seneca and Mauss show, is both darker and brighter than that. Even in its best forms, there's an element of exchange in all giving. Let's say that I'm out with some friends at a bar. We don't buy our drinks individually. I offer to buy the first round (first Grace: the obligation to give). My friends feel obliged not only to drink up and say thanks (second Grace: the obligation to receive) but to buy a future round of drinks (third Grace: the obligation to reciprocate). Each round of drinks is purchased in a spirit of generosity, but it's a generosity that extends an obligation—a beautiful obligation in this case, but an obligation nonetheless. The friend who doesn't

get a chance to buy a round inevitably says, "I'll get you next time." If a friend makes a point of never reciprocating in any way (it obviously doesn't have to be buying drinks), the breakdown eventually undermines the relationship. In fact, the breakdown of gift-giving is what the undermining of a relationship mostly is.

Gifts and money, though they both involve exchange, work differently. In a financial economy there's a precise value to whatever good is exchanged. In gift exchanges it's the continual back-and-forth that's ultimately valued. Seneca goes so far as to advise us not to worry at all about the extent of the reciprocity: "What difference does it make to me whether I recover my benefits? Even if I recover them, they must be given again."[10] Once we enter into the exchange of gifts, we're bound to each other. In fact, part of what's nice about a money economy is that it frees its participants from always having to be in an infinite give-take-reciprocate relationship. Once goods are exchanged for cash, buyer and seller can go their separate ways without any further obligation. However, without thick zones of gift exchange encircling the marketplace and affectionately tying people together, society disintegrates into a nasty war of self against self.

Seneca writes about the Graces in a treatise entitled *On Benefits*. Meaning literally "good deed," a benefit (*beneficium*) refers to a central social practice: doing and returning a favor. Much of ancient Rome operated according to the darker side of gift-giving, comparable to the mafia in *The Godfather*. Vito Corleone does you a favor, and, as he puts it, "Someday, and that day may never come, I will call upon you to do a service for me."[11] Once Vito's favor has been bestowed, you're a "friend" under the mobster's protection, though you must now give unconditional respect to your Godfather and pay him tribute on a regular basis. Power in this context means the ability to give. It's about benefiting others with your money and status and thus increasing your power. In ancient Rome, it was the job of wealthy patrons to support clients (*clientes*) with favors of banquets, money, protection, and land. We've already talked

about Maecenas, a notable example, whose clientele included not just Horace but Virgil and Propertius among other less famous poets. Generally speaking, clients would show up in the morning in the atrium of the patron's house, make their requests, and sometimes accompany the patron around town as a way of showing off the extent of his entourage. In return for the patron's support, clients would offer their services to him: supporting his political agenda, accompanying him to war, composing him poems. Our word "patron" comes directly from the Latin word *patronus*, which is derived from *pater*; it basically means "Godfather."

Against this backdrop, Seneca begins his treatise, "There is almost nothing, I would claim, more harmful than our ignorance of how to give and receive benefits."[12] The problem is that Seneca's Romans focus on the benefits of possession and status rather than on the virtues of giving and receiving. The secret of a joyful life is generosity for the sake of generosity and gratitude for the sake of gratitude. Seneca says, "It matters not what is done or what is given, but with what attitude, since the benefit consists not in what is done or given but rather in the intention of the giver."[13] When we see people, institutions, and goods mainly in terms of how they benefit us, we corrode our humanity. Rather than strive to get attention, we should strive to pay attention. When we focus on the energy of giving itself, our otherwise selfish energies find constructive expression, and our power grows with our goodness. Here's how Seneca interprets the imagery of the Three Graces:

> And what about the fact that the group dances in a circle with intertwined hands? It is because a benefit goes through an orderly sequence, passing from hand to hand and yet returning to the giver, and loses its integral character if the sequence is at any point broken, being most beautiful if the continuity is maintained. In the dance, though, the older sister has a greater value, like those who confer benefits. The Graces have joyful expressions, just as those who give and receive benefits generally do.

They are youthful because the remembrance of benefits should not grow old. They are virginal because benefits are unspoiled, pure, and revered by all. Benefits should not be constrained or obligated—that is why the Graces wear loose robes. And the robes are translucent because benefits want to be in full view.[14]

The Graces in their loveliness symbolize what it means to hold humanity sacred. We'll soon see that Augustine enjoins you to love and do as you will. Seneca asks you to honor the Graces and do as you will.

When we're not joining in the dance of giving and gratitude, an abyss opens up in us that nothing can fill. We want more, more, more—more money, more things, more status, more distraction. We compare ourselves unfavorably with others, regardless of the blessings we enjoy. Greed and envy, the opposites of generosity and gratitude, open us to the tyrannical love of power itself, which finds an outlet in the whimsical making and breaking of people on display in the gladiatorial games. Insofar as we're interested in the good life, we have to withdraw from the crowd and transform its otherwise destructive energies into virtues generative of meaningful face-to-face relationships utterly opposed to the multitude's faceless roar. We're encircled by either the Graces or the Colosseum.

How well does Seneca do in living up to his Stoicism? The charge of hypocrisy has always dogged him. The case against him is that he denounces tyranny while teaching a tyrant, attacks wealth while amassing a fortune, inveighs against usury while charging interest, censures extravagances while throwing lavish dinner parties, recommends calm in the face of death while weeping at the loss of loved ones, and attacks the games right after attending them. As it happens, Seneca pleads guilty to the charge that he imperfectly practices what he preaches. He simply argues that he's trying. He isn't wise, but he's seeking wisdom. He may be sick, but he's trying to heal himself. Philosophy isn't a magic cure-all. It's not about having it all together. It's the activity of the soul in shaping itself.

It's about trying to find the best moral principles and integrate them into our lives. It's about the joy of growth, not the bliss of perfection. Part of philosophy's grace is its tolerant opposition to what's unreformed in human nature. We're encircled by the Graces *and* the Colosseum.

But I think there's another point to be made about Seneca's contradictions that speaks to the essence of Rome and how the collaged city magnifies the mind. Consider another big contradiction in Seneca. In the last book of Plato's *Republic*, Socrates says, "There's an ancient quarrel between poetry and philosophy."[15] Seneca lives that quarrel. Scholars beat their heads on the fact that his Stoicism preaches the triumph of reason over the passions, while his tragedies show the failure of reason to overcome the passions. One school of thought says that the plays are the psychological return of everything Seneca's Stoicism represses. Another school thinks that Seneca's poetry teaches us just how bad things get when reason fails. One of the central lessons of Rome is the fruitlessness of tying everything up. The truth is the whole, and the whole is broken. It's not just the crack in Seneca's soul; the crack crazes into his work. Seneca's tragedies express the state of being aghast and watching anyway. Seneca's essays hold in tension our wretchedness and our greatness. Are there contradictions? You bet. Like Rome, Seneca is greater for them.

A different take on the Colosseum and human nature, which represents the shift from philosophy to Christianity, is found in another divided thinker: Aurelius Augustinus Hipponensis (AD 354–430)—commonly known as Augustine of Hippo, St. Augustine, or just plain Augustine. Most of what we know of him comes from the world's first autobiography, Augustine's own *Confessions*, a long prayer about the sins of his life that culminates in a philosophical exploration of memory. Born to a pagan father and a Christian mother, he lived much of his life in Roman North Africa. Studying in Carthage as a teenager, he fell in love with philosophy

after reading Cicero's now-lost dialogue the *Hortensius*. Looking down at his mother's Christianity as quaint superstition, he was now in search of the truth, which first took him to Manicheanism, a synthesis of various religious traditions that regarded the universe as a battleground between the forces of good and evil. Augustine eventually went to Rome and established a school there but was put off by students who often skipped out on paying him. A friend hooked him up with a professorship of rhetoric in Milan. In both Rome and Milan, Augustine dabbled in Neoplatonism, a philosophy that holds we should make an intellectual ascent up the ladder of existence to experience divine oneness. Augustine did indeed catch a few glimpses of the radiance of ultimate existence, but he was disappointed at the fragility of mystical experiences. In Milan, after having met Ambrose, a Christian who could express the truths of the religion with intellectual force, Augustine started to see Christianity as a living option, though he struggled with adopting its strictures. After a period of inner turmoil, he had a conversion experience and went on to become arguably Christianity's most influential theologian. Until his death from sickness while the Vandals were sacking his city, his last few decades were spent as bishop of the seaport Hippo, now Annaba in Algeria, where he delivered numerous sermons, composed his philosophical masterpieces, and battled against Christian sects that he regarded as heretical.

The passage from Augustine's *Confessions* about the Colosseum involves Alypius, a former student turned friend, who traveled from Africa to Rome to study law. When his buddies found out that he disdained the brutality of the gladiatorial games, they put Alypius's convictions to the test, dragging him with "friendly violence" to a show at the Colosseum. Refusing to enjoy himself, Alypius kept his eyes squeezed shut. But when one of the gladiators was about to be laid low, the crowd roared, and curiosity got the best of the young philosopher. Here's Augustine (remember, he's talking to God):

[Alypius] was struck in the soul by a wound graver than the gladiator in his body, whose fall had caused the roar. The shouting entered his ears and forced open his eyes. Thereby it was the means of wounding and striking to the ground a mind still more bold than strong, and the weaker for the reason that he presumed on himself when he ought to have relied on you. As soon as he saw the blood, he at once drank in savagery and did not turn away. His eyes were riveted. He imbibed madness. Without any awareness of what was happening to him, he found delight in the murderous contest and was inebriated by bloodthirsty pleasure. He was not now the person who had come in, but just one of the crowd which he had joined, and true member of the group which had brought him. What should I add? He looked, he yelled, he was on fire, he took the madness home with him so that it urged him to return not only with those by whom he had originally been drawn there, but even more than them, taking others with him.[16]

Doesn't Seneca's advice about crowds seem on point? But the key line in this passage, which signals the shift from philosophy to Christianity, is about how Alypius "presumed on himself when he ought to have relied on you." The point is that no matter how wise and committed you are, you're never going to be saved without the grace of God.

The reason for the necessity of God lies in Augustine's conception of sin. The philosophical tradition prior to him understands moral failing as the result of ignorance or weakness. We do wrong because we misperceive what's really good, or because our willpower is too feeble to carry out what we know to be right. The proper response is to discipline our mind and build up our resolve. But Augustine holds that we have something in us that does wrong *because it's wrong*. Self-improvement will always be insufficient, because there's more to the story than our failings. Given our perversity, we're just not going to be able to save ourselves. The proper response to sin is to give ourselves over to God in a radical act of humility.

Augustine clarifies his idea about sin with a story of how as a teenager he and some pals, bored one night, got the idea of breaking into a neighbor's yard and stealing pears from his tree. They carted off every last one, nibbling on a few but throwing most to the pigs. Augustine doesn't see how the standard philosophical theory of wrongdoing can account for the allure of crime itself. "My desire," he says, "was to enjoy not what I sought by stealing but merely the excitement of thieving and the doing of what was wrong."[17] The kind of thing we generally write off as a teenage prank reveals to Augustine a brokenness in human nature.

The Confession's pear story echoes the Bible's apple story. Adam and Eve eat of the fruit not because they're hungry, but because they want to be like God. Our delight in crime is based on refusing to be dependent on anything higher than ourselves. This choice of evil for evil's sake warps human nature. According to Augustine, ever since the emergence of human consciousness symbolized by Adam and Eve's transgression, sin is passed down genetically through semen. In a twist that explains Jesus's divinity, Augustine reasons that the only way someone could be free of sin would be to have a virgin for a mother. Those of us whose moms conceived us in the normal manner are sinners from the get-go. To help Augustine recall his depravities, the Confessions begins with descriptions of infants as little tyrants who whine and cry until free people slave for them. He sees in babies all the evil of human history in germinal form. Iniquities like stealing pears or cheering on the Colosseum's violence are mostly just a matter of gross motor development. Augustine notes one baby who's jealous whenever his brother is nursed. It's not that the kid is hungry or neglected. Little Cain just doesn't like the fact that little Abel is temporarily getting all the attention. Augustine's observations put me in mind of what Leo Rosten said of his pal W. C. Fields: "Anyone who hates dogs and babies can't be all bad."[18]

The Confessions deals with a state of brokenness similar to what we just saw in Seneca—in this case, being open to Christianity but

unable to practice it: "The self which willed to serve [God] was identical with the self which was unwilling. It was I. I was neither wholly willing nor wholly unwilling. So I was in conflict with myself and was dissociated from myself."[19] The big difference is that the Stoic regards the gap between our givenness and our ideal as the condition of self-improvement, whereas the Christian regards it as a sickness to be endured and hopefully cured for the sake of salvation.

Whereas Alypius is addicted to violent spectacle, Augustine is addicted to sex. He has a longtime live-in concubine, the mother of his only child. When he's finally betrothed to a more fitting mate, his concubine must be sent off. Because his fiancée is only ten years old, he has to wait two more years until she's of marriageable age. In the meantime, Augustine considers procuring another concubine: "I thought I would become very miserable if I were deprived of the embraces of a woman."[20] He accepts intellectually that chastity would be the right choice for him, but he can't bring himself to give up sex. He famously prays, "Grant me chastity and continence, but not yet."[21]

Violence and sex are chief among the attractive forces of what Augustine calls the "Earthly City," which refers not exactly to actual communities but to any time we put self-love before the love of God—which just happens to be the common state of most actual earthly communities. Citizens of the Earthly City are driven by what he identifies as the *libido dominandi*, the egotistical will to dominate others. The idea is that when you don't serve God, you try to make others serve you—and are angry or envious when you're forced to serve.

When Augustine looks at Rome, he sees a whole lot of the *libido dominandi*. We sometimes portray this moment in history as free-spirited, sex-positive pagans versus dour, repressive Christians. But the truth is that ancient Rome had a brutal system of punishments like crucifixion and live burial, an exploitative economy powered by slave labor, a violent entertainment industry on full display in the Colosseum, a proud culture of colonization and plunder, and

an entrenched hierarchy of sexual abuse that included tossing aside unwanted wives and concubines, raping slaves on a regular basis, and forcing anal sex on unsuspecting boys. The Christian strictures on partying, marriage, sex, and homosexuality were much closer to Me Too reforms than Victorian uptightness.[22] There was a vast number of people—women, young people, slaves, gladiators—whose bodies and lives didn't belong to them. A big part of the good news of Christianity was that the vicious old days were over and nobody was disposable.

Because we're driven by what we love, the truth isn't going to be established in our souls by rational argument. The forces of power and sex are just too strong. At best the work of reason can humiliate our pretensions and make a spiritual clearing where we can wait for grace. What we need is a radical change in the object of our love, a conversion, which is what Augustine experiences in AD 386 in a garden in Milan where he's hanging out with Alypius. Humiliated at how little control he has over his sexual drive, Augustine slinks away from his friend and breaks down in tears. Suddenly hearing a child's voice chanting, "Pick up and read, pick up and read," he hurries back to Alypius, picks up Paul's letter to the Romans (nota bene: Romans), and randomly reads: "Not in riots and drunken parties, not in eroticism and indecencies, not in strife and rivalry, but put on the Lord Jesus Christ and make no provision for the flesh in its lusts."[23] A wave of relief washes over Augustine. He is understood. He is loved. After he tells his friend of the mystery of grace, Alypius marvels at the passage and reads on, "Receive the person who is weak in faith." Amazed at God's love, he too converts to Christianity.

What's the essence of being a Christian? Jesus boils it down to two commandments: "Thou shalt love the Lord thy God with all thy heart, and with all thy soul, and with all thy mind," and, "Thou shalt love thy neighbor as thyself."[24] Augustine's way of putting it is, "*Dilige et quod vis fac*" (Love and do what you will).[25] Note that he's not saying, "*Ama et quod vis fac*," which would describe his behav-

ior prior to conversion. The verb *amare* (singular imperative: *ama*; noun: *amor*) means "to love" in the sense of sexually desiring or having affection for (by the way, after converting Augustine breaks off his marriage and gives up sex). *Diligere* (singular imperative: *dilige*; noun: *dilectio*) means "to love" in the sense of esteeming or caring for. Augustine's point is that whatever we do, we should esteem God and care for humanity. Doing what we will in the state of love certainly doesn't mean that anything goes or even that we should always be nice. The analogy Augustine uses is that we should treat others sort of like how loving parents treat their offspring. Good parents engage in all actions, including chastisement and punishment, with care for their children. Likewise, we must sometimes criticize and discipline people but never forget to hold their humanity sacred. Our moral laws, as important as they are in checking our sinful personalities and pointing us in the direction of justice, should always serve this higher sense of love. In those brief flashes when our soul embodies charitable love, we don't even need moral codes—the strict goodness of God flows naturally.

A few brief decades before Augustine's birth, Constantine's Edict of Milan legalized Christianity in AD 313 and set in motion the Christianization of the Roman Empire. Henceforth, every emperor—with the interesting exception of Julian the Apostate—was Christian. But many Roman citizens were still attached to polytheism, believing its rituals were essential to staying on the good side of the universe's invisible forces. Others, like Alypius and Augustine prior to conversion, flirted with philosophical versions of polytheism, disdaining its superstitious elements but regarding it as having a metaphorical truth and a social usefulness. In Augustine's time, as Christianity was gaining prominence, a series of imperial edicts tried to stamp out paganism (the term "pagan" is a translation of *paganus*, which probably derived from *pagus*, meaning "country bumpkin," because the old religion lingered in rural areas). The backlash included not only vigorous intellectual debates but anti-Christian riots. In the meantime, the army of Alaric, the

Visigoth king (a Christian himself), was moving against Rome. Pagans and Christians alike appealed for divine intervention. If either the gods or the saints were listening, they didn't care. Rome fell to the Visigoths in AD 410.

Social conservatives made the argument that Rome's sacking was due to Christianity's demolition of time-tested values. Probably more to console demoralized Christians than to convince indignant polytheists, Augustine rebuts the argument in his most ambitious work, *The City of God against the Pagans*. To make sense of human history, we must see it as torn between the Earthly City, the fallen human condition driven by self-love, and the Heavenly City, a.k.a. the City of God, the redeemed human condition steered by charitable love. If Babylon symbolizes the Earthly City, and Jerusalem the Heavenly City, Rome symbolizes history itself, the human condition compounded of Babylon and Jerusalem. Christianity didn't bring about the sack of Rome. What Christianity brought to the empire is salvation—not the earthly success of its people but the possibility of their heavenly happiness. Augustine is under no illusion that any political regime can ever overcome the *libido dominandi*. Life as we know it is a perpetual conflict between the value systems of the Earthly City and the Heavenly City. Until God's kingdom is finally established, there will be twists and turns of fortune, and the good guys won't always win. The City of God, which ideally should be represented on earth by the church, is a light to guide the pursuit of justice in the squalid mess of history.

In one sense, Augustine is progressive. He adopts an upstart religion and brings an African sensibility to Rome. In another sense, Augustine is conservative. He regards the best of established law as a check on human nature and brings Roman policies back to Africa. He draws heavily on traditional philosophy to formulate a revolutionary theology. His intellect is layered with Ciceronian humanism, Manicheanism, Neoplatonism, and Christianity. How his philosophy blends and scrambles old and new reminds me of Rome itself. In a memorable passage in the *Confessions*, Augustine

says, "Late have I loved you, beauty so old and so new: late have I loved you."²⁶ He's talking about how for most of his life he loved the creations of God without loving the true beauty of their creator. It's easy for me to apply that passage to Rome. Though its cultural and linguistic effects are everywhere, people like me come late to the ancient city and find what's oldest anew. Even when we've seen the sites, we haven't necessarily seen what the Eternal City is. Rome embodies the mystery of memory, what Augustine calls the "stomach of the mind."²⁷ Like our memory, the city digests things subconsciously, binds together disparate moments, inexplicably sustains identity, gives opportunities for grace, excretes a lot of junk, and sometimes throws up unexpected fragments.

As hard as it was for Christians like Augustine and Alypius to overcome their addictions to sex and violence, the great feat of Christianity in the Roman Empire was to stop wondering about things like the ethics of pleasure and spectatorship and to start identifying with the people whose bodies and lives had been legally stripped from them. Jesus commands the faithful to take up their crosses and follow him. After centuries of weakly allegorizing this injunction, it's easy for Christians to forget that it was once taken to mean actually submitting to the brutality of an unjust system as a way of doing spiritual jujitsu on it. Prior to the Edict of Milan, Christians commonly subjected themselves to crucifixion and a host of other vicious penalties—stoning, beheading, flaying, even grilling (St. Lawrence is reported to have said, "Turn me over; I'm cooked on that side"). Historians now doubt that Christians as such were executed in the Colosseum, but there's a shred of evidence for the long-standing legend. Here's how St. Ignatius of Antioch (ca. 108–40), as he's being transported to Rome for execution, anticipates in a letter what was going to happen to him: "Let me be fodder for the wild beasts; that is how I can get to God. I am God's wheat and I am being ground by the teeth of wild beasts to make a pure loaf for Christ . . . Come fire, cross, battling with wild beasts, wrenching of bones, mangling of limbs, crushing of

my whole body, cruel tortures of the devil, only let me get to Jesus Christ."[28] The spiritual reversal worked up to a point. The Roman attempt to shut down Christianity with merciless punishments backfired. The believers' brave nonviolence in response to state-sanctioned, socially accepted sadism made visible the cruelty in the system, earned the admiration of the Roman elite, and won over the downtrodden.

So, what are we supposed to do with the violent pathologies of being human? The basic choice posed by Stoicism and Christianity is between gradualism and radicalism. Stoics see our failings as a function of just how mixed up we are about what's truly good. Christians see our sins as the result of an inherent evil. Stoics don't like guilt. What's the point of guilt? We're all works in progress. Christians begin with guilt. How can we not be guilty before the tribunal of ultimate justice? Guilt opens the door to repentance and radical reformation. The Stoic job is to live the examined life, revising our judgments through cognitive therapy and philosophical friendship. The Christian task is to live the holy life, confessing our sins and throwing ourselves on the mercy of God and a sanctified community. Because we're all struggling confusedly to do good, Stoicism recommends moral strictness with ourselves and compassionate understanding for others. Because we're all involved in personal and structural evil, Christianity recommends harsh judgment of all sins but extensive forgiveness of all sinners.

Stoicism is eminently realistic and reasonable. Pathologies like crime or the games embody a paradox for the Stoics. On the one hand, they're to be accepted as an expression of humanity. On the other hand, their viciousness is to be condemned as a violation of humanity. Marcus Aurelius, for instance, was disgusted by the violence of the Colosseum, but as emperor he allowed the games as a distraction for plague-fatigued citizens, though he tried to reform them to reduce their viciousness. Given the brutality of human nature, the cost of Stoic acceptance is high. It's easy for us in the ruins of the Colosseum—perhaps not wrong, but incredibly

easy—to criticize the Stoics for not radically opposing things like the games or slavery. But there's something profoundly sensible about the Stoic idea that we're all compromised, individually and culturally, and that the pursuit of wisdom and goodness means that our great mission in life is to make gradual improvements while also finding joy in the world as is.

By being less realistic and less reasonable about the human condition, Christianity is arguably more beautiful than Stoicism. A new kind of love is born, one that finds expression in humility and sacrifice. Not only is there the care of the downtrodden, there's the idea that we're all downtrodden, which is the kind of amazing grace that saves wretches like you and me. But the cost of the Christian ideal is also high. Christendom has not exactly been a shining example of holding humanity sacred. Beautiful as an inspiration for underdogs, Christianity is usually ugly as a religion of the privileged. The *libido dominandi* is such that the powerful are corrupted when they believe themselves to have a cosmic get-out-of-jail-free card. All human ideals produce hypocrisy, but Christianity among the upper classes, with rare exceptions, produces a particularly repellant variety, where people amass wealth and status while swearing on scriptures that call for poverty and humility. Plus, when we have no sanctioned outlet for our violent tendencies, our destructive energies get pushed underground where they do tremendous harm: we torture ourselves with guilt and torture others in the name of justice. Originally an antimoralistic religion, Christianity is somehow prone to obnoxious moralism. It's easy to do evil when you're saving other people's souls. If we take the terms in their philosophical sense, it's probably wise to have some Stoicism tempering your Christianity or some Christianity tempering your Stoicism.

Philosophy and religion have been trying for quite a while to teach the violent part of us to hold humanity sacred. There's a stubborn Nero in the human soul that I'm just not sure is educable. There's an oft-quoted sentiment attributed to the Venerable Bede in the eighth century: "As long as the Colosseum shall stand, Rome

too shall stand; when the Colosseum falls, Rome too shall fall; when Rome falls, the world shall fall as well."[29] It's likely that he wasn't talking about the Flavian Amphitheater but the Colossus of Nero—which did indeed fall! Well, I guess the world came to an end a long time ago! But if we take the statement in its usual way, couldn't we interpret it allegorically to mean that violence will be our fate until the Earthly City is given the big thumbs-down by God? Seneca, in that letter where he bemoans how humans are killed for sport, compares good relationships to an arch, the kind the Romans used as the architectural basis for their arenas, for an arch "would collapse without the stones' mutual support."[30] It is astonishing how the arches of the Flavian Amphitheater have withstood centuries of earthquakes, erosion, and plunder. Perhaps those who seek the good life should ignore the Colosseum's function and learn from its form.

DETOUR PAST OVID'S FINE ART OF GETTING A ROMAN LOVER TO HIS FINE ART OF GETTING RID OF A ROMAN LOVER

Publius Ovidius Naso—we know him as Ovid (ca. 43 BC–AD 17) —says that he was exiled from Rome because of "a song and a mistake."[31] The song was the *Ars Amatoria*—literally the *Art of Love*, though its meaning would be more accurately conveyed by *A Seduction Manual for Playboys and Playgirls*. "Do what you will and make love" was Ovid's philosophy. It did not sit well with Caesar Augustus and his imperial plan for discouraging fornication.

Ovid's poem remains subversive. Conservatives and progressives alike still want to exile him! Is the problem, as conservatives hold, that it's accurate about human nature and hence sexually corrupting? Or is the problem, as progressives hold, that it's sexist about human nature and hence politically incorrect? Or maybe you're the kind of person who'd rather have a Roman lover than be either progressive or conservative? In any case, when we look

past the poem's satire and cheekiness, here's the gist of his advice
for a man seeking a woman:

- Keep your fingernails clipped and clean, have a professional
 cut your hair, wear clothes that fit, and try not to smell bad.
 Otherwise, don't be a dandy.
- Go to places where there are lots of women—parties, shows,
 houses of worship—and let chemistry be your guide. (Roman
 sites should be treated as pickup centers.)
- Strike up casual conversations and seize opportunities to be
 helpful.
- Drink wine but not so much that it impairs your eye for
 beauty.
- Cultivate a little mystery and danger, because a woman thrills
 to stolen passion.
- Play to your strengths: confidence is attractive.
- Gently brush up against her when you can.
- Win over her girlfriends to your cause.
- Promise to give her things—but be careful about letting her
 fleece you.
- Educate yourself and woo her with whatever eloquence
 you can muster, because "all women fancy themselves a love
 object."[32]

And here's his basic advice for a woman trying to snare a man:

- Live it up when your natural charms are at their peak: they'll
 fade sooner than you think.
- Shave your armpits and legs, keep your teeth clean, and
 wear makeup in a way that doesn't seem like you're wearing
 makeup.
- Hairstyles matter—but don't be too fussy, as a few loose curls
 are sexy.

- Dress to enhance your best parts and downplay the rest; a little strategic bare flesh works wonders.
- Study the arts to polish your charms.
- Strut your stuff: make him come to you.
- Exchange written messages, because they enflame a man's desire.
- Drop hints about how much you're desired by others, even if they're not true, because jealousy also enflames a man's desire.
- Arrive late to parties: expectation, darkness, and soft lights are your friends.
- When making love, use taboo words and moan in pleasure, even if you're faking—though hopefully you're not. Ovid notes, "Men and women should share the same / Pleasures. I hate it unless both lovers reach a climax: / That's why I don't much go for boys."[33]

(As his comment about boys indicates, socially accepted sex wasn't exclusively between a man and a woman. But homosexual sex, at least the kind that was openly discussed, involved little seduction and often involved a man penetrating a teenage boy.) Once your seduction is successful, Ovid's advice for maintaining a relationship is regular sex, as it helps partners overlook each other's misdeeds. "When she's been raging at you, when she seems utterly hostile, / Then is the time to try an alliance in bed. She'll come through. / Bed's where harmony dwells."[34]

When your affair lands you in trouble, you can turn to Ovid's sequel to *Ars Amatoria* called *Remedia Amoris*—literally *Remedies for Love*, though it could be not unreasonably translated as *Fifty Ways to Leave Your Roman Lover* ("Hop on the bus, Publius"), as Ovid's style is ever light and allusive. It's meant for men and women alike.

- Get out early, as soon as you sense there's a problem: it's just going to get worse.

- If you're having troubles breaking free, dwell on your lover's bad traits.
- If the situation is dire, choose a position for sex where you can focus on your lover's ugly parts.
- If you're still smitten, pretend you're not: fake it till you unmake it.
- Don't reread love letters. Burn them, if you have the heart.
- Don't read love poetry—even Ovid's.
- Dwell on your nonromantic problems.
- Either don't drink wine or else hit the bottle hard: anything in-between will land you back in bed.
- Once you're out, keep busy and social: time on your hands is self-torture.
- Aim for friendly indifference, as hatred and strife keep love kindled.

If you're not confident that Ovid's ancient advice will work, there's a well-known modern trick you might try. Turn your back to the Trevi Fountain and throw a coin with your right hand over your left shoulder: it guarantees that you'll return to Rome—first things first. Then, throw a second coin over your shoulder: it'll bring you a Roman lover. If you return to the fountain in the midst of your affair and throw a third coin over your shoulder, it means that you'll get married (we moderns tend to be sentimentalists about love affairs), though I've heard cynics say that the third coin is for getting rid of your Roman lover (maybe it amounts to the same thing). But if you're considering the coin method, here's what Ovid has to say on the subject, "Witchcraft's ways are outdated . . . Never rely on magic, never trust a spell"—advice published in AD 2.[35]

What was Ovid's mistake? Nobody knows for sure what the error behind his exile was, but some evidence points to his having used the fine art of seduction on the emperor's daughter—or maybe even granddaughter.

THINGS TO SEE AND CONSIDER:
ROME AS HOLINESS

When Augustine's beloved mother Monica was planning her first trip to Rome, she complained to the bishop Ambrose that the Eucharist was being celebrated in different ways in different places. His reply has become famous, "When in Rome, do as the Romans do." If you want to see where Monica died, take a thirty-minute tram ride from the Piramide metro station (next to the **Pyramid of Cestius**) to **Ostia Antica**. The ruins of this old port city, where Augustine and Monica had a conversation that led to a shared mystical vision before her death, are in many regards more interesting than those of Pompeii. The on-site museum has many fine sculptures, including a **Three Graces** from Seneca's time. You can also climb around in several **Mithraea**, cave-like temples of a mystery cult that I discuss in the next chapter. It's worth finding the menorah relief on a column in the ruins of the **Ostia Synagogue**, one of the world's oldest synagogues. Though Augustine's mother was originally buried in Ostia, Monica's tomb has been moved to the Roman church named after her son: **Sant'Agostino in Campo Marzio** (aspire to be a philosopher whose mother is well remembered!). The church—with a facade built out of stone appropriated from the **Colosseum**—contains Caravaggio's *Madonna di Loreto*, Raphael's *Prophet Isaiah*, Bernini's *Two Angels* sculpture above the high altar, and Guercino's *St. Augustine, St. John the Baptist, and St. Paul the Hermit*, where Augustine's upward-pointing finger is suggestive of Plato in the *School of Athens*. Among other places in Rome, portrayals of Augustine can also be seen in the **San Clemente's Catherine Chapel**, where he's among the four "doctors of the Church" along with Gregory, Jerome, and Ambrose (the bishop to whom Monica complained), as well as Raphael's *Disputation of the Sacrament* in the Raphael Rooms of the **Vatican Museums** (Musei Vaticani), where he's among the four doctors flanking the Eucharist. If you're seeking *sapienza* (wisdom),

a lovely place near Sant'Agostino is **Sant'Ivo alla Sapienza**, one of the city's architectural wonders, designed by Francesco Borromini. If it's a test of your holiness to find it when it's open, I've often failed! (Try Sunday morning.) Stefano Maderno's *Martyrdom of St. Cecilia*, a baroque masterpiece in **Santa Cecilia in Trastevere**, is a haunting sculpture of the uncorrupt body discovered when the tomb of the saint, martyred in the second century AD, was opened in 1599. Is her corpse's incorruptibility proof of holiness or just an accident of its conditions? (The body has now rotted, I assume.) However, if your goal in Rome really is holiness, the churches may not be optimal. Corruption of the divine is a tradition almost as old as corruption of the body, so the power that raised them isn't always compatible with holiness. Romans sometimes say that the ubiquitous SPQR—the ancient abbreviation for *Senatus Populusque Romanus* (Roman senate and people)—actually stands for *Soli Preti Qui Regnano* (Only Priests Rule Here). At passing priests Roman prostitutes can sometimes be seen making a sign to ward off the evil eye. Because the holy and the unholy are so scrambled in the Eternal City, another possibility is *Sono Pazzi, Questi Romani* (They're Bonkers, These Romans). As places devoted to holiness go, you might try the **Great Synagogue** (Tempio Maggiore) in what was once the Ghetto. The **Jewish Museum of Rome** in the Great Synagogue's basement narrates the tragic, heroic history of the Jewish community in the Eternal City, which begins well before all Christianity. In the neighborhood of Trastevere, you occasionally stumble on *Stolpersteine* or *pietre d'inciampo* (stumbling stones) that record where Holocaust victims were forced from their homes. But if you insist on a church for your holiness, I recommend the just-mentioned **San Clemente**, which we will now spelunk.

9

CRASH THROUGH
THE FLOOR

The Mysteries of the Basilica of San Clemente

We keep crashing through the floor ... into the cellars of
time, even while we imagine ourselves to be occupying the
top floor of the present.

ROBERT MUSIL

In 1848, Joseph Mullooly, the Irish Dominican abbot of the Basilica
of San Clemente, began to suspect that his church was not the Basil-
ica of San Clemente—at least not the original one. Even though
everyone referred to it as the Roman church dedicated to St. Clem-
ent in the late fourth century, its architectural style didn't seem
quite right. Plus, old histories suggested it had been rebuilt. Could
it be that the current Basilica of San Clemente was constructed
atop the old Basilica of San Clemente? Could there be a disappeared
building under his very feet? That same year famously brought, in
Mullooly's words, "sacrilegious revolution," which delayed research

FIGURE 9.1 · Apse Mosaic (ca. AD 1130), Basilica of San Clemente. A little over a century after this mosaic was made, Thomas Aquinas was summoned to Rome by Pope Clement IV and wrote, "The Son in turn is the Word; not, however, just any word, but the Word breathing Love; the Word as I want the meaning understood is a knowledge accompanied by love." Aquinas, *Summa Theologiae*, vol. 7, *Father, Son and Holy Ghost*, ed. T. C. O'Brien (Cambridge: Cambridge University Press, 2006), 223.

into his conjecture.[1] It wasn't until 1857 that the abbot, with a small team, began to dig through the walls into the foundation.

After years of hauling out dirt and debris, one hundred and fifty thousand cartloads of it (as is usual in Rome, their digging turned up statues, shards, inscriptions, sarcophagi), they uncovered the bones of a large basilica similar in structure to the one it supported. Every wall they dusted off revealed a fresco of pious wonder. One showed a mother reaching for her child in a temple encircled by fish and octopuses. The Dominican abbot recognized the anchor next to the child as a reference to St. Clement, whose martyrdom was being drowned in the Black Sea. The story goes that when its waters receded, the saint's body was discovered in a tomb built by angels. The fresco they dusted off was of a subsequent miracle. A child who'd disappeared in an ebbing tide was found a year later in Clement's underwater temple, safe and sound. Mullooly was right! He'd parted the ocean of history and revealed the original Basilica of San Clemente. Its art had miraculously survived, relatively safe and sound.

The excavations weren't over. The team's work revealed a staircase in the ancient church—going down. They eventually unearthed another building under the buried basilica: an ancient complex with walls of elaborate brickwork (there's an argument over whether it was primarily an apartment, an imperial mint, or a warehouse). In one of its many rooms was a statue of a man emerging from a rock, an image of the miraculous birth of Mithras, the central god of an ancient mystery cult that once competed with Christianity. The abbot was shocked.[2] The church his church was built on was built on a pagan temple! Mullooly, whose remains are under the high altar of the lower church, didn't live to see his successor's excavations reveal evidence of a fourth level, an earlier republican-era building destroyed in the great fire in AD 64, the one that Nero blamed on the Christians.

In *Civilization and Its Discontents*, Sigmund Freud pictures the human mind as a fantastic Rome "with just as long and varied a past,"

where earlier stages of development magically survive alongside the new construction.[3] Freud's fantasia is close to being realized in San Clemente: a twelfth-century Christian church with fifteenth-century frescoes and an eighteenth-century ceiling, built atop a fourth-century Christian church with eleventh-century frescoes, built atop a first-century Roman complex used for a Mithraeum, built on the charred remains of a republican-era house. In Freud's thought-experiment, all you have to do is squint your eyes to see the unfallen originals. All you have to do in San Clemente is pay a small fee and go down the stairs. I have no idea why it's not one of the most popular sites in Rome, as it has more wow-factor than the Colosseum and the Trevi Fountain put together. Perhaps we still haven't found its lowest level: through a hole in the wall of the deepest room a spring can be heard burbling under the stacked buildings. If you let San Clemente get to you, you start feeling like you're always in a future basement.

Why was the Basilica of San Clemente built atop the Basilica of San Clemente? The standard theory is that the old church had to be rebuilt after a fire tore through the neighborhood when a Norman army sacked the city in 1084. The big problem with this theory is that there's no evidence of fire damage in the old church. Another theory—it's a little complicated—is that the church was filled in and built over because of politics. After Pope Gregory VII excommunicated the Holy Roman Emperor Henry IV, a pro-imperial synod responded by declaring a new pope: Pope Clement III, officially considered an antipope by the Catholic Church. After his burial in Rome, his body was exhumed and dumped into the Tiber as an act of *damnatio memoriae*. The art historian Lila Yawn suggests that the cult around Clement III then looked for a surrogate place to revere his memory—and went to San Clemente. Not only did the Clements share a name, they shared a fate: Clement I was buried in the Black Sea, Clement III in the Tiber. Because of the antipope's accidental but powerful associations with the church, it had become "symbolically dangerous."[4] The theory goes that it was

then destroyed and overbuilt with a new church that restyled Clement I to emphasize his piety and downplay his institutional power.

Why was the old church built on a Roman complex containing the temple of a mystery cult? Mithraism was a vibrant force in the cosmopolitan diversity of Roman religion from the time it arose in the first century to when Constantine's Edict of Milan legalized Christianity in the beginning of the fourth century. By the end of that century, when Theodosius began to promulgate decrees to outlaw paganism, Mithraism was close to extinction. Christians took over the complex, filled it in, and erected a basilica dedicated to St. Clement. The mystical religiosity of polytheism had been buried and resurrected as Roman Catholicism.

The roots of Roman Mithraism reach back thousands of years into the deep worship of the Indo-European divinity Mitra, appropriated by Zoroastrianism as a god of light waging war against the force of darkness. The cult sprang into existence in Rome or maybe Ostia in the first century AD. (The term "cult" is used here not to be dismissive but to say that Mithraism, like other mystery cults of the time, wasn't a full-fledged religion. It was a social option with a strong personal component within a polytheistic religious system that was mostly expressed in a public culture of myths and rituals.) Though women participated in other mystery cults, Mithraism involved small groups of highly-regimented men, often soldiers, who met in subterranean temples, designed as microcosms of the universe, for sacred meals in front of what's called the tauroctony, an image of Mithras slaying a bull. The primary ritual involved seven ascending grades of initiation, symbolized by a raven, a bridegroom, a soldier, a lion, a Persian, a sun-runner, and a father. Because what we know about Mithraism is based almost exclusively on the ruins of temples scattered from the Black Sea to Britain, please append a big "maybe" to all I've just said about it!

One thing we can say with confidence about mystery cults like Mithraism is that they were a mystery. Their members were sworn to secrecy, which is part of why we know so little about them. The

initiation ritual at their center shouldn't—and maybe can't—be told. Besides the Cult of Mithras, important mystery cults in Rome included the Cult of Magna Mater (the Great Mother), the Cult of Isis (an Egyptian goddess), and the Cult of Dionysus ("every drinker in fact could claim to be a servant of this god," according to Walter Burkert).[5] Their belief system had something to do with reconceiving death as a stage in a holy sequence. Consider the history of that deity in the wineglass—of whom Ovid says, "No god is closer."[6] After grapes are born and ripen, they're plucked, tortured (their guts are stomped out), and left for dead. Then they're resurrected in glory as Chianti.

What was the central experience of the mysteries? It's basically that same transformative trek as those grapes through death and rebirth. The closest we have to a first-hand description is Apuleius's second-century novel the *Metamorphoses*, popularly known as the *Golden Ass*, which I explore at greater length in the next chapter. After describing a stage of purification, here's how he evokes the visionary experience ("I shall continue to report only what can without sin be revealed to the minds of the uninitiated"):

> I approached the boundary of death and placed my foot on
> Proserpina's threshold. I made my way through every level
> of the universe and back. In the middle of the night, I saw the
> sun flashing in the purest brightness. I came face to face with
> the gods below and the gods above. In unmediated nearness,
> I worshiped them.[7]

Apuleius doesn't report the means of achieving the mystical state at the heart of the initiation. All he says is that the rite is "a species of voluntary death . . . a rescue granted in answer to prayer."[8]

Compare Apuleius's account of an initiation with Richard Boothby's account of a psilocybin journey cited in Michael Pollan's *How to Change Your Mind*, a book about contemporary research into psychedelics.

I conceived that I was either dying or, most bizarrely,
I was already dead . . . I felt all my organizing categories of
opposition—dreaming and wakefulness, life and death, inside
and outside, self and other—collapse into each other . . . Reality
appeared to fold in on itself, to implode in a kind of ecstatic
catastrophe of logic.[9]

Pollan discusses how psychedelic experience is used to reconcile
people with mortality. The mysteries, according to Cicero, are
about learning "a way of living happily and dying with brighter
hopes," and that "death is not only not an evil, but a good."[10] Some
scholars and drug enthusiasts have gone so far as to hold that hal-
lucinatory substances played a role in mystery cults.[11] It wouldn't
surprise me. But it also wouldn't surprise me if these groups had
figured out other tricks for voyaging beyond the ego. The essence
of all profound experience is a "trip," a journey, the paradox of
getting out of the self to transform the soul. In a sense, mystics are
the original tourists, returning from their trips with tales of what
lies beyond. I should also emphasize that the mysteries weren't an
isolating experience. They knit together a community.

The subjects of How to Change Your Mind speak of their trips as
revelations of universal love. Pollan quotes a cancer patient who
tells of being "bathed in God's love," and a life coach who says,
"The core of our being, I now knew, is love." During his own LSD
hallucination, Pollan mutters to his guide, "All this time spent
worrying about my heart. What about all the other hearts in my
life?"[12] The inmost experience of the universe seems to say, "Know
I am love and do as you will." Since life normally presents itself
more as a vale of tears than a triumph of love, enthusing about all
the hearts in your world can seem like holding up a Hallmark card
against a shotgun. Could this be why mystery cults prohibited their
initiates from talking about their initiation? The ancient scholar
Macrobius says, "Plain and naked exposition of herself is repugnant
to nature . . . She wishes her secrets to be treated by myth. Thus

the mysteries are hidden in the tunnels of figurative expression."[13] Pollan himself is embarrassed by the lameness of describing cosmic atonement. But he notes how in the grip of the experience banal platitudes "glow with the force of revealed truth."[14]

The mysteries use myths of sacrificial death to make their revealed truths glow. In the remains of a Mithraeum in the crypt of Santa Prisca (another Roman church built atop its competitor), there's a fragmentary inscription that gives a clue to the tauroctony's meaning: *ET NOS SERVASTI . . . SANGUINE FUSO* (and you saved us . . . with blood poured forth). Speaking simultaneously to our sense of violation and our hope of renewal, sacrifice has always been central to religion. It binds together love and suffering. The historian Manfred Clauss says of the tauroctony's symbolism, "The bull is sacrificed so that new life may be produced, life brought by Mithras, god of light, the Sun, a god who is indeed almighty."[15] Perhaps the special appeal of Mithraism to soldiers was that it endowed masculine categories of slayer and slain with transcendent meaning.

There are obvious similarities between the Cult of Mithras and the religion built atop it. Like Mithras, the Christian God saves humanity by means of a sacrificial death. As in the Mithraic service, the Christian service involves a sacred meal consumed before an image of holy suffering. Like the other mysteries, Christianity promises salvation, insisting that love overcomes death. To top it all off, Mithras's miraculous birth was celebrated on December 25, which, according to an ancient commentator, was what led the Christians "to observe the Feast of the true Birth on the same day."[16] There's a long-standing meme, from Ernest Renan in the late nineteenth century to Bill Maher in the early twenty-first century, that Christianity is just knockoff Mithraism.

In fact, there are outstanding differences between Christianity and the other mystery cults. A huge one is that Christianity presented itself as a new religion, not as just another option in the smorgasbord of Roman polytheism. Symmachus, a defender of the old religion, declares, "There's no one way to reach the great

secret."[17] Jesus says the opposite to his followers, "I am the way, and the truth, and the life; no one comes to the Father, but by me."[18] Though cults like Mithraism promised eternal salvation, they saw themselves as integrated with their city and its traditions in an eternal cycle of death and rebirth. According to the Christian vision, the City of God is irreducible to the Earthly City and won't be fully realized until after the apocalypse.

Another big difference between Christianity and the mysteries is reflected in its architecture. Most Roman Catholic churches are basilicas: rectangular buildings with a central nave and longitudinal aisles defined by rows of columns. In the ancient world basilicas served as standard-issue public buildings (look at the stubby ruins of various places in the Forum to see the floorplan). To celebrate its message of divine love, Christianity appropriated a quintessentially *public* structure. Rather than conceal its message of salvation as the mysteries did, Christianity asked—and continues to ask— its adherents to proclaim the good news far and wide. As at San Clemente, it's a big-tent mystery religion raised on the cramped quarters of a mystery cult.

The communication of Christian salvation is often either kitschy or crazy-sounding, a little like the kooky lessons of an LSD trip. But Christian art at its best finds ways of believably revealing its great secret. The mosaic in the apse of San Clemente's upper church is a glorious example. At its center is the crucifixion of Jesus on the Tree of Life. Twelve doves perch on a cross that blooms in an explosion of acanthus vines. The roots of the living crucifix reach into the four rivers of paradise, where stags drink from the gushing waters. Above it all, God's hand reaches down through the sky with a victory wreath. Held in the swirls of the acanthus, the whole world goes about its business: birds feed their hatchlings, shepherds milk their ewes, women feed their chickens, monks work on their books. Meanwhile, Mary and John stand by a loved one who's suffering on the cross. Like most profound things, the mosaic is incredibly playful, even whimsical in places, and also incredibly

tragic. Around the top of the arch is the inscription, "GLORIA IN EXCELSIS DEO SEDENTI SUP[er] THRONUM ET IN TERRA PAX HOMINIBUS BONAE VOLUNTATIS" (Glory to God in the highest, seated on the throne, and on earth peace to people of good will).

A smaller inscription running below the mosaic interprets the image in awkward Latin: "The church of Christ we represent by this vine (the wood of the cross [and] the tooth of Jacob and Ignatius rest in the body of Christ inscribed above), which the law withers but the cross makes green."[19] The emphasis on how law kills what religion waters is perhaps further support for the hypothesis that the upper basilica was built to champion the pope over the emperor supported by the antipope. It also happens to be what Christianity is all about. The message of the mosaic, supercharged by the relics integrated into it, is that God's sacrifice of his son has restored eternal life after sin brought death into the world. San Clemente's mosaic is a hallucinatory vision of love spiraling through the universe, a visual counterpart to the mystical poem from the same era "The Dream of the Rood," where the "rood" is also both the crucifix and the tree of everlasting life.

> The choicest of visions I wish to tell,
> which came as a dream . . .
> It seemed that I saw a most wondrous tree
> born aloft, wound round by light,
> brightest of beams. All was that beacon
> sprinkled with gold.[20]

When it comes to religion, it's easy to get so tangled in questions of belief that you lose sight of the central mystery of salvation. For that matter, it's easy not to see God at all for the dog-eat-dog world. The logic of parsing dogma makes sense only once you glow with the ecstatic catastrophe of logic at the dogma's core. Augustine, in the first book he writes after converting, actually uses the concept of a mosaic to explain the problem. When we look only at tile after

tile, we don't see what's really going on. The mosaic's image, which is somehow made of its pieces and yet irreducible to its pieces, must be grasped by a visionary act of consciousness.[21]

In the Christian myth, Jesus is resurrected in a body that's both new and the same. Though he's barely recognizable to his disciples, he can be identified by his old wounds. In San Clemente, a cave of the mysteries is resurrected as a frescoed Christian church, which is resurrected as a basilica with a glittering mosaic of the mystery. Though each version appears in a shining new light, it retains the wounds of its previous destruction. Depending on what level you're on, you're in the past of the past, the past of the present, or the past of the future. No matter where you are, you're in the presence of the past and the future of a presence. Part of the mystery is that the mysteries keep piling on top of each other, never totally the same, never totally different. We could say of San Clemente, "The mystery of Rome we represent by this site."

At the end of his tome on the site he excavated, Joseph Mullooly appends "The Skeptic's Dream," a piece written by an "anonymous friend" in a manner suspiciously like that of the preceding pages. The friend, who styles himself as too modern and enlightened to believe in the tall tales of religion, tells how on vacation in Rome, while observing birds flying in and out of the Colosseum's arches, he dozed off and dreamed that he was in the Basilica of San Clemente. The traveler writes, "A voice, different from any I had ever known, fell on my ear: 'Even the stones of Rome speak,' it said, 'come with me, and I will tell you what they say.'"[22] The voice takes him on a tour through what Mullooly had unearthed. He sees fresco after fresco of self-sacrifice and martyrdom. Chastising the traveler for not believing in anything but what he can see and touch, the voice argues that whenever we feel ourselves glowing at sacred art, we're sensing a secret about existence. The saints pictured on the walls gave up their wealth, their power, and even their own lives for the invisible world of faith, hope, and love, because they were tapped into a power categorically greater than anything that can be seen or

touched. The voice claims that the truth shines especially brightly in San Clemente, since its broken stones and fading frescoes remind us that the material world falls apart. "Yes, these very walls, hidden for centuries, have now, as it were, been brought to light to add yet a testimony to the awful fact, in this age of inconsistency and incredulity, fast gliding from the mind of man, that this sphere is not to revolve for ever."[23] The idea that the traveler is modern and enlightened proves to be absurd: our very planet is wandering in the future's dark basement! Then the traveler wakes up and hurries from the Colosseum to the church of his dream, where he's bowled over by the mosaic of the intersection of time and eternity, "that holy symbol so dearly loved by the early Christians, that even on their very tiles they engraved it." He ends, "I felt that I too had been conquered by its power."[24]

THINGS TO SEE AND CONSIDER:
ROME AS MYSTICAL EXPERIENCE

If you go to **Ostia Antica**, make a point of finding the **Mithraeum at the Baths of Mithras.** When I first stumbled into its underground cave and saw its tauroctony in the darkness lit by a sunbeam, I was almost subject to an accidental initiation into the mysteries. Among other Mithraic stuff at Ostia not to be missed: a mosaic floor in the **Mithraeum of Felicissimus** that shows the grade structure of the cult. Among the many remains of Mithraea in Rome, two accessible ones are the **Mithraeum in the Palazzo Barberini** and, of course, the **Mithraeum in the Basilica of San Clemente.** To visit the **Mithraeum in the Church of Santa Prisca**, you must make an appointment. If it's Christian mysticism you're interested in, I've already mentioned Bernini's sculptures of women in the throes of intense religious experiences that look an awful lot like orgasms: *Blessed Ludovica Albertoni* (1674) in the **Church of San Francesco a Ripa** and *St. Teresa in Ecstasy* (1647–52) in **Santa Maria della Vittoria.** Around Teresa and the Cupid-like angel piercing her with his spear,

Bernini places sculptures of the Cornaro donor family (this is in the church's **Cornaro Chapel**), who examine the swooning nun and discuss her ecstasy among themselves. It's like some strange scene of group X-rated criticism. Then again, what are we doing but looking and discussing? The poses of the Cornaro men put me in mind of the poses of the philosophers in Masolino's *St. Catherine Disputing with the Scholars* (1425–31) in the **Castiglione Chapel**, another marvel in our **Basilica of San Clemente**. The legend is that the emperor Maxentius summoned the best pagan thinkers to refute Catherine's Christian theology. They failed. She won. But aren't the chapel's subsequent scenes of miracles and martyrdom even more compelling than whatever she's explaining to the philosophers about the mystery of her faith? Caravaggio's *Conversion of St. Paul* (1601) in **Santa Maria del Popolo** suggests Saul's intensely inward experience with a confusing brightness that intrudes on the otherwise shadowy everydayness. In *The Varieties of Religious Experience*, William James quotes from the story of the Jewish atheist Alphonse Ratisbonne who finds himself in Rome's **Sant'Andrea delle Fratte**: "If at this time any one had accosted me, saying: 'Alphonse, in a quarter of an hour you shall be adoring Jesus Christ as your God and Saviour' . . . I should have judged that only one person could be more mad than he—whosoever, namely, might believe in the possibility of such senseless folly becoming true." A black dog trots down an aisle, and suddenly the whole church vanishes. The dog is then replaced by an experience of God: "Heavens, how can I speak of it? Oh no! human words cannot attain to expressing the inexpressible."[25] Ratisbonne claims that it was nothing special about the church that summoned God—other than maybe the dog. But it's also possible to have a mystical experience while looking at sacred art, like Mullooly's skeptic beholding San Clemente's apse mosaic, or a young Thomas Merton on his first trip to Rome wandering into the **Basilica of Saints Cosmas and Damian** and being bowled over by its apse mosaic. He nicely evokes how Christian art paradoxically reveals the mystery.

I glanced at it, I looked back, and I could not go away from it for
a long time, it held me there, fascinated by its design and its mys-
tery and its tremendous seriousness and its simplicity . . . I didn't
know what it was: it was not a material thing, it was an intellec-
tual and spiritual quality these ancient artists had given to their
works. But it was not something that could not be seen, and not
something you had to accept blindly: for it was there, you could
see it . . . I was looking all the while at a kind of miracle.[26]

Merton famously goes on to become a monk. Late in his life, he
broadens his sense of religious experience and speaks of "the
Christ of immediate experience all down through the mystical
tradition . . . the apophatic Christ-light that is not light, and not
confinable within any known category of light."[27]

DETOUR THROUGH THE MOST
BEAUTIFUL THING IN ROME

The apse mosaics of San Clemente and Cosmas and Damian are
breathtaking, but the most beautiful object in Rome is the Ludovisi
Throne, which can be found in the Palazzo Altemps, the loveliest
of the city's least-crowded museums and the least-crowded of its
loveliest. The "throne" is a block of off-white marble carved with
bas-reliefs. Though its style suggests it's Greek, probably dating
from the late fifth century BC, we're not really sure where it's from,
who made it, or what purpose it served. The subject of the central
panel is the birth of Aphrodite.

As is well known from Botticelli's iconic painting, the goddess of
love is born full-grown from ocean froth. In the Ludovisi Throne,
Aphrodite is wearing a see-through gown. Drenched with seawater,
it clings to her shoulders, her breasts, her bellybutton. The Horae,
goddesses of time, pull her up by her arms out of eternity. They've
begun to draw a veil over her. She looks up at one of her midwives.
Her expression is eloquent of "Who are you?" or maybe "Help

me." A close look reveals problematic touches. The goddess's ear isn't in the right location. The placement of the Horae's feet in relation to their legs seems impossible, like one of M. C. Escher's illusions. Nevertheless, as William Carlos Williams says, it seems "perfection, actually, which had survived the endless defamations of this world."[28]

If you've ever fallen in love, as I did in the Mithraeum of San Clemente, you're well-positioned to understand the imagery. Love appears at first sight in almost all its glory. It's half in this world, half in eternity. You feel alive and helpless. Strange proportions enhance the attraction. The hours work to reveal and to conceal it. Its beauty is immune to the endless defamations of this world.

I said the most beautiful object in Rome is the Ludovisi Throne. The most beautiful thing in Rome is falling in love.

FIGURE 10.1 · Raphael and workshop, *Venus and Cupid*, Loggia of Cupid and Psyche,
Villa Farnesina. On this spandrel, a jealous Venus is commanding her son to punish Psyche,
and the god of love, seeing the surpassingly beautiful mortal for the first time, is falling in
love. In Apuleius's *Golden Ass*, the literary source of the imagery, the goddess says, "Avenge
your parent—and do it thoroughly—by stern chastisement of that insolent loveliness. . . . Let
that virgin be caught by rampant passion for someone utterly out of bounds, whom Fortune
has mulcted of his standing and inheritance . . . Let his lot be so loathsome that he would look
in vain through all the world for anyone as pathetic as himself." Perhaps Cupid is also sensing
that his mother's curse prophesies his own fate. Apuleius, *The Golden Ass*, trans. Sarah Ruden
(New Haven, CT: Yale University Press, 2011), 87–88.

10

MAKE A GOLDEN ASS OF YOURSELF

The Metamorphoses in Agostino Chigi's Villa

> I have had a most rare vision. I have had a dream—past the
> wit of man to say what dream it was. Man is but an ass if he
> go about to expound this dream.
> WILLIAM SHAKESPEARE

The Villa Farnesina, a pleasure palace splashed with Renaissance masterpieces, should really be called the Villa Chigi, as it has everything to do with Agostino Chigi (1466–1520), who ordered its construction and commissioned its art. It's called the Villa Farnesina because the Farnese family, envious of the house's beauty, purchased it from the Chigi family in 1577 and owned it for several centuries. Now a relatively uncrowded museum owned by the Italian state, the Villa Farnesina teaches fascinating lessons about self-transformation and conveys "love and do what you will" in a sense so far from Augustine's chaste commandment that it circles

around to almost the same holiness. Let me make an ass of myself and try to expound this most rare vision.

Like so many great Romans, Agostino Chigi wasn't born a Roman. Growing up in a rich Sienese banking family, he moved to Rome in his early twenties and established himself by lending money to the Borgia pope Alexander VI. Chigi's fortune skyrocketed when he cornered the market on alum, a mineral salt used as a dye fixative, and thus established control over the international textile market. In 1503 he supplied Giuliano della Rovere with bribe money to secure the papacy. Taking the name Julius II in tribute not to Pope Julius I but to Julius Caesar, *Papa Terribile*—as he'd come to be called—wanted to remake the city and the Papal States into a Latin-Christian powerhouse on par with the Roman Empire. Julius II and Chigi delighted in their alliance. The pope reached into the financier's deep pockets to finance his military exploits and urban renewal projects, while the financier solicited papal threats of excommunication to leverage potential rivals and strike deals.

The Renaissance wasn't just the revival of classical ideals of beauty. For Julius II, it meant the complete overhaul of Rome and the reassertion of its global power. It included wars and power grabs. It was bound up with the violent plunder of the New World. If you're the type who wants to think the Renaissance was all sweetness and light, you need to face the horror. But it also involved the extensive patronage of art and scholarship, because its powerbrokers knew that beauty and knowledge can be as powerful as violence and authority—and are certainly more lasting. Julius II commissioned Bramante to build the Tempietto and start work on St. Peter's Basilica, Raphael to design the Raphael Rooms in the Vatican (including the *School of Athens*), and Michelangelo to sculpt *Moses* and paint the ceiling of the Sistine Chapel. If you're the type who wants to reduce the Renaissance to carnage and exploitation, you should open your eyes to the splendor. About the fact that violence and beauty have had a long-standing torrid love affair, I have nothing reassuring to say.[1]

For Agostino Chigi, the Renaissance was even more personal. Not only did he support Julius II in the remaking of Rome as well as patronize artists and scholars in the remaking of classical ideals, Chigi was engaged in the remaking of himself. In his adopted Rome, as opposed to his native Siena, his status as a merchant banker meant that the aristocracy looked down on him, no matter how much money he had. In fact, his obscene wealth, which the upper classes often required, fueled their jealousy and meant that they were even more inclined to disdain him as merely rich, a leech on baronial families who prided themselves on nonfinancial goods like education and lineage. Knowing that an outsider can never be fully accepted by those born into the elite, Chigi decided to change the rules of the game and forge an unprecedented identity, one that synthesized finance and art, trade and conversation, exploration and philosophy, power and love. He did so by building a house. "Chigi's Roman villa was designed," as Ingrid Rowland observes, "to present, and in part to explain, a complex man to a society that had no category to accommodate him other than the category he was engaged in creating for himself."[2]

Julius II was interested in revamping parts of the old district in Rome known as Trastevere. Seizing the opportunity, Chigi commissioned a fellow Sienese, Baldassarre Peruzzi (1481–1536), to design a suburban villa there in the spirit of ancient Roman noblemen's country houses—places for getting away from the hubbub, especially in the summer. Construction began on April 22, 1506, the auspicious anniversary of the founding of Rome itself. The house was to be an expression of the man, refashioning Chigi's identity by projecting him into myth, garden, and architecture. Mercury, the suave messenger-god of merchants and thieves, Chigi's favorite, figures prominently in the Loggia of Cupid and Psyche. So does Ceres with her cornucopia, a symbol of Chigi's extensive holdings in the grain industry. Peruzzi, a painter as well as an architect, was in charge of painting the Room of the Frieze, a large waiting-room decorated with various mythological scenes, including one where

Chigi is portrayed as Hercules slaying the Hydra. In what's now known as the Loggia of Galatea, the ceiling of which is decorated with images relating to Chigi's horoscope, we have Sebastiano del Piombo's fresco of the cyclops Polyphemus, who's also (in all likelihood) modeled on Chigi. This isn't Homer's blinded savage but a Renaissance Polyphemus derived from ancient Roman poetry: an outsider with a poetic heart who's elevated from his lowly station by falling in love with the beautiful nymph Galatea.

Though we now visit the Villa Farnesina for the paintings inside it, it was originally famed for the gardens outside. They were soon destroyed by a flood in 1514, but we know something about the layout from contemporaneous poets who sang of abundant orchards, lavish vegetation, ancient sculptures, burbling fountains, and underground grottoes. The fruits and flowers, like the art and architecture, were laden with significance. To signal Chigi's historical prestige, the grounds teemed with plants mentioned in Pliny the Elder's *Natural History*, the great encyclopedia of the ancient world. To signal the global reach of his financial empire, the gardens also sported exotic plants culled from Asia and the New World. The vegetation even made its way indoors. Raphael's assistant Giovanni da Udine painted lush garlands around the fictive architecture of the Loggia of Cupid and Psyche. These charming images of nature's fecundity, abounding with over 170 identifiable species, also make crass references to sex organs, as in an obscenely phallic gourd penetrating an obscenely vaginal fig. Sometimes a gourd penetrating a split fig is not just a gourd penetrating a split fig! The symbolism could be read as a celebration of Chigi's erotic prowess, but I'm guessing it was mostly just sophomoric fun.

Chigi's villa set fresh standards by which members of the Roman aristocracy were judged and usually found wanting. Did they think that lineage and education mattered? Well, Chigi's palace was based on a truly ancient design, and its sumptuous paintings brushed aside centuries of Christian piety in favor of the Greek and Roman mythology that was now the poetic grammar of the day's cutting-

edge intellectuals. (If challenged on his Christianity, Chigi could always parry that the allegories had something to do with virtue and the soul's ascent to divine love.) He hosted plays and poetry readings, wined and dined foreign dignitaries, threw wild parties, and celebrated lavish holidays. He showed off his wealth at one banquet by having his guests toss their solid gold plates into the Tiber after each course. Once the guests had stumbled home, Chigi's servants hauled up a net in the river that he'd hidden there to capture the valuables. Not only did his stunt ensure that the plates could be used again, it prevented any light-fingered nobles from taking home a golden souvenir.[3]

The most stunning of the rooms in the villa, into which the original guests would have entered, is the Loggia of Cupid and Psyche, designed by Raphael. In his biography of the artist, originally published in 1550, Giorgio Vasari calls the great painter "a very amorous person" and says that, because his amorousness was distracting him from his work on the loggia, Chigi arranged for Raphael and his mistress to be locked up together in the villa until the project was completed. Contemporary scholars doubt the tale because most of the work on the Loggia of Cupid and Psyche was done not by the master but by his workshop. I'm less sure than our historians that Vasari is wrong. Who's more trustworthy, a man who knew people Raphael knew or scholars five centuries later who would blanch and run if they were transported back to sixteenth-century Rome? Sure, early historians can be sensationalistic and credulous, but it's practically the job description of historians nowadays to relay great stories and then to claim that they never happened.[4] Plus, is it really so unbelievable that a man locked in a house with his mistress would have his assistants do the lion's share of the painting?

It wasn't just Raphael who was "very amorous." The whole villa was a hotbed of male sexual energy. Giovanni Antonio Bazzi, a.k.a. Sodoma, who frescoed Chigi's bedroom with scenes of Alexander the Great's wedding night with Roxane, had something of a reputation with "beardless youths," as his unfortunate nickname suggests.

Giulio Romano, the painter of Raphael's designs for the figures in the Loggia of Cupid and Psyche, made a series of erotic paintings that became the basis for a book—engraved by Marcantonio Raimondi, another of Raphael's entourage—called *I modi* (*The Ways*), illustrating sixteen different sexual positions. Pietro Aretino, who started out as Chigi's houseboy in the villa, got in trouble by composing a set of dirty sonnets to accompany the book's imagery. Chigi was no exception. He was by all accounts a womanizer who fathered several illegitimate children. But he was truly and madly in love at least twice. (Against A. E. Housman's "Anyone who thinks he has loved more than one person has simply never really loved at all," I set Radmila Lazić's "Many times I fell in love forever.")[5] Chigi's villa wouldn't be so moving if it wasn't at least as much a pleasure palace for his beloveds as an architectural assertion of his power and status. There's a touch of Jay Gatsby in Agostino Chigi.

His first true love was Imperia Cognati (ca. 1481–1512), whose mother was a prostitute who plied her trade near St. Peter's, where a tenth of the inhabitants were involved in sex work. It was common throughout the Middle Ages for priests to have concubines and to avail themselves of prostitutes. But the Italian Renaissance, with its burgeoning court culture and ideals of beauty and learning, elevated the ancient trade to an artform. To accompany and pleasure the courtiers there arose a class of courtesans, glamorous beauties who generally were lavished with expensive gifts rather than paid for their services. Imperia was the most illustrious of them all. As Georgina Masson says in *Courtesans of the Italian Renaissance*, "There seems to be no doubt that she outshone all the other courtesans of the day, as the moon the stars."[6] Her "broad white brow" and "crown of golden hair" and "delicious breasts" were the subject of numerous encomia from nearly all the major and minor poets of the day.[7] After composing her own poetry and music, she performed it on the lute or the *viola da braccio*. With her exquisite taste in art and extensive library, she riveted the luminaries of the Renaissance in discussion. In ancient Rome, the emperor (*imperator*) could be

declared divine (*divus*). In reborn Rome, Imperia's nickname was *La Divina*. It wasn't just Chigi who was madly in love with her: almost all the major players of Renaissance Rome were smitten.

You get a sense of *La Divina*'s status in a charming episode documented by one of her contemporaries. One day in the market a gourmand by the name of Tamisio spotted a huge fish, a grayling, and became obsessed with dining on it. As Seneca noted many centuries before, Roman society works by strategic gift-giving. So, the fishermen took the grayling to the Capitoline and presented it to some civic authorities they hoped to flatter. Tamisio followed them, hoping to get an invitation to their subsequent banquet. But the authorities wanted to make inroads with a powerful cardinal. The gourmand followed the fish. The cardinal, knowing who was top dog in the city, made a great show of presenting the fish to Agostino Chigi in his villa. Now Tamisio really imagined dining in splendor! But the grayling's social mobility wasn't finished. The gourmand followed the fish to Imperia's door. Here's Masson again: "He presented himself, and in due course sat down to dine with Imperia and shared it with her. Imperia, unlike all the eminent persons to whom the grayling had been sent, apparently did not pay compliments—she simply accepted them."[8]

Imperia's sole child was fathered by Chigi: her daughter Lucrezia (we'll detour through her story soon). After Imperia had exacted a promise from Chigi that he would look out for their child, she took her own life by means of poison around 1512—perhaps because she'd been spurned by a man she was in love with. Chigi paid for a lavish funeral, unheard of for a courtesan. As the saying goes, Mars gave Rome an empire, Venus gave Rome Imperia.

About a year before Imperia's suicide, the financier met the last great love of his life. On a debt-collecting excursion to Venice, he came under the spell of Francesca Ordeaschi, a greengrocer's daughter. Chigi whisked her back to Rome and had four children with her. She probably spent more time in his pleasure palace than anyone. All the while, he was seeking a more suitable wife than a

commoner. Francesca was pregnant with their fifth child when Chigi finally wised up and demanded that Pope Leo X marry them in 1519 and retroactively legitimize their children. He was in love with her. So what if she happened to be a greengrocer's daughter? The moralists and the snobs would just have to deal with it.

Before tales of love and great beauties derailed me, I was saying that the most enchanting room in the Villa Farnesina is the Loggia of Cupid and Psyche, which is all about—well, love and a great beauty. Decorated with images designed by Raphael and mostly executed by his workshop, it allegorically depicts the soul's ascent to immortality (the word for soul in Greek is *psyche*; Cupid, of course, is the naughty god of erotic energy), culminating in a wedding banquet where Chigi is depicted as one of the gods. We can assume that Chigi's favorite guests were familiar with the sources of the imagery. The fun for the cognoscenti involved inside jokes and mystical meanings, as well as the simple but satisfying pleasure of recognizing plants, gods, and episodes. To join in the fun, let's recall the story, which we know through one of the most enjoyable works of ancient Roman literature: Apuleius's *Metamorphoses*, which had become popular in Chigi's day after having just appeared in a new edition in 1500 with commentary by a leading humanist scholar.

A native North African, Lucius Apuleius Madaurensis (ca. 123–70) studied rhetoric, philosophy, and literature in Carthage, Athens, and Rome. On his wanderings, which encircled the entire Mediterranean, Apuleius was initiated into several mystery cults and functioned as a priest of Asclepius. He worked as an orator and a teacher, including in the Eternal City. His works don't fit neatly into disciplinary boundaries. *On the Guardian Spirit of Socrates*, a book of immense influence on the Middle Ages, deals with the irrational side of Platonism and argues for the importance of spiritual intermediaries (*daemones*) between mortals and the gods. *On the Cosmos* is a free translation of a pseudo-Aristotelian treatise into which Apuleius slips a long passage on the nature of the winds.

His *Apology* is his triumphant courtroom defense against the charge of using magic to seduce and marry a widow for her fortune. The *Metamorphoses*, commonly known as the *Golden Ass* (*Asinus Aureus*—"golden" because it was such a good yarn), based on a now-lost Greek novel, is simultaneously a rollicking narrative about sex and magic, a philosophical allegory about love and the soul, and an insider's anthropology of mystery cults.

Like the author, the main character of the *Golden Ass* is named Lucius and hails from Madaura in North Africa. On his way to Thessaly, Lucius has an affair with his friend's slave Photis. Because his friend's wife is reputed to be a witch, Lucius gets Photis to help him spy on her while she's working her magic. He wants to learn her secrets so he can turn himself into an eagle. One thing leads to another, and Lucius is instead turned into a donkey. Much of the novel follows his misadventures through Greece as a man in the body of an ass. Used and abused, he gets an education in the viciousness common to our species and the humility necessary for our salvation. After a particularly low point when he's supposed to have sex with a woman in a packed theater as a freak show, he manages to escape and prays to the Queen of Heaven to be rescued. The goddess Isis appears and tells the ass how to become human. Lucius recovers and is initiated into her mystery cult. The denouement involves a journey to Rome and his continued religious service.

Lucius overhears various stories as an ass, but the longest and most famous is that of Cupid and Psyche, the inspiration for the Villa Farnesina's loggia as well as the source of fairy tales like "Beauty and the Beast." The story goes that Psyche, one of three daughters of an unnamed royal family, is so beautiful that people begin to worship her instead of venerating Venus. In a fit of jealousy, the goddess tells her son Cupid to make Psyche fall in love with someone horrible. After an oracle prophesies that Psyche must marry a monster, her parents arrange for her a wedding/funeral procession up a mountain. Left for dead, she's borne by a soft magical wind down a cliff to a vast palace where she's served and entertained by

invisible beings. Every night her husband visits the bedroom and makes love to her in the dark. But he warns Psyche never to gaze on him. Lonely for her family, she begs her skeptical husband—with "kisses of great rhetorical effect"—to let her sisters visit.[9] He gives in, but only after telling her that she's pregnant, and that if she can keep their secret, their child will be divine. Her sisters are carried by the magic wind and take a tour of Psyche's enchanted mansion. Sick with envy, they plot to bring her down and soon convince her to go against her husband's wishes. That night, after he's asleep, Psyche lights a lamp and discovers that her husband is none other than Cupid, who had fallen in love with her at first sight. He's so beautiful that she falls madly in love with Love. When the lamp's hot oil drips on his shoulder, Cupid wakes up, realizes that he's been betrayed, and flies off into the night.

Heartbroken and alone, Psyche considers suicide but is dissuaded by the god Pan. She goes back home and tells each of her sisters separately what happened—with the added fib that Cupid in his anger exclaimed that he wanted to marry one of her sisters instead. Each sister sneaks away and jumps off the cliff, eager to be wafted to their immortal fiancé—but the wind is no longer under Cupid's orders to carry them. After their inadvertent suicides, the pregnant Psyche goes on a journey to find her husband. She comes across Ceres, the goddess of agriculture, and Juno, the wife of Jupiter, and piously presents herself to them. Though they're sympathetic to her plight, they can't go against a fellow goddess. Psyche realizes she must go to Venus herself.

In the meantime, Venus is informed of Cupid's betrayal and threatens him with misery and disgrace. She also runs into Ceres and Juno who point out the irony that the goddess of love is angry that love has finally found her family. Venus solicits Mercury's help, and the messenger-god announces that Venus will give seven kisses and a thrust of her honeyed tongue to anyone who can help her capture Psyche. (The designated meeting place for the divine French kiss was once a notorious place of prostitution in Rome:

"the turning-post at the racecourse where Venus Murcia's shrine is."[10]) When Psyche surrenders herself to her cruel mother-in-law, Venus hands over her daughter-in-law to her servants Worry and Sadness to be tortured. Then, for her redemption, Psyche is given a set of impossible tasks: sorting a great pile of mixed seeds, shearing wool from the sun-god's sheep, and collecting water from the source of the underworld's rivers. The mere mortal can't do any of the tasks on her own, but she ends up pulling them off with help from a team of talking ants, a magical reed, and Jupiter's eagle. One last task is for her to descend into the underworld and ask for some makeup from its mistress Proserpina. An enchanted tower helps her with this last otherwise-impossible task. But just as Psyche is on the verge of success, curiosity gets the best of her. She opens the box of mysterious makeup, and Proserpina's beauty sends her into a coma. Cupid flies to Jupiter and begs for help. Despite all the troubles Cupid has caused him, the king of the gods can't resist. He gives Cupid a kiss and orders Mercury to convene a meeting of the gods, where they decide to make Psyche an immortal and marry her off to her lovebird. The story concludes with a great wedding banquet and the eventual birth of Cupid and Psyche's daughter Pleasure.

Like much of the imagery of Renaissance art, Apuleius's tale of Cupid and Psyche participates in an aesthetic of teasing the mind. We're given an abundance of clues, some of which are obvious (e.g., Love gives Soul over to Worry and Sadness), but the combinations of imagery and mythology are ambiguous enough that we never puzzle it all out. Luckily, the end of the story isn't that hard to decode. We find our immortality through our commitment to love. Think of the immortality of a family that comes from the loving care of children, or the immortality of reputation that comes from loving devotion to an ideal, or the immortality of mind that comes from paying loving attention to something true or beautiful.

It's not just the Loggia of Cupid and Psyche that's informed by Apuleius. The whole villa is a version of Cupid's pleasure palace,

where the master keeps his paramour whenever he flies off on business. What Apuleius says of the god's dwelling could just as well be said of the financier's: "The house made its own daylight whether the Sun felt like helping or not: the rooms, the porticos, the doors themselves gave out a lightning brightness. The rich furnishings matched the majesty of the building. It really looked like an imperial residence, a celestial one built for Jove, but for socializing with human beings."[11] Just like Cupid's house, Chigi's villa woos certain people and inspires lethal envy in others.

Chigi projects himself into his house mainly as an agent of metamorphosis: Hercules founding civilization, Alexander allying with far-flung lands, Cupid fulfilling his lover's fantasies. But the banker's most interesting self-projection, in my view, is as a subject of metamorphosis. In the Room of Galatea, adjacent to the Loggia of Cupid and Psyche, Sebastiano del Piombo paints Chigi as the meaty cyclops Polyphemus. This time the imagery derives from *Stanzas for the Tournament*, a poem by Angelo Poliziano (1454–94) that exerts a huge influence on Renaissance art, including Botticelli's famous *Birth of Venus*. Sebastiano's *Polyphemus* draws on Poliziano's contrast of Hercules, a hero debased by desire, and Polyphemus, a beast uplifted by love. Drawing on Ovid's *Metamorphoses*, Poliziano portrays the cyclops not as a vicious savage but as a comic figure: an overgrown monster who writes poems, warbles love songs to a sea-nymph way out of his league, and becomes so jealous of Galatea's lover Acis that he crushes him with a boulder. In the *Stanzas*, as in the Villa Farnesina, the ogre is simultaneously the butt of a joke and an allegory of how love can civilize even an uncouth outsider.

Raphael's *Galatea* (ca. 1514), right next to it, continues the iconography of Sebastiano's *Polyphemus*. Directly based on a stanza in Poliziano, the fresco depicts the nymph on a seashell pulled by sleek twin dolphins. Three flying putti overhead train their bows on her, while randy mermen cavort about her in the waves. The wind blows her face and hair in the direction of Polyphemus's song, while the reins of her chariot twist her body away from

him. Though the strong gorgeous Galatea may be the product of Raphael's imagination (he claims in a letter that he observes various beautiful women and then ascends to the Platonic form of female beauty depicted in his paintings), it's widely believed that his main model for imagining the nymph was none other than his friend and neighbor Imperia Cognati.

In one sense, the Villa Farnesina teaches us something about not giving a damn. Rome is just the name of a crazy place where a lot of crazy people have done a lot of crazy stuff. Why not do the crazy stuff you're meant to do without worrying about what the Farnese family thinks? If you do that crazy stuff, you just might end up transforming yourself into something they envy. But that's not the whole story. Though not giving a damn helps in the end (it certainly helped Chigi in business, romance, and high society), it often turns you into a monster first. Like Lucius, we crave a magic trick to transform our lives. But it's not so easy. Self-knowledge requires a certain amount of humiliation. Luckily for us, life throws us in unprepared, it doesn't let up for several years, and then we're thrown out unprepared. In the meantime, we inflict suffering on others and on ourselves. It's not just a character in an ancient Roman novel who's laid low by lust and curiosity. We're pretty much all asses—both in the sense of being humiliated by brute being and in the sense of regularly acting like idiots or jerks.

But there are two kinds of asses. Your garden-variety asses are everywhere: people who don't realize they're asses. You find them especially among those who have power and privilege. Apuleius identifies them in the Golden Ass by their belittling unidirectional laughter at others. What Lucius sees in his sojourn as an ass is how society, behind a veneer of virtue and respectability, is mostly pieced together of viciousness and violence. The other variety of asses—let's call them "golden asses"—are those who realize their asininity. Though they can still be pains, golden asses have special powers that make them lovable—like the ability to communicate with intimacy, to make things of beauty, or to see things nobody

else can. Knowing their own doubleness, they use language with winks of double meanings. Their sense of humor is reflexive, such that they're able to laugh not only at others but at themselves — sometimes ruefully, sometimes with belly laughter. They're capable of forgiveness, though it can often take a while. The irony is that golden asses, in knowing their asininity, are in the process of humanization. By having himself portrayed as a ridiculous monster, Agostino Chigi proves himself to be a golden ass.

I hate to break it to you, but your soul isn't going to be saved by following five or ten rules, no matter how helpful, no matter how ingeniously formulated. That old fairy tale is clarifying. The soul is in a castle. The soul is in the dark. The soul is tricked by its own family. The soul drives away what it loves most. The soul goes on a strange journey. The soul is whipped by worry and sadness. The soul almost never learns. The soul is in need of help from animals, plants, buildings, and gods. The soul must learn to converse with the dead. The soul is almost always in need of saving. Where can you find your soul? There she is, on that spandrel, surprising the goddess of love with the beauty of death, as white rock doves fly by!

The really important lesson is that the soul can't quite save itself. It needs to be saved time and again by love. Experience inevitably humiliates us. Love not only humiliates but elevates us. Though the Villa Farnesina doesn't celebrate the charitable Christian love that Agostino's ancient namesake commands, when you add it all up, it still comes to a version of "love and do what you will." Sure, it involves bedroom shenanigans, but it's also about the energy that drives us in all meaningful pursuits, as well as the affection that bonds us with family, friends, and associates. The lesson of Chigi's villa, rooted in Apuleius's novel as well as Ovid's and Poliziano's poems, is that the self-renewal we seek is best found by giving ourselves over to the mysteries of our loves and quirks, as violent and disruptive as they can sometimes be. Only by opening ourselves up to what's vulnerable and particular about ourselves do we achieve

our genuine holiness. Maybe a better formulation than "love and do what you will" is "love and don't give a damn."

As much as I've gleaned from thinking about the Villa Farnesina, the spot wouldn't be so deliciously Roman if it wasn't slippery about pricelessness and money, love and sex, mythology and vegetables. Beauty and wisdom merge in a goddess who's a courtesan. All those naked ladies are complex allegories for the soul and also pretty nice erotica. The plants symbolize wealth and genitalia. Chigi is a god and a monster. The Renaissance is beautiful and horrible. The villa is a love nest and a school of virtue.[12] So much of Rome is about overpowering us. The Villa Farnesina is certainly impressive, but it's the rare building in Rome that's more about love than power. Better put, it's about the power of love to overcome the love of power. You want to touch its truths. Like the fairy tale says, the offspring of the soul's marriage to love is pleasure.

THINGS TO SEE AND CONSIDER: ROME AS FALLING IN LOVE

A piece of graffiti found under **Santa Maria Maggiore** says "ROMA SUMMUS AMOR" ("Rome, a love supreme"), an ancient school kid's extension of the classic Roma-Amor palindrome.[13] Though there are paintings, sculptures, and sites in Rome, like the **Villa Farnesina**, that commemorate erotic love's supremacy, the real story of Amor is Roma itself. There's something seductive, something downright fleshy, about the city's textures and terracotta hues, to say nothing of its people-packed buses. In one of his *Roman Elegies*, Johann Wolfgang von Goethe declares that he can understand ancient marble only by running his hand along his lover's warm thighs. The poem, he claims, was composed in bed as he tapped out its meter on her naked back—perhaps in the **Casa di Goethe**, the city's museum to its great German tourist that was once his home. One of Raphael's masterpieces, *Portrait of a Young Woman* (1518–20)

in the **Galleria Nazionale d'Arte Antica** in the **Palazzo Barberini**, shows (probably) Margarita Luti, Raphael's mistress, known as *La fornarina* (the baker's daughter), flirtatiously touching her own bare breast. Michelangelo, Raphael's slightly older contemporary, is less straightforward in depicting eros in his paintings and sculptures. His many love poems tremble with how he lives for sin and longs for salvation. But is there some hope in his *Last Judgment* (1536–41) in the **Sistine Chapel**, where among the saved we see two men locked in a passionate kiss? By contrast, Caravaggio's *John the Baptist* (1610) in the **Galleria Borghese** or *John the Baptist (Youth with a Ram)* (1602) in the **Capitoline Museums**, though they're officially about the itinerant holy man, suggest almost no holiness beyond the kissability of a young man's flesh. Also in the Capitoline, in the room with the *Dying Gaul*, is the statue of *Cupid and Psyche* locked in an endless kiss. A competitor to the **Ludovisi Throne** for the most beautiful thing in Rome is the bas-relief **Hermes, Eurydice, and Orpheus** (copy ca. AD 100, original ca. 400 BC) in the **Villa Albani**. This Roman copy of a Greek bas-relief—"a dance of slowness, reluctance and grief"—suggests that we're constituted by the desire for love to conquer death, though death conquers even the greatest love.[14] A less mythic goodbye can be found in Vittorio de Sica's movie *Stazione Termini*. The departing main character, when she's asked by her Italian lover why she had an affair with him, says, "It was you, it was Rome, and I'm a housewife from Philadelphia."

DETOUR BY LUCREZIA TO LUCRETIA

Do you find the lifestyle of a Renaissance courtesan glamorous? As for the Divine Imperia herself, she did everything she could to keep her daughter from leading it. Imperia sent Lucrezia to a convent as soon as she was old enough to realize what her mother's profession was. The courtesan spent the rest of her life making a series of shrewd deals to ensure that when Lucrezia came of age, she'd have enough money and property for a decent life. On her deathbed,

Imperia enlisted Agostino Chigi—Lucrezia's father—to secure a good husband for their daughter. He arranged for Lucrezia to be married to a kind, well-to-do spice merchant from Siena, Chigi's hometown.

A few years into Lucrezia's marriage, Cardinal Petrucci met her and, seeing that she'd inherited her mother's beauty and intelligence, had her husband imprisoned on false pretexts. He wanted her for himself. Before Petrucci could rape her, Lucrezia calmly excused herself to do her hair. When she didn't emerge from her bedroom, Petrucci's men broke in and found her lying on the floor. Like her mother before her, Lucrezia had poisoned herself. The cardinal and his men fled at the sight of her convulsing, swollen body. The members of her household rushed in and were able to nurse her back to health. Unlike her mother before her, Lucrezia lived.

All the tales of Rome begin, "Twice upon a time." Lucrezia's story retraces that of her legendary namesake Lucretia back in the days of the monarchy, almost exactly two thousand years prior to Petrucci's villainy. In Livy's telling, a few Roman men—among them, Sextus Tarquinius, the son of the king—got drunk and started gossiping and complaining. Soon they were quarreling about who had the best wife. They decided to settle the matter by paying their wives unexpected visits. Each woman was caught gossiping, complaining, quarreling, and getting drunk—except for Lucretia, who was knitting in silence. Her beauty and virtue triggered the Tarquin prince. A few days later, when Lucretia's husband was away, he slipped into her bedroom at night and held a sword to her throat. When she wouldn't have sex with him, he issued an ultimatum. Either she'd sleep with him, or he'd kill her and her servant—and claim that he'd caught them in adultery.

The next day, Lucretia called on her father and husband, asking each to bring a witness, and revealed to them that she'd been raped by the king's son. After making them swear to take vengeance on the prince, she drew a knife and plunged it into her heart. Brutus—one of the witnesses—pulled the knife from her breast and swore

that he'd live under a tyrant no longer. They took her corpse to the Forum, where outraged Romans vented about serial abuse by the Tarquins and vowed on her knife to live free. Led by Brutus, they went on to overthrow the monarchy and establish a republic. (Twice upon a time, five centuries later, another Brutus would raise a knife against tyranny.)

The stories of Lucretia and Lucrezia tell us something as important as any Roman novel or Renaissance painting about the meaning of love.

> I hate and love. Why, you ask?
> No clue. But do I ever. It's torture.[15]

As that raw couplet of the ancient Roman poet Catullus shows, the opposite of love isn't hate, which is entangled with the pains and humiliations of love. As the abusive men in our stories show, the opposite of love is rape, which is bound up with the power-trips and degradations of lust. The republic is based on the dignity in us that rebels against a politics of rape. The freedom for which the true republic stands is the love of love. Love love, and do as you will. Perhaps the meaning of love, therefore, can best be seen in Imperia's excruciating decision to give up her daughter and do all she could so that Lucrezia, after all these centuries, might finally have a good life.

V

Make a Palace of Your Memory

The power of memory is great, very great, my God. It is a
vast and infinite profundity. Who has plumbed its bottom?
This power is that of my mind and is a natural endowment,
but I myself cannot grasp the totality of what I am. . . .
People are moved to wonder by mountain peaks, by vast
waves of the sea, by broad waterfalls on rivers, by the
all-embracing extent of the ocean, by the revolutions of the
stars. But in themselves they are uninterested.

AUGUSTINE

FIGURE 11.1 · Raphael, *School of Athens* (1509–11), detail. Euclid and his students in the electric circuit of education. Wilhelm Dilthey says of the painting, "I especially enjoyed how the harmonious spirit of the divine Raphael tamed the strife of systems locked in a life and death struggle into a peaceful conversation." Dilthey, *Selected Works*, vol. 6, *Ethical and World-View Philosophy*, ed. Rudolf A. Makkreel and Frithjof Rodi (Princeton, NJ: Princeton University Press, 2019), 165.

11

BE THE CONVERSATION

The Philosophy of Raphael's *School of Athens*

> The only people really at leisure are those who take time for
> philosophy. They alone really live. They are careful stewards
> of not just their lifetime: they annex every age to their own
> and make use of all the years that have gone before. Unless we
> prove ungrateful, it was for us that the illustrious founders
> of divine schools of thought came into being, for us they
> prepared a way of life.
>
> SENECA

In 1894, in a castle in Silesia, after a conversation with a friend late
into the night, Wilhelm Dilthey retired to his bedroom, where a
reproduction of Raphael's *School of Athens* hung. The philosopher
fell asleep. The painting of philosophers came alive. His ancient
predecessors began to move and talk. A host of new thinkers joined
the crew—Goethe, Spinoza, Descartes, Bruno, and others. At first
it was marvelous for the dreamer to see the metaphor of history's
great conversation made real. Then the philosophers started to

sort themselves into the two halves of Raphael's image. On one side, thinkers committed to science and math, hostile to the mystification of religious thinking. On the other, thinkers committed to freedom and poetry, hostile to the reductionism of scientific thinking. The argument between them intensified. The physical distance between them grew, as if a rift in their marble floor was about to open. Dilthey recalls, "The unity of my own being seemed to be torn asunder, since I was attracted now to this group and now to that one."[1] He woke up before he could do anything about it.

Dilthey's nightmare isn't all that fantastic. I've known philosophy departments divided into factions who hated each other's guts. But the meaning of Dilthey's nightmare isn't limited to academic infighting. Any large human community contains people with different ideas about what's the case, what counts, and what's right. The possibility of civil dysfunction lurks in the basic fact of differing "philosophies." The religious and political wars that ripped apart Europe in the centuries between Raphael and Dilthey testify to the scope of the trouble. But that's not the only problem, even if it's the costliest. Dilthey is also concerned with how we understand ourselves. Ever since the Renaissance, our individual lives have become increasingly fragmented among scientific, technological, religious, and political worldviews. Our souls are shredded by ideas we only half-understand. Those dysfunctional philosophy departments stare back at us in the mirror.

Ingrid Rowland conjectures that the idea for Raphael's *School of Athens*—the impetus for Dilthey's dream—was conceived in the Sistine Chapel on January 1, 1508, just a few months before Michelangelo began work on its ceiling. Battista Casali gave a lecture there arguing that the best weapon against the Ottoman Turks was not any armament or piece of propaganda but rather the books of the Vatican Library, particularly the wonders of Greek, Latin, and Arabic philosophy. Knowledge—whoever finds it, wherever it's found—is power. Receptively listening to the argument was Pope Julius II, known not only for his military expeditions but his

commitment to the arts. Rowland says, "And there is no question, five hundred years after Julius's election in December 1503, about which investment, armies or art, has proven the shrewder."[2]

Shortly after the lecture, Raphael was commissioned by Julius II to design and paint the room containing the Vatican's library, though the book shelves have long since been moved. In fact, Raphael designed (with guidance from intellectual advisers) and painted (with help from his workshop) several chambers, now known as the Stanze di Raffaello (Raphael Rooms). Each is a comprehensive work of art with murals on all four walls and decorated ceilings and floors. The *School of Athens* is in the room that came to be known as the Stanza della Segnatura (Room of the Signature), because it was there the pope signed important documents. It contains not just the *School of Athens* but the *Disputation* (an image of theologians on earth and in heaven), the *Parnassus* (an image of poets on the mountain-home of Apollo and the Muses), and the *Cardinal and Theological Virtues* (an image of the seven virtues above an emperor and a pope exercising their authority). Let's take a good look at the greatest of these masterpieces, because right there on the fresco's surface are some profound lessons for how to get out of Dilthey's nightmare and lead a good life.

The focal point of the *School of Athens* is a conversation between two figures, Plato and Aristotle, identifiable as such because the older figure is holding a folio of his *Timaeus*, and the figure next to him is holding a folio of his *Nicomachean Ethics*. Plato is pointing upward, presumably to illustrate his theory that ultimate reality transcends the visible world. His scientifically minded student's outstretched hand seems to say, "Let's bring it back down to earth." Coleridge remarks that everyone is born either a Platonist or an Aristotelian.[3] Well, here we have the original born Platonist and the original born Aristotelian! Because the two sides of the composition appear to stand for the opposition of idealism and empiricism, maybe they're having a debate about whether the truth lies in eternal forms or embodied realities. Then again, maybe Plato and

Aristotle aren't arguing at all. Maybe they're hammering out how theory informs practice. Think of the books they're holding: Plato's lays out metaphysical principles, whereas Aristotle's describes moral activity.

Regardless of what exactly they're talking about, the crucial thing is that Plato and Aristotle are having an intellectual exchange. Just a little over a decade before Raphael started the *School of Athens*, Filippino Lippi—an artist whom Raphael likely met—finished the *Triumph of St. Thomas Aquinas over the Heretics* (ca. 1488–93) in the Carafa Chapel in Santa Maria sopra Minerva. I wouldn't be surprised if Lippi's exquisite fresco of theological triumph directly influenced the *School of Athens*, as it has a strikingly similar design: various thinkers spread out on different levels of fictive Roman architecture. But there's a huge difference. Lippi's work is centered on Thomas Aquinas calmly disputing as his foot rests on an ugly personification of sin crushed by a big book. At the sides, in the foreground, we see various defeated heretics with their erroneous books in disarray on the ground. It's an image of the perennial human dream of the right view defeating all the wrong views. By contrast, Raphael's fresco depicts lively intellectual exchange. All the books are being productively used. The focal point is a conversation between two philosophers rather than the triumph of one theologian over all the others. Instead of an image of ideological triumph, it's an image of philosophical freedom.

Plato's side of the *School of Athens* depicts mostly intuitive, abstract thinkers. It's presided over by a statue of Apollo, the god of knowledge. To Plato's right (our left) is Socrates: the iconography of the bearded old man with beady eyes and ugly nose is unmistakable. He's lecturing a group of outlandishly dressed students, counting off points on his fingers as teachers often do during a lesson. Below that group, in the lower left, we have a set of figures encircling Pythagoras, one of whom is copying down his work. Notice the slate at the great mathematician's feet containing a set of proportions for the music of the spheres (we'll detour through its

mystery soon). Craning his neck across the centuries to peek at the mystic formula is the Muslim philosopher Ibn Rushd (Latinized as Averroes), whose garb is that of the Ottoman Turks, suggesting that political and religious enemies can be sources of wisdom. Because Epicureanism celebrates pleasure, Epicurus is the chubby, joyfully engaged writer on the far left. Because tradition has it that the pre-Socratic sage was melancholic due to his doctrine that everything is already outdated, Heraclitus is in modern clothing at the bottom of the steps, brooding and absent-mindedly jotting down his pessimism.

Aristotle's side depicts mostly precise, evidence-based thinkers. It's presided over by a statue of Minerva, the goddess of wisdom. At the bottom, echoing the circle of students around Pythagoras, we have Euclid, the bald man hunched over the chalkboard, instructing a circle of students in the geometry that helped Raphael to structure his painting. A figure is coming up the steps in the direction of Aristotle, perhaps to demonstrate that one ascends from mathematics to higher forms of science. Diogenes the Cynic is portrayed as the insouciant figure reading on the stairs like the whole world is his personal sofa, because Cynicism holds that social conventions are just a bunch of pretentiousness. In the bottom right corner of the painting, we have a curious group that seems to include astronomers holding their globes (Zoroaster? Ptolemy?) as well as the painter Apelles, perhaps to indicate Raphael's belief that painting is no mere trade but a liberal art on par with the systematic observation of the stars.

We could keep on guessing who's who in the fresco, a game that's been going on since Giorgio Vasari, the Renaissance originator of art history, named eight of the fresco's fifty-eight figures, getting at least one spectacularly wrong.[4] As far as I know, the record goes to the German scholar Anton Springer, who in 1883 claimed to identify fifty-two figures, leaving only a few backward-turned heads and the pupils of Euclid a mystery.[5] Because some of the philosophers are modeled on people Raphael knew, scholars also guess at why

one person is portrayed as another. Plato, for instance, is modeled on Leonardo, because Leonardo had the knack of penetrating to the forms of things and taught Raphael the linear perspective superbly on display in the *School of Athens*. Euclid is modeled on Bramante, because Bramante was excellent at applying geometry to architecture and helped Raphael with designing the fresco's fictive architecture. Heraclitus is modeled on Michelangelo, because Michelangelo had a dark view of the world and inspired Raphael with the genius on display down the hall in the Sistine Chapel. The great painter Apelles is modeled on—Raphael himself! As fun as these games can be, I'd caution against getting too caught up in them. Renaissance artists like to tease us. Raphael gives us plenty to work with, but he's created zones of unknowing to stimulate educated guesswork. Who are those students of Euclid anyway?

What we see in the *School of Athens* is less a set of symbols, or even *a* philosophy, than the activity of thinking itself. What Raphael shows is instantly recognizable vignettes of dialogue, demonstration, contemplation, lecturing, note taking, copying, learning, writing. He makes visible the mostly invisible universe of the intellect, which is something rare for an artist to pull off. Our age is particularly bad at it. How many times do we have to see the clichéd sequence of a head scratch, a furrowed brow, and the eureka-moment? The tradition Raphael inherits is only marginally better. Early Renaissance altarpieces occasionally portray a "sacred conversation" where theologians stand around looking like they're thinking deep thoughts. Another artistic tradition familiar to Raphael is the allegorical portrayal of the intellect as Dame Philosophy. Above the *School of Athens*, in fact, is Raphael's version of that tradition, a tondo of a woman holding two books, *Moralis* and *Naturalis*. She's doubly flanked: first, by statues of the many-breasted goddess of nature; second, by genii, one holding the sign "*causarum*," the other "*cognitio*," forming Cicero's phrase "the knowledge of causes." The image signifies that philosophy is to be understood broadly as the inquiry into the ultimate principles of

the universe and the good. But given the processes of knowledge-seeking below Dame Philosophy, no viewer has ever cared over-much about her symbolism. It's like the allegorical image is there simply to highlight how far Raphael has come in breaking through to the living reality.

One of my favorite examples of Raphael's vividness is the young man, on Aristotle's side, who props himself against the building and awkwardly crosses his legs to support his notebook while he jots down a sudden idea. I also love the figure, on Plato's side, iden-tified variously as Boethius, Anaximander, Empedocles, Zeno, or Archytas of Tarentum, who cranes over to copy down what Pythag-oras is writing. The old scholar is as ardent as any young student, and his outstretched posture looks just like theirs when they're trying to get caught up on a lesson by copying a neighbor's notes. But the clearest example of Raphael's magic is the scene, in the lower righthand corner, of Euclid's instruction of four students, where you can see an invisible idea flowing in a circuit of education. Stooped over with a downturned bald head, Euclid pours out a geometrical demonstration on a chalkboard on the floor. The idea bounces off the chalkboard onto the pupil whose face has the look of someone who doesn't quite get it yet. Right above his head is the face of another student who's pointing down at the chalkboard and looking up with an expression of dawning understanding: "Am I getting this right?" The student above him is buoyed up by his comprehension of Euclid's lesson: "Yes, I see!" To his right (our left), the final student already understands the proof and is anticipating the next move. To complete the circuit, this student's hand touches the first struggling student's back. Four of the five heads in this astonishing cluster form a compositional circle that contains in its center the head of the student who's in the intermediate stage of understanding. What we see is the electric progress of education itself. It's really a miracle.[6]

It may be known as the *School of Athens*, but it's situated in Rome. Because he was never in Greece, Raphael uses Roman architecture

as a way of envisioning the ideal city-space of philosophy. Mixing his own studies of ancient bath complexes with Bramante's work-in-progress plans for St. Peter's, Raphael creates a corridor of barrel-vaulted spaces pointing back to a triumphal arch that frames Plato and Aristotle. The philosophers have finally earned an arch worthy of their triumph! It's easy to get so taken up by guessing who's who you miss that the *School of Athens* is really about a city and all the beautiful stuff that can happen there: weirdly dressed people chatting, jotting down thoughts in their notebooks, hanging out with friends, trading observations with strangers, wandering around, and enjoying solitude. There's plenty of eccentricity. The environment is part inside, part outside. There's a blend of cultures. There's a mix of generations, including a well-behaved baby. There's an interplay of art and science. There's the absent-mindedness that's really present-mindedness to what matters. The one tragic absence is women—at least to my eyes. Interestingly, my students see in the painting several women that I take to be long-haired flowy-dressed men. There is, however, a decent chance that the mysterious feminine-featured person staring out at us in the lower left is actually the philosopher and mathematician Hypatia, the brilliant fourth-century Alexandrian woman. Then again, that same figure could be Julius's nice-looking nephew Francesco Maria della Rovere, who grows up to get entangled in all sorts of nasty military and political intrigue, and whose eventual death by poisoning may have inspired the play within the play in *Hamlet*. I've also heard the speculation that the female-looking figure is Pico della Mirandola, the Renaissance philosopher famous for his *Oration on the Dignity of Man*. Back to the guessing game!

The other walls of the Stanza della Segnatura provide visual contrasts. The *Parnassus* takes place in a mythologized rustic setting. The *Virtues* is an allegory in the behind-the-scene setting of the powerful. The *Disputation*, opposite the *School of Athens*, finds its ultimate resolution in a utopia atop the clouds. The *School of Athens* is firmly in an open public space. We're not in the realm of

myth. We're not in the halls of power. We're not in the City of God. We're in a city—an ideal city, to be sure, but a realistically ideal city, which is just what a school should be. The other frescoes give us visions of unity: law under the virtues, literature under the Muses, and theology under the Trinity. They're all impressive, but they're not as interesting as the *School of Athens*, which gives us a vision of plurality: philosophy as dynamic interaction. The other frescoes are about finding. The *School of Athens* is about seeking.

Does the plurality in human culture mean that we're doomed to war and division, as Dilthey's nightmare implies? We probably are destined to trouble, but I don't think that the problem is philosophical disagreement as such. Ideological conflicts reflect and exacerbate our strife, no doubt; but the *School of Athens* shows us the believability of a community where differing ideas are bandied about without violence. Given our human limitations, both political and intellectual life will always have their factions, but these factions don't need to be rancorous—even though they often are. My personal experience bears out what we see in the painting: you mostly just need face-to-face conversation and a curious mind. There's a big difference between exploring even the craziest ideas in candid exchanges and using ideas as messaging for powerplays and mob mentalities. We're enlarged and enlivened when we open ourselves up to other voices and visions. The *School of Athens* shows us how beautiful it is when people learn from those whose authority derives from the content of what they have to add to the conversation.

Robert Williams, in *Raphael and the Redefinition of Renaissance Art*, argues that the key to Raphael's achievement is the concept of decorum, the ancient ideal of fittingness that Cicero claims is crucial to holding a civilization together. Drawing on Vasari, Williams identifies three aspects of artistic decorum.[7] First, it's the ability to show things or people as they quintessentially are: the image fits its subject. When Raphael paints Plato, he embodies Platonism. Second, decorum means internal harmony: the image fits together.

The metaphor, going back to Horace, involves the living body. When the parts are misshapen or discordant, the organism suffers. When an artist fuses all the parts into a balanced whole, the work comes alive. Finally, art should treat its environment with grace and respect: the image fits its surroundings. It should reflect and enhance where it is—in the case of the *School of Athens*, the Vatican Library. We naturally recognize the presence of artistic decorum, because it makes the world more beautiful.[8]

When we think of art's ethical dimension, we have a tendency to think about its content: what's the message? But the great philosophers tend to think about its form: how do things like rhythm or color insinuate themselves into our inmost sense of the world and shape our feelings of right and wrong? Following the lead of Renaissance thinkers, Williams argues that artistic decorum helps to generate moral and political decorum.

> Raphael has not only shown the path to good style, he has not only shown how to run an efficient, harmonious, and creative workshop, he has shown [in Vasari's words] "how one should deal with great men, with those of middle station, and with the lowest." He has, in other words, demonstrated the same sense of decorum in his personal conduct as in his paintings. . . . Vasari is not just saying that Raphael is a great artist who happens to be a great man, but that, in Raphael, art completes and perfects itself by disclosing its fundamental relation to morality. Art has moral content, not just because it can illustrate moral subjects, but because, being a form of labor, it is a form of action, and hence, of virtue. Raphael's achievement is to show that the very substance of art is virtue.[9]

Though it runs counter to much of what we currently think, it's worth considering that the art we practice and surround ourselves with, in the aesthetic of its craft, sets the tone for how we live.

Cicero's republican ideal of decorum is related to his skepticism

and his eclecticism: our human minds are unable to know the truth in any absolute sense, though we should strive to find and apply the best ideas we can, always remembering we could be wrong. Part of the grandeur of the *School of Athens* is that its Ciceronian form is totally fused with its Ciceronian content. The plurality of voices and temperaments isn't a problem: it's what underlies and coordinates the gorgeous activity. Raphael's vision of the city, with all its interacting anachronistic thinkers, extends Cicero's vision of the republic through history. Whether the figures of Plato and Aristotle are endlessly debating or temporarily working out a synthesis is less important than that they're engaged in an ongoing conversation where the truth overrides their egos.

Like Cicero, Dilthey comes to the conclusion that though the whole truth is never going to be available to us, a portion of the truth lies in each worldview, and neither the mystical nor the scientific temperament alone is completely sufficient. Like Raphael, Dilthey believes that we find ourselves by becoming citizens of history. Reflecting on the *School of Athens*, he says, "Human beings free themselves from the torment of the moment and from the fleeting character of every joy only by submitting themselves to the great objective forces that history has generated."[10] By reckoning with the zigzags of a historical tradition, we come to see our own moment as historically conditioned, which gives us some necessary humility. We also see possibilities we wouldn't otherwise have seen, which empowers us as seekers of goodness, meaning, and beauty. "Living in history without living in the past / Is what the task is," as the poet Charles Wright puts it.[11]

There's one more lesson—a related one, a mysterious one—that I've learned from looking at the *School of Athens*. The best way I can sum it up is this. Unless we're in conversation—no, unless we *are* the conversation, I'm not really me, you're not really you, the past really isn't the past, and now really isn't now. Here's a humbler way of putting it. Our lives are better off in conversation with the conversation. If we're just spectators of art and ideas, even if we're

exceptionally well-informed spectators, we miss what they're really about.

I mentioned that the lower right corner of the fresco contains Raphael's self-portrait. He's the handsome young man in a dark cap looking out at us. While almost everyone else in the painting is absorbed in contemplation or discussion, the painter exchanges a glance with us. Maybe the man in the white cap in front of him is his teacher Perugino. (Is the guessing game inescapable?! Is life itself the guessing game of what it all means?!) When I look at Raphael's self-portrait, or when Raphael's self-portrait looks at me, I can almost hear what he's thinking: *I'm inside this painting. All artists live inside their work while they're absorbed in making it. You could even say that I'm still in it. My self-portrait testifies to that. Naturally, there's a whole world outside my painting. The world that I imitate in my art. The world that all these philosophers are debating about. You're in this world right now. Plato points up, Aristotle points down. It's the fate of humanity to grapple with those coordinates. I'm looking out, you're looking in. Isn't humanity also to be in and out of art, in and out of philosophy, in and out of all human things? Doesn't our humanity dwell in the back-and-forth of the conversation? Doesn't our individuality lie in the in-between where our gazes meet?*

DETOUR BEYOND A PAINTING TO THE MUSIC OF THE SPHERES

In Raphael's *School of Athens*, the Greek letters atop Pythagoras's tablet spell EPOGDOON. Below are the numbers VI (6), VIII (8), VIIII (9), and XII (12), each of which is connected to the others with various looping lines that contain more Greek words: DIATESSERON, DIAPENTE, and DIAPASON. At the bottom is a sequence of ones (I) in a pyramid of one, two, three, four, which is known as the tetractys.

Epogdoon means "on top of an eighth." It refers to the mathematical process of adding a number to an eighth of itself. For instance, $8 + (8 \times 1/8) = 9$, and so the *epogdoon* of eight is nine. Another example: $16 + (16 \times 1/8) = 18$, and so the *epogdoon* of sixteen is eighteen. Plu-

FIGURE 11.2 · Diagram of the tablet near Pythagoras in Raphael's *School of Athens*, reproduced by the artist and art historian Giovanni Pietro Bellori in 1751.

tarch claims that Pythagoras hated the number seventeen, because it separated sixteen from its *epogdoon*. The beauty of eight and nine is that they're natural numbers with nothing separating them from their *epogdoon*.

The number sequence atop the tablet—6, 8, 9, 12—gives us a set of ratios on the basis of the *epogdoon* (9:8—the major second): the *diatesseron* (8:6—the perfect fourth, which is 4:3), the *diapente* (9:6—the perfect fifth, which is 3:2), and the *diapason* (12:6—the octave, which is 2:1). Notice that these ratios are formed of the relationships of the numbers one, two, three, and four that appear at the bottom of the tablet. These ratios supply the tuning for the tetrachord of the Lyre of Hermes, the strings of which correspond to the four seasons, the four humors, the four elements, and the four phases of the moon. The tetractys also signifies the organization of space: one makes a point, two makes a line, three makes a plane, and four makes a tetrahedron in three-dimensional space. To top it all off, 1 + 2 + 3 + 4 = 10 (the X at the bottom), the base of the decimal numeral system, as well as the number of fingers on our two hands. Pythagoras uses the tetrachord in the project of mapping the planetary chord of the heavens: the music of the spheres.

In *The Hitchhiker's Guide to the Galaxy*, Douglas Adams speculates that the "ultimate answer to life, the universe, and everything" is forty-two. Nope, it's actually *epogdoon*. The universe is a palace of eighth notes.

Though he was certainly grateful for the heady proportions that helped him with his art, my guess is that Raphael cared less about mathematically answering the universe's puzzle than about visually distinguishing Pythagoras from his counterpart Euclid. Whereas Euclid is patiently walking his students through a proof, Pythagoras is completely absorbed in his own work. In contrast to Euclid's students who follow each step, Pythagoras's disciples have to bend around the master to see his mystic formula, which a youthful figure holds as if in a game of keep-away. Here Raphael shows us how intellectual growth can be enlivened by the mystery of an intense thinker. Some truths must be understood privately, in their own sweet time, in a flash of math presenting itself as music.

THINGS TO SEE AND CONSIDER:
ROME AS THE RENAISSANCE

In his essay "On the Uses and Disadvantages of History for Life," a primer for philosophical travel (though, funnily enough to an American like me, directed at a German audience whose big problem was caring too much about historical knowledge), Nietzsche says that a traveler to Rome can learn "the greatness that once existed was in any event once possible and may be possible again." All it takes is "a hundred men educated actively working in a new spirit to do away with the bogus form of culture . . . The culture of the Renaissance was raised on the shoulders of just such a band."[12] You might also learn from Rome's High Renaissance that what's truly revolutionary is a return to the source. There's nothing like repetition to show originality! Bramante's **Tempietto** (1502) of **San Pietro in Montorio**, a textbook example of flawless architectural balance, looks back to various circular Roman temples, like the

Forum's **Temple of Vesta**, while it also looks ahead to Bramante's complete overhaul of **St. Peter's Basilica** (begun in 1506). You can see an earlier version of the aesthetic in the **Bramante Cloister** (begun in 1500) in **Santa Maria della Pace**, which also contains Raphael's *Sibyls Receiving Instruction* over the arch to the **Chigi Chapel**—yes, Agostino Chigi. Raphael's main surviving architectural work is another **Chigi Chapel**, in the **Basilica of Santa Maria del Popolo**, where Raphael's friend and patron was buried. Among Raphael's many paintings in Rome, some of my favorites are in the **Galleria Borghese**: *The Deposition of Christ* (1507), *Portrait of a Man* (ca. 1502), and *Portrait of Young Woman with Unicorn* (ca. 1506), which all resurrect the old Ciceronian ideal of decorum in color and form. As masterful as Michelangelo was as a painter (though while you're in the **Sistine Chapel**, try to spend a little time looking away from his work at the other masterpieces by Botticelli, Perugino, Signorelli, Ghirlandaio, and others) and as an architect (see his wonderful **Basilica of Santa Maria degli Angeli e Martiri**, the awe-inspiring **Dome and Drum of St. Peter's Basilica**, or the mesmerizing **Campidoglio**), Michelangelo's greatest talent was coercing life from stone, like the tender tragedy of the *Pietà* (1498–99) in **St. Peter's Basilica**, the sinuous new aesthetic of the *Risen Christ* (1519–20) in **Santa Maria sopra Minerva**, or the commanding charisma of the *Moses* (1513–15) for **Julius II's Tomb** in **San Pietro in Vincoli**. It's said that Michelangelo, in a moment of frustration, struck that last masterpiece with a hammer, hollering, "Speak to me!" A nick in Moses's knee can be cited as evidence. Interestingly, Rome's *statue parlanti* (speaking statues) did start speaking up in Michelangelo's time. The original talking statue is the *Pasquino*, a beat-up Hellenistic fragment right off the **Piazza Navona**, on which Romans ever since the sixteenth century have been posting notes grumbling about injustice and lampooning the dysfunctional government. What ancient statues mostly said to Michelangelo was, "Learn the human body from me!" The main figure of **Laocoön and His Sons** was used by Michelangelo as the model for Christ in the *Last Judgment*

(1536–41)—though in its presence we've left the High Renaissance for what's classified as Mannerism. The **Belvedere Torso** (ca. 100 BC) was used by Michelangelo as the model for various figures on the **Sistine Chapel Ceiling** (1508–12) as well as Bartholomew in the *Last Judgment*, the resurrected saint holding the attribute of his martyr-dom, a flayed skin-sack that many consider to be Michelangelo's self-portrait.

12

UNLOCK THE SOUL IN YOUR SOUL

Giordano Bruno in the Campo de' Fiori

> Tutto, tutto, tutto è memoria (Everything, everything,
> everything is memory).
> GIUSEPPE UNGARETTI

It's easy to forget—in an age of online shopping, transnational corporations, and omnipresent advertising—that words like "markets" and "marketplace" aren't just synonyms for "the economy." Once upon a time they described real spaces open only at certain times. Splendidly, Rome's Campo de' Fiori remains a market*place*. Packed during the day with temporary stalls and their customers, lined with restaurants and shops, and fed by streets with names like Via dei Giubbonari (Street of the Tailors) and Via dei Cappellari (Street of the Hat Makers), it's a kind of modern forum, where economics has pushed the work of politics to faraway buildings, but public life lingers on in the newspapers and spirited conversations under the vendors' umbrellas.

FIGURE 12.1 · Ettore Ferrari, *Sculpture of Giordano Bruno* (1889), Campo de' Fiori. When Bruno first came to Rome and visited the place where he was eventually to be burned at the stake, he wrote, "A mixture of desperate souls . . . you'll find as many as you like in Rome, in Campo de' Fiori." Quoted in Ingrid D. Rowland, *Giordano Bruno: Philosopher/Heretic* (Chicago: University of Chicago Press, 2008), 78.

Towering over the hustle-bustle of the Campo de' Fiori is a monument to Giordano Bruno, who broods philosophically on the boxes of bright vegetables and "I ♥ Rome" T-shirts. An expression of Italian nationalism, the sculpture by Ettore Ferrari was erected in 1889 as a defiant gesture against the former papal domination of the country. Though it's melodramatic in a nineteenth-century manner, I wouldn't change a thing about it. I love how the hooded thinker casts a dark spell over the noisy piazza of for-sale modernity. The inscription reads, "*A BRUNO—IL SECOLO DA LUI DIVINATO— QUI DOVE IL ROGO ARSE*" (To Bruno—from the century foretold by him—here where the pyre burned), for it's on this spot in the Campo de' Fiori that Bruno was burned at the stake by the Roman Inquisition on February 17, 1600. For good measure, they stopped his tongue with an iron spike (or perhaps a leather gag), fearing his eloquence at the moment of death. The modern myth is that the philosopher was executed for refusing to bow to authority even when he was threatened with death after challenging the willfully ignorant church on behalf of the new heliocentric science. Like most myths, it's mostly true but not in the way most people think. Bruno was indeed executed for his intellectual defiance of Catholic dogma—just not exactly for his belief in science and free speech. He also anticipates aspects of modernity—just not really in the reason-versus-faith sense. In fact, the Nolan, as he calls himself, channels very unmodern energies, blending them with modern ideas in a weird but visionary philosophy. The philosophical martyr, resurrected in bronze, now glares obstinately in the direction of the Vatican. On the anniversary of his execution, various freethinkers gather at the monument to lay flowers at his feet. Even those who don't believe in God need saints!

In her poem "What He Thought," Heather McHugh tells the story of some contemporary American poets at a restaurant in the Campo de' Fiori. One of them asks if the nature of poetry is closer to the everyday hubbub of the marketplace or the grand statue of Bruno. McHugh immediately answers, "The truth is both, it's

both." Their host, an administrator in a gray suit (someone you wrongly don't expect poetry from), offers an alternative answer. After describing the riches of Bruno's mind and the horror of the iron spike, he concludes that "poetry is what / he thought, but did not say" right before the flames consumed him.[1] Well, let's try to understand the secret that the Campo de' Fiori's condemned philosopher keeps to himself, for it pertains to the meaning of Rome, the meaning of the Renaissance, the meaning of education, and—well, let's just say it—the meaning of life.

Our story begins with a story, which comes down to us via Cicero, though it was ancient even when he told it in *On the Orator*. Sometime around 500 BC, at a well-attended banquet, Simonides of Ceos chanted a poem commissioned by the host that included praise of the twin gods Castor and Pollux. After it was over, the host—his name was Scopas—gave Simonides only half the agreed-on sum, saying that the poet should collect the balance from the gods whose praises took up half the poem. Just then a knock comes on the door: two young men summoning Simonides. The poet leaves the party. While he's looking for the callers who have now mysteriously disappeared, Scopas's roof caves in. Not only is everybody at the banquet killed, their bodies are so mangled that their families are unable to recognize them for burial. Yet out of the ruins Simonides identifies one after the other by remembering the position of each at the banquet table. The invisible callers, if you haven't already guessed, were the twin gods, who paid their half of the bill by removing the poet right before the building collapsed.

Out of the experience Simonides invents the art of memory, using what's known as the "method of *loci*" or the "memory palace." Cicero explains,

> [Simonides] inferred that persons desiring to train this faculty must select places and form mental images of the facts that they wish to remember and store those images in the places, with the result that the arrangement of the places will preserve the order

of the facts, and the images of the facts will designate the facts themselves, and we shall employ the places and images respectively as a wax writing tablet and the letters written on it.[2]

The basic idea is that you internalize an actual space—say, the Forum—and associate whatever you want to remember with mental things you arrange in its places (*loci* in Latin). Some memory artists became so adept they could recite all twelve books of Virgil's *Aeneid* forward *or backward*, depending on which way they went through their inward space. But most people, it seems, used the system not to recall individual words but to remember organizing topics; in fact, the Greek word for topics—*topoi*—is the name for the memory-places. So, for your four-hour speech (it wasn't uncommon for speeches to go on that long or longer in the Forum) you could associate part one with something you place in front of the Curia, part two with something in the Basilica Aemilia, etc., and then move through it mentally without leaving anything out, relying on your genius to improvise on each topic, or perhaps having learned the words of each part by rote. (It's likely that the expressions "in the first place" and "in the second place" derive from the method of internalizing *loci*.) Simonides's discovery—built on tragedy—is that our minds are associative and form memories by relating the new to the known, particularly to a familiar spot. Remembering one thing by itself is next to impossible, but remembering two things together is a cinch.

To appreciate the historical importance of memory palaces, you have to remember that people didn't always have published material, like books or the internet, in the widely available form to which many of us nowadays are accustomed. Oratory was not only the primary way of conveying a message but a major form of entertainment—in a courtroom-drama sort of way. Also, intellectuals would often encounter ideas only once, by way of a lecture or maybe a brief appointment with a manuscript. Since memory could be offloaded only up to a point onto scrolls and libraries,

there was a need for serious powers of recall. Memory couldn't be left to a passive faculty: it had to become a highly developed art.

What was a practical technique in the ancient world, mainly for orators and intellectuals, acquired a spiritual significance in the Middle Ages. Albertus Magnus and Thomas Aquinas recommend that the faithful use the "artificial memory" as a way of stamping the virtues and vices on their souls as a roadmap away from hell. Frances Yates, in her magnificent *The Art of Memory*, conjectures that medieval churches were physical incarnations of memory palaces. Speaking of the *Summa Theologiae*, with its 3,125 articles of Christian wisdom, she says, "The extraordinary thought now arises that if Thomas Aquinas memorized his own *Summa* through 'corporeal similitudes' disposed on places following the order of its parts, the abstract *Summa* might be corporealized in memory into something like a Gothic cathedral full of images on its ordered places."[3] It's a perfectly reasonable speculation, given that for the mostly illiterate medieval churchgoers, the chapels, frescoes, icons, and statues of their houses of worship *were* their mythology, their aesthetics, their ethics, their metaphysics.

By the time the art of memory entered the Renaissance, it had taken on a magical dimension. The pivotal figure was Ramon Llull (1232–1316) whose twist was to internalize not just places but concentric wheels, which could be inwardly spun to generate novel ideas. By arranging fundamental concepts in combinatory patterns, Renaissance memory artists, taking Llull as their inspiration, tried to summon divine wisdom and wield magical powers. Does the idea of magic here strike you as farfetched? It shouldn't. The "artificial memory" prefigures what now envelops us in the form of "artificial intelligence," which also uses combinatory algorithms to summon into existence a creative intelligence—or the semblance of it—capable of performing superhuman feats of mathematics, marketing, spell-checking, or chess. With Bruno, whose teaching of this supercharged art of memory was his chief way of making

a living, it revealed a different kind of power: the magic of the Renaissance itself.

Born in the small rundown town of Nola, Giordano Bruno (1548–1600) moved from city to city and country to country in search of illumination and spiritual kinship. His uprooted rootedness makes him one of the first true Europeans. As a teenager the Nolan entered the Dominican order in San Domenico Maggiore in Naples (its art and architecture helped furnish his personal memory palace) and, after entering into conversation with the ancient philosophers, including Lucretius and the Stoics, began to rethink the fundamental tenets of Christian faith. He traveled to Rome and lived in the convent of Santa Maria sopra Minerva, where thirty-three years after Bruno's execution Galileo would be forced to deny heliocentrism. Soon the Roman Holy Office prepared an indictment for heresy against Bruno (one of the charges: having read books by Erasmus). He struck off before they could arrest him, setting up shop over the next two decades as a lecturer, monk, or memory tutor in Noli, Savona, Turin, Venice, Padua, Lyons, Geneva, Paris, London, Marburg, Wittenberg, Frankfurt. After being turned over to the Venetian Inquisition, he was transferred to Rome and spent the last seven years of his life in a pontifical prison not far from where the construction of St. Peter's Basilica was wrapping up.

Forget the glum scowl on the monument in the Campo de' Fiori. Bruno was exuberant, imaginative, cranky, and pugnacious. Here's the salutation of his letter of application for an academic post at Oxford—mind you, this is just the salutation:

> Philotheus Jordanus Brunus Nolanus, doctor of a more sophisticated theology, professor of a more pure and innocent wisdom, known to the best academies of Europe, a proven and honored philosopher, a stranger only among barbarians and knaves, the awakener of sleeping spirits, the tamer of presumptuous and stubborn ignorance, who professes a general love of humanity in

all his actions, who prefers as company neither Briton nor Italian, male nor female, bishop nor king, robe nor armor, friar nor layman, but only those whose conversation is more peaceable, more civil, more faithful, and more valuable, who respects not the anointed head, the signed forehead, the washed hands, or the circumcised penis, but rather the spirit and culture of mind (which can be read in the face of a real person); whom the propagators of stupidity and the small-time hypocrites detest, whom the sober and studious love, and whom the most noble minds acclaim, to the most excellent and illustrious vice-chancellor of the University of Oxford, many greetings.[4]

His preferred way of referring to most academics was "pedantic asses." He thought of himself, by contrast, as a "holy ass."

The academic asses of Bruno's day came in two varieties: the trendy humanists whose Ciceronian etymologies trumped their desire for self-knowledge and the fuddy-duddy Aristotelians whose long-standing theories, though showing distinct signs of weakness, were still oppressively dominant. When Bruno was at Oxford, a five-shilling fine was levied against students or teachers caught disagreeing with Aristotle's *Organon*.[5] While he doesn't reject every aspect of Aristotelian thinking, Bruno bucks against most of it. For instance, while Aristotelians hold that "substances" are individual beings and "accidents" are the various features and attributes of substances, Bruno posits that God is the one great substance and what we perceive as individual beings are God's accidents.

There is one simple Divinity found in all things, one fecund Nature, preserving mother of the universe insofar as she diversely communicates herself, casts her light into diverse subjects, and assumes various names. See how we must diversely ascend to her by partaking of various endowments; otherwise we, in vain, attempt to contain water in nets and catch fish with a shovel.[6]

In Bruno's vision, God is the inner essence of nature. "If [God] is not Nature herself, he is certainly the nature of Nature, and is the soul of the Soul of the world."[7]

A related aspect of Aristotelianism that Bruno rejects is the geocentric model of the universe, amplified by Ptolemy, that served for the prior millennium as the cosmological foundation for the church. On the geocentric view, the whole universe is a finite globe made up of concentric spheres, sort of like the layers of an onion or the tiers of the Catholic hierarchy. Everything has a natural place in a graded order. On Bruno's view, the universe is an endless expanse swirling with an infinite number of solar systems roughly like ours. There's no such thing as a natural or higher place in the universe. There are only relative places in a never-ending expanse.

There are at least two aspects of heliocentrism that recommend it to Bruno. First, it's suggestive of his idea that God is at the center of everything. The universe turns on God, just as we turn on the sun. Part of what makes Bruno's heliocentrism challenging to the church is the implication that God doesn't need to be handed down to us through an ecclesiastical hierarchy. God is to be found within. "We have the knowledge not to search for divinity removed from us if we have it near; it is within us more than we ourselves are."[8] Second, the Copernican system holds that the earth moves. Since self-motion is a sign of life (this is an aspect of the old Aristotelian view that Bruno accepts), the whole universe, including our home planet, must be alive. In Bruno's wild recursive vision, where Lucretian atomism has been infused with both Stoic animism and heliocentric science, infinite living solar systems blaze around God, while God blazes deep in all things.

Though Bruno endorses heliocentrism, it's hard to describe his approach, relying more on insight and intuition than observation and math, as scientific. He'd definitely be on Plato's side in the *School of Athens*. But is method all that counts in science? The funny thing is that the Nolan's poetic ideas about physics are often closer to the truth than his scientific contemporaries' hypotheses. Bruno

holds that ours is but one solar system among countless solar systems, that there is no true up or down, that there is likely life on other planets. He correctly intuits what happens when an object is dropped from the top of a masthead on a moving ship, even if his reasoning for it doesn't quite add up. Let's not forget that even Galileo, for all his brilliant logic and careful observation, uses more than just scientific method to rule out the geocentric model. All great scientists work on hunches and make speculative leaps. I admit that Giordano Bruno doesn't belong at the center of the history of science. But his mysticism shouldn't be totally excluded from it. As Johannes Kepler writes in a letter to an illustrious friend, "Those who can conceive the causes of phenomena in their minds before the phenomena themselves have been revealed are more like Architects than the rest of us, who consider causes only after they have seen the phenomena. Do not, therefore, Galileo, begrudge our predecessors their proper credit . . . you refine a doctrine borrowed from Bruno."[9]

Bruno's mystical philosophy is part of what's known as the Hermetic tradition. The *Corpus Hermeticum* is a body of Egyptian-Greek texts, rendered from Greek into Latin by Marsilio Ficino around 1500, in which Hermes Trismegistus—the Thrice-Great Hermes—reveals wisdom to his disciples about the soul's ascent to God. Cicero speaks of five different Mercuries, a.k.a. Hermeses, the last of whom killed the many-eyed giant Argus and fled to Egypt, where he was known as Thoth, the scribe of the gods. Though shortly after Bruno's death it was argued that the texts of the *Corpus Hermeticum* actually date from around the second century AD, it was believed throughout the Renaissance that they predated Plato and were the ancient writings of Thoth, a.k.a. Mercury, a.k.a. the Thrice-Great Hermes. In any case, Bruno holds there's an all-encompassing wisdom that has been taken up by various philosophies and religions—including Judaism and Christianity, as well as Platonism and Greco-Roman mystery cults. The Nolan hopes to

revive the primordial Egyptian truth, associated with sun-worship, in the dawn of heliocentric science.

At the center of Bruno's Hermeticism is the doctrine of the coincidence of opposites. Our experience of reality is that it doubles up into day and night, up and down, for and against, old and new, etc. When we cling to one side of an opposition, our knowledge is partial and always open to being challenged by those who cling to the other half of the truth. We must ascend to an intellectual vision that sees the dynamic unity of the opposition itself. Like the pre-Socratic philosophers, Bruno is particularly fascinated by the opposition of the one and the many, stillness and movement. In his view from above, the universe is an infinite number of moving finite beings (think of the wheeling starry sky or Rome on a busy day) and simultaneously the infinite stillness of God (think of the ordered constellations or the Eternal City). To reconcile the infinite many and the ultimate one, Bruno uses the ideas of microcosm and macrocosm. Individual finite beings are mirrors of the infinite one. God's whole starry universe is reflected in each of us. Each of us is made in the image of God. As Virgil says, *"Iovis omnia plena"* (All things are full of Jove).[10]

How do we find the divinity symbolized by heliocentrism? How do we arrive at the vision of unity that can reconcile maximal opposition? The short answer is love—not exactly the normal affections and attractions we feel (though sexual intercourse, Bruno admits, is "the sweetest fruit which the garden of our earthly paradise can produce"[11]), but those affections and attractions when they're intensified: the divine madness of love, what the Nolan calls "the heroic frenzies" (*gli eroici furori*). Our frenzies are heroic when they engage mind and spirit with equal force, and our whole being catches fire. Inspiring teachers, brilliant ideas, beautiful artwork, great wine—they all have the power to inspire heroic energies in us. Rome has the power in spades.

In a long line of mystical works that begins with Plato's *Sym-*

FIGURE 12.2 · Giordano Bruno, *Figura Amoris* (1588). This is Bruno's woodcut of what love looks like. He explains, "The [image], which is expressed in circles or in tangents that intersect with each other, is called the figure of Love, because the substance of the universe is opposition and concord, as it maintains contraries perpetually in concord, in the concordance of opposites, the union of differences and in difference of unions, the multitude united and the unity in the multitude." See Guido del Giudice, "Bruno e l'enigma degli archetipi," *La Biblioteca di Via Senato* 6 (2014): 28–31.

posium and includes Apuleius's *Golden Ass*, Bruno's *Heroic Frenzies* shows that love, awakened by experiences of beauty, leads us to God—not, in this case, the up-in-the-heavens God but the Nolan God-in-nature. In various philosophical dialogues around a set of his sonnets, Bruno shows how love is the revelation of the coincidence of opposites. His preferred metaphor for love is fire. Not only does fire transform and incorporate whatever it touches, it's suggestive of the sun at the center of everything. His poetry tracks the turbulence of its transformative power. Love torments you, and there's sweetness in the suffering. Love enslaves you, and you're never freer. Love's sensuality leads to its spirituality, and its spirituality makes your flesh tingle. Love humiliates you and somehow calls forth your highest self. Love heroically and do as you will!

Heroic love is essentially the worship of the Goddess. Our fren-
zies are ultimately for Diana, who can be thought of as the holy
appearance of the physical universe, the finite mode of the infinite
being, or the triple goddess of beauty, truth, and goodness. We
worship her not by suppressing our bodily drives and trying to be
angels or by shutting off our minds and behaving like beasts but by
finding the musical harmony of mind and body and coming alive
as human microcosms of her universe. Whenever we give ourselves
over to the love of anything capable of inspiring heroic frenzies,
we reap the here and now, which is also the infinite and forever.
More coincidences of opposites: God and Goddess, masculine and
feminine, finite and infinite, now and forever!

Whereas Dante, with his geocentric cosmology, turns away from
his beloved to make the final ascent to God, Bruno's heliocentric
vision puts the divine at the center of all lovers. Our being orbits
around the beloved subject or object. The way we consummate love
is through memory, which in its effort to hold time is ultimately
the attempt to recollect the infinite oneness from which everything
springs and to which everything owes its existence. The secret of
Bruno's memory palace is to make the mind resemble the order
of the universe itself. In a Neoplatonic twist, Bruno sees images as
"shadows" of the principles that illuminate reality; he particularly
likes astrological and mythological imagery. When we arrange
these shadows in meaningful patterns in our mind, like planets
around the sun, we channel the cosmic power inside everything. It's
like how a bunch of everyday words, when arranged rhythmically
in an act of inspiration, become an unforgettable poem. Bruno's
aspiration is to make his entire mind an unforgettable poem.

What keeps Bruno from being a straightforward pantheist is
his view that we'll never be totally one with the One, for God and
love are inexhaustible. "It is evident that the light is beyond the
circumference of the soul's horizon, but the soul will always be
able to penetrate it more and more; similarly, nectar is infinite and
the source of living water is inexhaustible, so that the soul can

become ever more and more intoxicated."[12] By experiencing and remembering what we love, we're always bringing out more of who we are. God is always more infinite than we imagine. There's always another floor to crash through. A less Nolan way of putting the point is that you never say of anyone or anything you truly love, "Been there, done that." You can always book another trip to the Eternal City.

Bruno's writings on the art of memory are sublimely disorienting. His discipline clearly isn't a shortcut to what we narrowmindedly think of as practical ends. It's a thick web of connecting everything to everything else. By stocking his mind with various symbol systems and putting them into interactive orders, Bruno is able to unlock the Soul in his soul. Not only do creative ideas arise from his memory palace, he loads these ideas with symbolism in formidably inventive books like *The Expulsion of the Triumphant Beast*, *The Lantern of Thirty Statues*, *The Incantation of Circe*, and *The Kabbalah of the Pegasean Horse*. James Joyce, who incorporated Bruno's philosophy into his own memory-palace masterpieces, once observed, "Chance furnishes me what I need. I am like a man who stumbles along; my foot strikes something. I bend over, and it is exactly what I want."[13] When your memory is as well-stocked as the Dubliner's or the Nolan's, not only can you relate practically anything to what's on your mind (everything, after all, is one), the valves of your attention are so wide-open that you can zero in on what's necessary for your work — sort of like how an expert birder can spot in a distant tree the warbler nobody else notices. When you make your mind a poem, you become a poet. That's the magic.

In 1592, a nobleman by the name of Giovanni Mocenigo hired Bruno as a memory tutor. Soon disgruntled that he wasn't getting any shortcuts to black magic, Mocenigo denounced his teacher to the Venetian Inquisition. One of his charges was that Bruno wanted to found a new religious sect under the name of philosophy.[14] Another was that Bruno warned against killing a spider, as it might possess the soul of a friend. After being arrested and imprisoned for

several months in Venice, the Nolan was transferred to Rome, for a cellmate of his had sent a letter to the Roman Inquisition reporting that Bruno had revealed outlandish beliefs like there is no hell, for nobody should be damned forever; there are many worlds throughout the universe; Jesus was a mortal sinner like the rest of us; it's absurd to pray to saints in the belief that they'll actually intercede on our behalf; and nothing that the church believes is provable.[15] Bruno would wake in fits at night, curse God for the asses who were tormenting him, and give the finger to the heavens before falling back asleep.[16] Say what you will about the church's condemnation of Bruno, it's hard to argue that in his daring to be wise he didn't hold heretical positions—well, at least by the standards of Catholic orthodoxy. What really got Bruno into hot water was his refusal to accept that his beliefs were heretical—sure, maybe "heretical" relative to those who held power, but how could they be genuinely heretical if they held the truth?

After years of arguing with his inquisitors, Giordano Bruno faced death and embraced the end of his journey. Cardinal Bellarmine demanded a recantation of his philosophy, the Nolan refused, and Pope Clement VIII sentenced him to be executed. Bruno responded, "You may be more afraid to bring that sentence against me than I am to accept it."[17] In the jubilee year of 1600, on the day after Ash Wednesday, a day of Christian repentance, Bruno mounted an ass and was taken in chains to the Campo de' Fiori. Tied to a stake and burned alive, he was consumed by the excruciating reality of his favorite metaphor for our union with God. His punishment was to be made into a sun in the center of the marketplace as lesser lights revolved around him. "Before the flames had died," as Czesław Miłosz writes in his great poem on the Campo de' Fiori and the nature of history, "the taverns were full again."[18]

So, what exactly is the mystery known to the Campo de' Fiori's philosopher? What was the eloquence that the iron spike prevented him from revealing? As much as I've been trying to point to it in my swift tour of his philosophy, it can't really be said. (I think of

the title of one of Bruno's works: *Of Innumerable Things, Vastness, and the Unrepresentable*.) Like all mysteries, it must be known by first-hand experience and requires divine madness, hard work, and dumb luck. But I'll take one last stab at pointing you in the general direction of the vastness—with the caveat that I'm speaking to you in a Nolan spirit, not describing Bruno's philosophy to the letter.

You've been cheated into thinking that memory is a storage unit of information. Maybe you've offloaded its work onto your photo albums and hard drives, as it was being offloaded in Bruno's time onto libraries and art collections. Maybe you've even been brainwashed into thinking of education as nothing more than skills, topics, and facts—or, worse yet, tests and diplomas. If you absorb these insults to your humanity and turn into nothing but a competent functionary and a distracted spectator, if you make your own intelligence artificial, you may as well put under your Facebook photo, "Preceded in death by myself." Build not thereon! Your mind is actually a starry dynamo, capable of shaping and reshaping reality into truth, goodness, and beauty. Unlock the Soul in your soul! You have an imaginative knack like Rome's power to reinvent itself out of its ruins, and, even more cosmically, nature's power to remake itself out of itself.

It's not enough for the days and the seasons to happen on a weather app, or for paintings and sculptures to rest in museums, or for stories and ideas to sit on shelves. It's definitely not enough to upgrade the memory on your computer. Observe the tempo of nature. Look at art. Memorize poems. Internalize a tradition of history and philosophy. Wander aimlessly and pay attention. Hold humanity sacred. When the spirit moves you, arrange your thoughts and memories in various patterns—in fact, think of your soul as the music of those patterns. Listen to the kind of music without which the universe would be a mistake. Consult the landscapes and cities you know, because their topography will guide you. Look up at the stars and see what you can learn. Practice the crafts of making and thinking that help you to realize your talents.

Be not for yourself alone. With love as your architect, make a palace of your memory. Here's how Frances Yates puts it:

> For the secret, the Hermetic secret, was a secret of the whole Renaissance. As he travels from country to country with his "Egyptian" message Bruno is transmitting the Renaissance in a very late but peculiarly intense form. This man has to the full the Renaissance creative power. He creates inwardly the vast forms of his cosmic imagination, and when he externalizes these forms in literary creation, works of genius spring to life . . . It was Bruno's mission to paint and mould within, to teach that the artist, the poet, and the philosopher are all one, for the Mother of the Muses is Memory. Nothing comes out but what has first been formed within, and it is therefore within that the signifi-cant work is done.[19]

For what it's worth, whatever I possess of memory's magic is responsible for this book.

THINGS TO SEE AND CONSIDER:
ROME AS THE MEMORY PALACE

Though you should examine Ettore Ferrari's **Statue of Giordano Bruno** (1889), with its reliefs of the trial and execution on the base, the sculpture is mostly worth experiencing as part of the **Campo de' Fiori**. You can contemplate it from one of the restaurants on the square. But if you're looking to have your food inspire heroic frenzies, you should plan ahead and book a table at **Roscioli**, just a block down the Via dei Giubbonari (Street of the Tailors). It's only a ten-minute walk from there to **Santa Maria sopra Minerva**, the abbey of which was Bruno's residence in Rome on his first stay. The name speaks to the Nolan philosophy: a Christian church built over a temple to the Egyptian goddess Isis who was identified as Min-erva, the Roman name for the Greek goddess of wisdom. It was in a

room in this church's convent that Galileo was forced to recant that our planet revolves around the sun. Legend has it, as Galileo was led to house arrest, he grumbled under his breath, *"E pur si muove"* (And yet it moves). Beyond Santa Maria sopra Minerva's tombs and art (including Michelangelo's *Risen Christ* [1519-20] and Bernini's *Memorial to Maria Raggi* [1647]), the philosophical tourist will want to see the astonishing **Carafa Chapel** by Filippino Lippi, which contains a depiction of how *"sapientia vincit malitiam"* (wisdom defeats evil), the fresco I mentioned in my discussion of the *School of Athens*, where Thomas Aquinas—the rare Aristotelian whom Bruno admired—is serenely defeating all heresies. Right outside the church is Bernini's *Elephant and Obelisk* (1667), which raises the question of why Romans and everyone else are so fascinated by obelisks. In Rome there are eight ancient Egyptian obelisks, five ancient Roman obelisks, and any number of more modern ones. The crass Freudian hypothesis probably shouldn't be dismissed. The Hermetic answer is that we love obelisks because they point us, literally and historically, to our most ancient form of sun-worship. In the **Piazza della Rotonda**, right in front of the **Pantheon**, is an obelisk that was found near Santa Maria sopra Minerva, originally from Heliopolis. Ficino—and perhaps Bruno—believed that Hermes Trismegistus himself wrote Egyptian hieroglyphs on the obelisk, and their cryptic imagery contains the same wisdom as can be gleaned from his philosophical writings. May you be so lucky as to see the **Borgia Apartments** in the **Vatican Palace**, decorated with gorgeous frescoes by Pinturicchio (I've seen them but once; they're not always open to the public). In the **Room of the Liberal Arts** are depictions of queens on thrones allegorizing the Trivium and Quadrivium. In the **Room of the Saints** are scenes of Mercury killing Argus and Hermes Trismegistus talking with Isis and Moses. Why would the church, which would soon persecute Bruno for his Hermeticism, decorate their walls with Egyptian magic? Frances Yates speculates that it was a momentary reversal of policy, just in case there was indeed something to it. What church or palace in

Rome can't be read as a memory palace? Freud, you will recall, sees Rome itself as an image of the human mind with its stacked layers.

DETOUR OF THE LITTLE SOUL
BEHIND THE PANTHEON

For a long time, I found the inscription on the Pantheon baffling. If you fill in the abbreviations, it translates, "Marcus Agrippa, son of Lucius, thrice consul, made [this]."[20] The baffling thing is that Marcus Agrippa died a century before the Pantheon was built. It's true that Agrippa had a structure built on the site, perhaps even one dedicated to all the gods, but it burned down well before Hadrian commissioned what stands there to this day.[21] Why would an emperor go out of his way to avoid taking credit for one of history's most marvelous pieces of architecture? Why would he commemorate a predecessor instead?

While working on this book, I kept thinking about the Pantheon as the memory palace of Rome itself. Behind its striking pediment, it swirls together gods, saints, and artists in the great brain of its concrete dome. I recalled a passage in Marguerite Yourcenar's novel *Memoirs of Hadrian* where the emperor dreams up the Pantheon.

> More and more the different gods seemed to me merged mysteriously into one Whole, emanations infinitely varied, but all equally manifesting the same force; their contradictions were only expressions of an underlying accord. The construction of a temple of All Gods, a Pantheon, seemed increasingly desirable to me.[22]

Then I came across something I hadn't remembered, something that gave me a clue to the inscription: "Even in my innovations I liked to feel that I was, above all, a continuator."[23] That peculiar word "continuator" made me think of the end of the novel, one of my all-time favorite passages, when Hadrian is facing his death.

Life is atrocious, we know. But precisely because I expect little of the human condition, man's periods of felicity, his partial progress, his efforts to begin over again and to continue, all seem to me like so many prodigies which nearly compensate for the monstrous mass of ills and defeats, of triumph and error. Peace will again establish itself between two periods of war; the words *humanity*, *liberty*, and *justice* will here and there regain the meaning which we have tried to give them. Not all our books will perish, nor our statues, if broken, lie unrepaired; other domes and other pediments will arise from our domes and pediments; some few men will think and work and feel as we have done, and I venture to count upon such continuators, placed irregularly throughout the centuries, and upon this kind of intermittent immortality.[24]

Marcus Agrippa, son of Lucius, thrice consul, made this. Thanks to Yourcenar, the inscription made sense to me. It's reminding us that we're carried along by family, politics, art, and culture. We're the future that our predecessors dreamed and made in the past. Think of a mathematical sequence like 1, 2, 4, 8. It's not necessary to express 16 or 32, even though those numbers are part of it. Likewise, without saying his name, the inscription conjures Hadrian as the continuator of a sequence.

When we're young, we dwell in the possibilities we feel inside ourselves. We live in all the lives we could lead. Our projected self is enormous. As we grow older, and door after door slams shut behind us, we're forced to confront the only life we'll ever lead. Our actual self is quite small. Whatever we are is dwarfed by everything we're not, even if we're emperor of Rome. It's common at this point to want our name on a building, literally or metaphorically. But what if instead of trying to shore up our ego against the ravages of time, we strive to be repairers and continuators of what others have begun? What if instead of placing our life against its numerous

foreclosures, we think of it as an ongoing contribution to a palace of memory?

After having lived as a continuator of a vital tradition, Hadrian was able to face the little bit of life that came and went with him. The only poem he's known to have written is his epitaph.

> Animula, vagula, blandula,
> hospes comesque corporis,
> quae nunc abibis in loca,
> pallidula, rigida, nudula,
> nec ut soles dabis iocos?

What good tone in the face of death! Here's my stab at a translation.

> Little soul, little tramp, little scamp,
> friend and guest of this body,
> where are you off to now,
> so stiff, so pale, so frail,
> not joking like you used to?[25]

The little soul suffers and has some fun. The little soul gets a chance to contribute to a dome and a pediment. Then the little soul must be moving on. It's sad. But it's no big deal. Life's a detour. The last line of Yourcenar's novel is, "Let us try, if we can, to enter death with open eyes."[26]

WHAT RESISTS TIME IS WHAT'S EVER FLOWING

Like knowledge of the self, knowledge of the heart of
Rome has always been incomplete due to ignorance,
obliteration, and destruction.

ANDREA CARANDINI

Seamus Heaney's last words were a text message in Latin. As the
Irish poet was going into surgery in 2013, he texted his wife, *"Noli
timere"* (Be not afraid). In the wake of his death, Heaney's son wrote,
"This wasn't as portentous as it seems: he frequently used Latin
as conversational shorthand."[1] (I'm not sure if the humor there is
unintentional or deadpan.) The influence of Latin on Heaney could
be a book unto itself. The dead language, taught to him by Father
Michael McGlinchey, gave him huge advantages: new vistas within
his mother tongue, an escape hatch from contemporary pressures
into a world of wisdom and history pertinent to those very pres-
sures, and a literature in a variety of satisfyingly human tonalities.

One of the last poems Heaney wrote before his death is entitled "Du Bellay in Rome." It deals with the relationship between past and present, dreamy Rome and grimy Rome, chiseled dead language and twittering text message. Given the circumstances, it's easy to read it as the reflection of a poet about to crumble as a biological creature and harden into an anthologized poem or two for even the people who know and love him.

> You who arrive to look for Rome in Rome
> And can in Rome no Rome you know discover:
> These palaces and arches ivied over
> And ancient walls are Rome, now Rome's a name.
> Here see Rome's overbearing overcome—
> Rome, who brought the world beneath her power
> And held sway, robbed of sway: see and consider
> Rome the prey of all-consuming time.
> And yet this Rome is Rome's one monument.
> Rome alone could conquer Rome. And the one element
> Of constancy in Rome is the ongoing
> Seaward rush of Tiber. O world of flux
> Where time destroys what's steady as the rocks
> And what resists time is what's ever flowing.[2]

As the title suggests, the poem is a translation of an old sonnet by the Renaissance poet Joachim du Bellay (*"Nouveau venu, qui cherches Rome en Rome"*). It's likely that Heaney first encountered this poem not in the original French but in a translation, perhaps the one by his friend and mentor Robert Lowell ("You search in Rome for Rome? O traveller!"). The wording of Lowell's version makes me suspect he actually came to the poem by way of the Baroque poet Francisco de Quevedo's Spanish translation (*Buscas en Roma a Roma, ¡oh peregrino!*); then again, maybe Heaney or Lowell first encountered it in a translation by Ezra Pound, their modernist predecessor from Idaho ("O thou newcomer who seek'st Rome in

Rome"). Pound's version leads me to believe that he first found the poem in a version made shortly after du Bellay's original by the English Renaissance poet Edmund Spenser ("Thou Stranger, which for Rome in Rome here seekest"). Does it come as no surprise at this point that even the original isn't the original? Joachim du Bellay derived his poem from a Latin epigram by his humanist predecessor Janus Vitalis ("*Qui Romam in media quaeris, novus advena, Roma*"). Rome is what's lost and found in translation.

In writing this book, I sometimes felt like I was uncovering something resistant to time. In the deep dig of history, I felt like I was dusting off tile after tile of the meaning of life. All the pieces began to shine and cohere: tragic pragmatism, eclectic metaphysics, passionate decorum, decorous passion, freedom as nondomination, public devotion to overarching masculine and feminine principles, social devotion to the Graces, private devotion to the suave god of communication and travel, self-knowledge in the symbol of the ass, opposition to superstitions and atheisms, commitment to reasonability and reverence, memory enlarged by art and history, habitual glances at death, initiation into the delicious mysteries of love, well-made pastas, living in the ruins. It all adds up! At last, the mosaic of Rome's wisdom in all its glory!

Well, I had to step back from it all and blur my eyes a bit to see this so-called coherent meaning of life. Let's face it: the truths of the philosophers and artists I've been discussing, let alone of the city and its global history, don't add up at all—certainly not in my telling! In fact, part of Rome's great beauty is how it foregrounds this never-quite-adding-up quality, how it strongly echoes but never quite repeats itself. It's all an incredible cubism of crooked histories, plural viewpoints, unfinished projects, recycled mishmashes, crass sublimity, and sublime crassness. As just one among many instances of Rome's coexistence of incompatibles, consider San Lorenzo in Miranda on the edge of the Forum. It's a Christian church built inside the Temple of Antoninus and Faustina, a shrine dedicated to two deified pagans by Marcus Aurelius, a persecutor of Christians.

That's right: Christians built a church inside a giant violation of the first of the Ten Commandments, erected by one of their enemies. It was practical, I guess—though they made no real effort to hide the pagan temple and even tried to showcase it in the Renaissance. That's Rome for you. It's like a coral reef, where dead things that once fed on each other are now stuccoed into a complex organism.

Like the Temple of Antoninus and Faustina, most of what I talk about here could be put to contradictory purposes. There are so many aspects of Rome's wisdom and beauty, let alone its evil and ugliness, that haven't made my book's semiarbitrary cut and would flat out contradict its narrative. I've sometimes had the divine thrill of figuring it all out, but I've never been more of an ass than when I felt that way. Like the poet says,

> Time destroys what's steady as the rocks
> And what resists time is what's ever flowing.[3]

Does our sonnet's final couplet mean that fleeting Rome is the Eternal City? Is the impermanent what's truly permanent? Is the eternal truth the fact that we eternally fail to find what we're looking for? So, maybe there *is* an eternal form of Rome after all! And yet how can brokenness and change ever be whole and unchanging? Well, you can see why philosophical types get obsessed with the city's mysteries.

In *Fleeting Rome* (*Roma fuggittiva*), a book named after our sonnet's final line in the version by Quevedo, there's an essay from 1963 by Carlo Levi that deals with what it means to internalize the city's mysteries. I'm starting to understand what it articulates about drawing life lessons from the not-quite-permanent, not-quite-impermanent realities of Rome.

> Here, everything has already existed: and existence has not
> vanished into memory, rather it has remained present, in the
> houses, the stones, the people: a remarkable welter of times and

differing conditions that resolves into an absolute simplicity
of emotion and interest. It has all been done before: only death
is still to come ("and it all ends in hell"). The virtues are not the
moral and ideological values (which the passage of too long a
time has gradually flattened out), but simpler and more visible
values: health, physical strength, knowing how to eat and drink,
knowing how to speak with a certain humour and brevity,
knowing how to command respect, sincerity, friendship. For
a people free of complexes and moralism, all possible human
conditions are understandable, acceptable, and normal.[4]

Isn't the meme that we're living through the fall of Rome both
tiresome and counterproductive? The truth is that the world has
ended many times over—and restarted many times over. Once you
dwell long enough on the birth and death of a thousand identities,
the birth and death of a thousand hopes for the good old days or
the new and improved, you can begin to find the paradoxical real-
ity and shining grace beyond cults, politics, and religions. Though
tourists probably won't earn Levi's virtues after a weeklong stay,
let's not underestimate ourselves. What he's describing, however
concentrated in the city of Rome, is actually in all human life—it's
everywhere, it's eternal, even if we often dodge the truth that all
goods and evils have already existed and yet remain present, even
if we often take shelter in our ideologies and moralisms.

 Plus, if you live in the West, you probably have been living in
Rome for much of your life—even if you've never been inside
the city limits. The last time I was there, I visited the churches of
San Clemente, San Luigi dei Francesi, and Sant'Ignazio. When
I got home, I drove my daughter through St. Clement, Missouri,
to St. Louis's St. Louis University, which is plastered with icons
of St. Ignatius. I hadn't escaped Rome even in eastern Missouri.
Cities all across the United States, Europe, and the Middle East base
their town squares on the model of the Forum, their stadiums on
the model of the Colosseum, their capitols on the model of the

Capitoline, and their palaces on the model of the Palatine. Rome's language (*lingua*) and concepts (*concepta*) are ubiquitous (*ubiquitas*)— republic (*res publica*), czar (*Caesar*), senator (*senator*), vandal (*Vandalus*), political parties (*partes*), etc. (*et cetera*). Cicero alone invented words that still fundamentally shape our thinking: *evidentia* (evidence), *qualitas* (quality), *quantitas* (quantity), *essentia* (essence), *humanitas* (humanity). Our coins not only look Roman but are engraved with Latin phrases. The known world of fonts is dominated by Times New Roman. Our calendar scrolls through months named after Roman gods, Roman rituals, and Roman emperors. Even our clocks can't quite give up the numerals of one of the worst number systems ever invented.

One of the things a conquered barbarian like me finds most exciting about the city and its history is its devotion to art. I'm not talking just about painting, architecture, and sculpture—though certainly those. I mean the art of everything. Ovid writes the *Art of Love*. Horace writes the *Art of Poetry*. Roman philosophers write their *Arts of Living*. Latin friars write their *Arts of Dying*. Renaissance visionaries write their *Arts of Memory*. Cooking is an art. Wine is an art. Dining is an art. Fashion is an art. Language is an art. Nonverbal communication is an art, especially with the hands. There's the ideal of *la bella figura*: the art of cutting a good figure. There's *l'arte di arrangiarsi*: the trick of finessing predicaments. There's the art of water: fountains gush gloriously throughout the city. There's the art of church floors: their swirling *opus sectile* spreads beauty under the soles of our souls. There's the art of the *crema* atop the coffee: I don't mean drawing tulips with microfoam but getting just the right texture and amount of creamy foam atop a yummy shot of *caffè*. In general, don't make the mistake of thinking that art means fancy. Real art deploys power with elegance. The great art of politics, in the best version of the Ciceronian dream, is to honor and uphold the dignity of all citizens. But the fundamental art, the one that justifies activities like politics, is what Levi is describing in *Fleeting Rome*: how the city can make us artists of life by returning

us to the "simpler and more visible values" of being human like eating and drinking, companionship and conversation, work and play, strength and love.

One of the great things about the legacy of Rome is that we're guaranteed to find a thing or two that reflects and extends us. But there's something more powerful than seeing ourselves magnified in parts of its tradition. Like Seamus Heaney, we can read ourselves into the whole of Rome and come to a vision of our possibilities and impossibilities. As we look back on our lives, what do we see? Ruins and rebirths. Crooked paths, unfinished projects, occasional glories. Unions, breakups. Lust and love. Missteps that turned into successes and missteps that remained mistakes. The will to dominance and a mishmash of value systems critical of domination. Sure, there's a prevailing pattern in us, but its expression is rarely linear. It's fractured, cubist, cobbled together. The past so haunts the present it's hard to know if it's even the past. We have to step back from it all and blur our eyes a bit to see the continuity among the fragments. Parts of us that made sense in one context now serve fresh purposes. We tell stories about who we are, though there are significant parts of us that don't make the semiarbitrary cut and often flat out contradict the narrative. Maybe they'll come in handy later. In short, what we see in the mirror is Rome. And it's not over yet. So, let's risk regret over resentment and strike off once again for the good life. Let's go. *Noli timere*.

ACKNOWLEDGMENTS

By ships and chariots
we go looking for the good life. But what
you seek is right here
in Ulubrae, if you can just keep a level head.

HORACE

Writing this book during the COVID-19 pandemic, I came to understand in my bones a sentence in Cicero, who claims to have heard it from Cato, who claims to have heard it said of Scipio Africanus: "He was never doing more than when he was doing nothing, and never less alone than when alone."[1] I too was never more active than when I was utterly deprived of things to do. I too was never less alone than when I was absorbed in the solitude of writing this book.

Here's a partial list of those at the party: my late grandfather George Darooge, who gave me the golden bough of world travel; my parents Chris and Carol Samuelson, and my sisters Amanda

and Megan, who understand like nobody else the rueful yet beautiful truth in the line from *National Lampoon's Vacation*: "Because getting there is half the fun—you know that"; my Latin professor Ed Phillips, who taught me not to fear the difficult joys of *amo, amas, amat, amamus, amatis, amant*; my mentor Donald Verene, who conveyed to me that the highest achievement in writing and life is to instruct, delight, and move each other; my partner in crime Renée Schlueter, who first invited me on her study abroad trip and thereby changed my life, as well as my other friends and colleagues on the Rome trip Ron Weber, Margaret Musgrove, Jessica Sheetz-Nguyen, and John De Frank, all of whom have taught me so much that goes uncredited here; my pals David Depew, Bob Sessions, and Lori Erickson, whom I count on for encouragement and conceptual guidance; my teacher-turned-friend Ellen Mease, who's never stopped giving me elaborate feedback on my papers about Cicero; my Rome companions Peter Mason and Florike Egmond, whose infinitely greater knowledge of the city and its history has been as nourishing and delectable as the meals they serve up when I'm there; the Maecenases at the Mellon/ACLS Community College Faculty Fellowship and the Endowed Chair Committee of Kirkwood Community College; the eagle-eyed classicist Scott Garner, who gave me invaluable pointers about my Latin translations; my brilliant guardian-angel editor Elizabeth Branch Dyson, who, after I signed off on an email with *"con affetto,"* mischievously signed off on her next message with *"con queso"*; the anonymous early reviewers of the manuscript, who transcended the usual academic fussiness and mostly just lavished praise on the good bits—and thereby stimulated better work from me; Trevor Perri, who nudged me to better prose with a deft touch, sometimes while reminiscing about memorable pastas; my dear friends Michael Judge, David McMahon, and Emiliano Battista, who give me the love and teasing we all crave; Scott Newstok, *animae dimidium meae*, with whom I studied Latin long ago over pitchers of beer, who has gifted me a minor library of books on Rome, and whose conversations and

correspondence continue to be so influential on me that I often don't know where his ideas break off and mine begin; my kids Irene and Billy, whose beloved eyes I imagined widening at the sites I was writing about; and Sarah Kyle, my Sarah, who not only had to put up with my one-track mind during the pandemic but, as an art historian of the Italian Renaissance, often had to set me straight (and still rolls her eyes at some of my reckless claims here): she will always be Rome to me.

Since I wrote this book in Iowa City with two canceled plane tickets to Fiumicino in my travel folder, let me add one more paradox to Cato's line: "He never traveled more than when he stayed home."

APPENDIX

Rome by Way of the Winged Eye

Whether or not you can afford plane tickets, books are still the unsurpassed technology of philosophical travel. They give us winged eyes. The infinite number of them that already exists on the Eternal City magically manages to increase every year. The things I don't know could outfit the equivalent of all the museums in Rome (the author finally admits in the appendix!). But here are some books I like a lot, roughly following the various sections of my book. The current bible for English-speaking travelers to the Eternal City is the *Blue Guide: Rome* by Alta Macadam. Not quite as far-reaching but deeper on its subjects, Georgina Masson's beautifully written *The Companion Guide to Rome* (originally published in 1965) has been recently updated. You might consider bringing with you Mary Beard's spirited, skeptical, and engaging *SPQR: A History of Ancient Rome* or Robert Hughes's *Rome: A Cultural, Visual, and Personal History*, which makes a strong case that Rome's vitality is rooted in its crassness as well as its sublimity. *Rome and a Villa* by

FIGURE A1 · The emblem of the philosophical traveler is, as it was for the quintessential Renaissance man Leon Battista Alberti, a winged eye. The motto QUID TUM ("What then?" in the sense of "So what?") is a bit of a scholarly mystery. I understand it as a blend of trying to figure out what really matters ("What follows from what I'm reading or observing?") and shrugging at the absurdity of life ("What does it all really matter in the end!").

Eleanor Clark is yet another exquisitely written book inspired by the city. Virgil's *Aeneid* (recommended translation: Robert Fagles) is a masterpiece of doubletakes: it's a ringing celebration of the foundations of Rome's imperial power—or, just as likely, a heartbreaking indictment of the foundations of Rome's imperial violence. It's also a study in how life is essentially a map of mis-readings. A short biography of Rome's most distinctive painter is Francine Prose's *Caravaggio: Painter of Miracles*, and a midsized biography of the city's most imposing artist is Franco Mormando's *Bernini: His Life and His Rome*. I recommend memorizing an ode or a sonnet of Keats so you have something to recite at his grave. Princeton University Press has lovely little volumes of all sorts of classic Roman authors, in a "how to" series, including Cicero's *How to Be a Friend* (*De Amicitia*) and *How to Grow Old* (*De Senectute*). Most of them can be read in the time it takes to drink two glasses of wine (one of my favorites in

the series is *How to Drink*, a translation of the Renaissance humanist Vincent Obsopoeus's *De Arte Bibendi*). A superb edited collection of various philosophical writings by Cicero is *On Living and Dying Well* (trans. Thomas Habinek). Pierre Hadot's *The Inner Citadel* is a brilliant guide to Marcus Aurelius's *Meditations* (preferred translation: Robin Waterfield). Goethe's *Italian Journey* is fascinating on lots of levels. Ronald Melville's translation of Lucretius's *De Rerum Natura* strikes me as a fine version of an especially tricky poem to translate. David Ferry's translations of Horace's books are readable and elegant. There's also a good volume edited by J. D. McClatchy of the *Odes*, where different contemporary poets give their takes on Horace's lyric poems. My teacher Donald Phillip Verene's best books form a trilogy: *Philosophy and the Return to Self-Knowledge*, *The Art of Humane Education*, and *The Science of Cookery and the Art of Eating Well*. Marcella Hazan's *Essentials of Classic Italian Cooking* never leads you astray, and *Marcella Says* has an especially helpful introduction if you want to draw out flavors. If you want a Roman focus, *Popes, Peasants, and Shepherds: Recipes and Lore from Rome and Lazio* by Oretta Zanini De Vita is excellent. When Joseph Brodsky discovered that none of his American students knew Ovid, he said, "You've been cheated."[1] I hope you haven't been cheated. But if you have, start with the *Metamorphoses* (Rolfe Humphries's translation) and the *Art of Love* (Peter Green's translation). Paul Barolsky's *Ovid and the Metamorphoses of Modern Art from Botticelli to Picasso* is a stimulating start to exploring the poet's vast influence on the visual arts. Seneca's clear and humane style comes through in most translations. The University of Chicago Press has recently been issuing volumes, both beautiful and rigorous, in *The Complete Works of Lucius Annaeus Seneca*. I like Henry Chadwick's version of Augustine's *Confessions*. I used Sarah Ruden's translation of Apuleius's *Golden Ass*, as it strives to capture the shifting tones of the original, but Robert Graves's translation can't be beat for readability. Ingrid Rowland's *The Culture of the High Renaissance* is great on Chigi and every other subject it deals with. Georgina Masson's *Courtesans of*

the Italian Renaissance is fabulous. Manfred Clauss's ***The Roman Cult of Mithras*** is rigorous. The first book to turn me on to the mysteries was Walter Burkert's ***Ancient Mystery Cults***. Here are three models of scholarship at its best: Robert Williams's ***Raphael and the Redefinition of Art in Renaissance Italy***, Frances Yates's ***The Art of Memory***, Ingrid Rowland's ***Giordano Bruno: Philosopher/Heretic***. Bruno's works are a fun maze to get lost in: I'd probably start with ***The Heroic Frenzies*** (I know Paul Eugene Memmo Jr.'s translation; Ingrid Rowland also has one). Marguerite Yourcenar's novel ***Memoirs of Hadrian*** blends history, philosophy, and storytelling in a mesmerizing way—like Rome. The essays in Carlo Levi's ***Fleeting Rome*** are lovely and wise. One of the most insightful and humane of all travel books, and a treasure trove of shining sentences to boot, is ***A Time in Rome*** by Elizabeth Bowen, which ends, "My darling, my darling, my darling. Here we have no abiding city."[2]

NOTES

Unless otherwise noted, I've translated the Latin verse quoted in the text (and a few other Latin passages as well). I'm not going to make the usual apologies for translating poetry. I'll do you one better and arm you with a do-it-yourself kit to improve on the poetic passages I've rendered into English. In these notes I provide not only the original but a word-for-word crib. For instance, here are the famous lines about daring to be wise from Horace, *Epistularum* 1.2.40–43 (which means *Epistles*, book 1, second poem, lines 40–43).

Sapere aude:
incipe. Qui recte vivendi prorogat horam,
rusticus expectat dum defluat amnis: at ille
labitur et labetur in omne volubilis aevum.

Here's my stab at a translation.

Dare to be wise:
do it. If you don't strike off now for the good life,
you're like the bumpkin waiting to cross the river
until it flows by. It keeps flowing. It just keeps flowing.

And here's the crib, in which every Latin word (e.g., "*sapere*") is given a straightforward English counterpart (e.g., "to-be-wise") in Horace's exact word order.

To-be-wise dare:
begin. Who right living puts-off the-hour[-of]
[is like] the-bumpkin who-waits until runs-off the-river: but it
keeps-flowing and will-keep-flowing in every streaming time.

My hope is that you not only improve on my shortcomings but see the mosaic-like beauty of the syntax. The cribs might also tickle those who remember such awkward parsing in Latin class.

INTRODUCTION

1 Federico Fellini and Charlotte Chandler, *I, Fellini* (New York: Cooper Square Press, 2001), 176. Fran Lebowitz observes, "Rome is a very loony city in every respect. One need but spend an hour or two there to realize that Fellini makes documentaries." *Metropolitan Life* (New York: Dutton, 1978), 64.

2 Dante Alighieri, *Purgatorio* 32.102.

3 James Joyce, *Letters of James Joyce*, vol. 2, ed. Richard Ellman (New York: Viking, 1966), 165.

4 Plato, *Republic* 368d–69a.

5 The base of Lord Byron's statue in the Villa Borghese is inscribed with these lines from his *Childe Harold's Pilgrimage*.

6 Plutarch says, "From whom, and for what reason, the city of Rome, a name so great in glory, and famous in the mouths of all men, was so first called, authors do not agree." *Plutarch's Lives*, vol. 1, trans. John Dryden, updated by Arthur Hugh Clough (New York: Modern Library, 2001), 25. Shakespeare's wisdom (*Romeo and Juliet* 2.2.49–51) is pertinent, "So Romeo would, were he not Romeo called, / Retain that dear perfection which he owes / Without that title." Just take the *o* off Romeo!

CHAPTER ONE

1 Eleanor Clark, *Rome and a Villa* (New York: HarperCollins, 1992), 289.

2 The letter from Tryphena can be found in Henry Bathurst, *Memoirs of the Late Dr. Henry Bathurst, Lord Bishop of Norwich*, vol. 1 (London: A. J. Valpy, 1837), 233–34. The longer account of the drowning of Rosa, as well as the exploits of Benjamin and Phillida, comes from Mrs. Hugh Fraser, *Storied Italy* (New York: Dodd, Mead, 1915), 183–211.

3 Fraser, *Storied Italy*, 185.

4 Bathurst, *Memoirs of the Late Dr. Henry Bathurst*, 233.

5 Fraser, *Storied Italy*, 204.

6 "In a word, despite the frantic efforts of those beneath whose eyes the accident occurred—among whom was Walter Savage Landor, who has made his moan over the tragedy in more than one tear-spotted page of verse—Rosa Bathurst was drowned in the Tiber." *Lippincott's Magazine of Popular Literature and Science* (Philadelphia: J. P. Lippincott, 1875), 127.

7 Henry James, *Italian Hours* (New York: Penguin Books, 1995), 173.

8 Percy Bysshe Shelley, preface to "Adonais," in *The Poetical Works of Percy Bysshe Shelley*, ed. Edward Dowden (New York: Thomas Y. Crowell, 1898), 422.

9 These lines, from Ariel's song in Shakespeare's *Tempest*, are the origin of the word "sea-change" to mean a metamorphosis. Unfortunately, this sea-change began when Shelley, just twenty-nine years old, drowned after his boat wrecked at sea. His washed-up body was identified by the book of Keats's poems in his pocket. When the poet was cremated, his heart wouldn't burn—perhaps because it had calcified due to a prior bout with tuberculosis. After a battle with Shelley's friend Leigh Hunt, his wife, the great Mary Shelley, claimed the heart, wrapped it in silk, and carried it around with her for the rest of her life. Between the epitaph and Shelley's name on the tomb, it says, "*COR CORDIUM*" (heart of hearts).

10 Hans Blumenberg, *Care Crosses the River*, trans. Paul Fleming (Stanford, CA: Stanford University Press, 2010), 95–96.

11 Ralph Waldo Emerson, "Letter to Margaret Fuller" (1840), in *The Letters of Ralph Waldo Emerson*, vol. 1, ed. Ralph Leslie Rusk (New York: Columbia University Press, 1939), 342. The whole sentence reads, "Heaven walks among us ordinarily muffled in such triple or tenfold disguises that the wisest are deceived and no one suspects the days to be gods."

CHAPTER TWO

1 I talk about "blues-understanding" in *Seven Ways of Looking at Pointless Suffering* (Chicago: University of Chicago Press, 2018), 203–22. The context is a discussion of Sidney Bechet, the Caravaggio of New Orleans jazz.

2 2 Sam. 18:33.

3 A summary of this scholarly debate can be found in Michael Fried, *The Moment of Caravaggio* (Princeton, NJ: Princeton University Press, 2010), 61.

The view that it was painted in 1606 has been advanced by Andrew Graham Dixon, *Caravaggio: A Life Sacred and Profane* (New York: W. W. Norton, 2010).

4 John T. Spike, *Caravaggio: Catalogue of Paintings* (New York: Abbeville Press, 2010), 240.

5 Blaise Pascal, *Pensées*, trans. A. J. Krailsheimer (New York: Penguin Books, 1995), 31.

6 W. H. Auden, "Musée des Beaux Arts," in *Collected Poems*, ed. Edward Mendelson (New York: Modern Library, 2007), 179.

7 Though we're not completely sure why Rome is called Rome, Ennius, as quoted by Cicero (*De Divinatione* 1.48), says of the fight between Romulus and Remus, "*Certabant urbem Romam Remoramne vocarent*" (They were fighting over whether to call the city Rome or Remora).

8 Pliny the Elder, who saw it in the palace of the emperor Titus, calls it "a work superior to any painting or bronze." *Natural History: A Selection*, trans. John F. Healey (New York: Penguin, 1991), 347. It's reasonable to believe—though no one knows for sure—that this sculpture was based on book 2 of the *Aeneid* and was made while Virgil's poem was still in progress. Lost for centuries, it was unearthed in 1506 in a vineyard near Santa Maria Maggiore. Michelangelo was called when it was found. He immediately recognized it as the sculpture Pliny praised.

CHAPTER THREE

1 I came across this image in a moving essay by Teju Cole, "Carrying a Single Life: On Literature and Translation," *New York Review of Books*, July 5, 2019, https://www.nybooks.com/daily/2019/07/05/carrying-a-single-life-on-literature-translation/. The image can be seen at: Khalaf Yazidi (@KhalafYazidi), "Dakhil Naso, a #Yezidi from #Sinjar carrying his blind father heading to Kurdistan to save him from death," Twitter, August 29, 2014, https://twitter.com/khalafsmoqi/status/505188569661849601.

2 Quoted in Franco Mormando, *Bernini: His Life and His Rome* (Chicago: University of Chicago Press, 2011), 59–60.

3 This quip is often attributed to John Gardner, who does indeed give this instruction to writers of stories: "As subject, use either a trip or the arrival of a stranger." *The Art of Fiction: Notes on Craft for Young Writers* (New York: Alfred A. Knopf, 1984), 203.

4 Kenneth Burke, *Counter-Statement* (Berkeley: University of California Press, 1968), 119. He also says there, "When in Europe, do as the Chinese."

5 "The fountain has no enemies . . . it is a device or invention which has given nothing but pleasure in the course of a long history. It has the ability to minister equally to joy and melancholy, to appeal to eye and to ear, to stand at a street corner ready to fill the water pots, or in a garden to assist the meditations of poet and philosopher." H. V. Morton, *Fountains of Rome* (New York: MacMillan, 1966), 17. (This happens to be the first book I ever read about Rome.)

6 Anthony Burgess, *ABBA ABBA* (Manchester: Manchester University Press, 2019), 47.

CHAPTER FOUR

1 Cicero, *Brutus, Orator*, trans. G. L. Hendrickson and H. M. Hubbell (Cambridge, MA: Harvard University Press, 1962), 21–23, translation slightly modified.

2 John Adams, *The Political Writings of John Adams*, ed. George W. Carey (Washington, DC: Regnery Publishing, 2000), 121.

3 Cicero, *De Oratore* 3.74.

4 Cicero, *De Domo Sua* 41.109.

5 Cicero, *The Republic and The Laws*, trans. Niall Rudd (Oxford: Oxford University Press, 1998), 21.

6 As Dante says in canto 22 of the *Inferno* (lines 14–15), "*ne la chiesa / coi santi, e in taverna coi ghiottoni*" (in church with saints, at the tavern with drunks).

7 Cicero, *On Living and Dying Well*, trans. Thomas Habinek (New York: Penguin Books, 2012), 116.

8 Cicero, *On Living and Dying Well*, 101.

9 Cicero, *How to Be a Friend*, trans. Philip Freeman (Princeton, NJ: Princeton University Press, 2018), 87.

10 Cicero, *The Republic and The Laws*, 20.

11 Cicero, *The Republic and The Laws*, 32–33.

12 See Philip Pettit, *Republicanism: A Theory of Freedom and Government* (Oxford: Clarendon Press, 1997).

13 "*Legum . . . omnes servi sumus ut liberi esse possimus.*" Cicero, *Pro Cluentio* 53.146.

14 Cicero, *Letters to Atticus*, vol. 2, trans. D. R. Shackleton Bailey (Cambridge, MA: Harvard University Press, 1999), 133.

15 Nicola Gardini, *Long Live Latin*, trans. Todd Portnowitz (New York: Farrar, Straus and Giroux, 2019), 55–56.

16 Cicero, *De Oratore* 3.61.

17 Cicero, *Tusculan Disputations* 5.10.

18 Cicero, *On Living and Dying Well*, 73.

19 Cicero, *On the Good Life*, trans. Michael Grant (New York: Penguin Books, 1971), 87. Cicero was from Arpinum, now called Arpino.

20 Cicero, *Tusculan Disputations II and V*, trans. A. E. Douglas (Oxford: Oxbow Books, 1990), 99.

21 The great scholarly account of the republic's demise is H. H. Scullard, *From the Gracchi to Nero: A History of Rome 133 BC to AD 68* (London: Routledge Classics, 2011).

22 Cicero, *The Republic and the Laws*, 81.

23 Cicero, *Letters to Atticus*, volume 5, trans. D. R. Shackleton Bailey (Cambridge: Cambridge University Press, 1966), 107.

24 Cicero, *Letters to Atticus*, vol. 5, 89.

25 Cicero, *How to Grow Old*, trans. Philip Freeman (Princeton, NJ: Princeton University Press, 2016), 109 and 77.

26 Cicero, *How to Grow Old*, 61.

27 Johann Wolfgang von Goethe, *Italian Journey*, trans. W. H. Auden and Elizabeth Mayer (London: Penguin Classics, 1970), 467–68.

28 Goethe, *Italian Journey*, 468.

29 Goethe, *Italian Journey*, 469.

30 *The Poems of Catullus*, trans. Peter Green (Berkeley: University of California Press, 2005), 61. This is poem fourteen. See also the *Select Works of Porphyry*, "On the Cave of the Nymphs," trans. Thomas Taylor (London: J. Moyes, 1823), 189. "For the Romans celebrate their Saturnalia when the Sun is in Capricorn, and during this festivity, slaves wear the shoes of those that are free, and all things are distributed among them in common; the legislator obscurely signifying by this ceremony that through this gate of the heavens, those who are now born slaves will be liberated through the Saturnian festival, and the house attributed to Saturn, *i.e.*, Capricorn, when they live again and return to the fountain of life."

31 Goethe, *Italian Journey*, 469–70.

32 Susan Stewart has written a detour-filled book called *The Ruins Lesson* (Chicago: University of Chicago Press, 2020), which is partly about what to make of Rome.

33 Yehuda Amichai, "Tourists," trans. Glenda Abramson and Tudor Parfitt, in *The Poetry of Survival*, ed. Daniel Weissbort (New York: St. Martin's Press, 1991), 84.

CHAPTER FIVE

1 "Bomb in Rome Badly Damages Michelangelo Building," *New York Times*, April 21, 1979, https://www.nytimes.com/1979/04/21/archives/bomb-in-rome-badly-damages-michelangelo-building-rome-bombing-badly.html.

2 Marcus Aurelius, *Meditations: The Annotated Edition*, trans. Robin Waterfield (New York: Basic Books, 2021), 87 (4.33 and 4.35).

3 Edward Gibbon, *The History of the Decline and Fall of the Roman Empire* (London: Penguin Books, 2000), 83.

4 Marcus Aurelius, *Meditations*, 203–4 (9.2).

5 Marcus Aurelius, *Meditations*, 132–33 (6.30).

6 Quoted in Pierre Hadot, *The Inner Citadel: The Meditations of Marcus Aurelius*, trans. Michael Chase (Cambridge, MA: Harvard University Press, 2001), 300.

7 Marcus Aurelius, *Meditations*, 8 (1.7).

8 Quoted in Hadot, *The Inner Citadel*, 191. The whole passage is interesting. "If you do not see your own beauty yet, do as the sculptor does with a statue which must become beautiful: he pares away this part, scratches that other part, makes one place smooth, and cleans another, until he causes a beautiful face to appear in the statue. In the same way, you too must pare away what

is superfluous, straighten what is crooked, purify all that is dark, in order to make it gleam. And never cease sculpting your own statue."

9 Marcus Aurelius, *Meditations*, 125 (6.13).

10 Marguerite Yourcenar, *Memoirs of Hadrian*, trans. Grace Frick and Marguerite Yourcenar (New York: Farrar, Straus and Giroux, 1954), 13.

11 Marcus Aurelius, *Meditations*, 86 (4.32).

12 Marcus Aurelius, *Meditations*, 131 (6.25).

13 Marcus Aurelius, *Meditations*, 28–30 (2.1).

14 Marcus Aurelius, *Meditations*, 86 (4.32).

15 Marcus Aurelius, *Meditations*, 199 (8.59).

16 Marcus Aurelius, *Meditations*, 177 (8.2).

17 Marcus Aurelius, *Meditations*, 214 (9.29).

18 Rainer Maria Rilke, *Selected Letters of Rainer Maria Rilke*, ed. Harry T. Moore (New York: Doubleday, 1960), 165 (Letter to Ilse Erdmann, January 31, 1914).

19 Marcus Aurelius, *Meditations*, 277 (12.3).

20 Marcus Aurelius, *Meditations*, 153 (7.17).

21 Marcus Aurelius, *Meditations*, 260–61 (11.15).

22 Hadot, *The Inner Citadel*, 209.

23 Marcus Aurelius, *Meditations*, 48–49 (3.2).

24 Zbigniew Herbert, "Animula," in *The Collected Prose*, trans. Alissa Valles (New York: Ecco, 2010), 467.

25 Italo Calvino, *Collection of Sand*, trans. Martin McLaughlin (Boston: Mariner Books, 2002), 95.

26 Quoted in Hadot, *The Inner Citadel*, 174–75.

27 See Miriam T. Griffin, "Philosophy, Cato, and Roman Suicide: I and II," *Politics and Philosophy at Rome: Collected Papers* (Oxford: Oxford University Press, 2018), 410.

28 Epictetus, *Discourses and Selected Writings*, trans. Robert Dobbin (New York: Penguin Books, 2008), 58 (1.24).

CHAPTER SIX

1 Dionysius of Halicarnassus, *Roman Antiquities*, vol. 1, trans. Earnest Cary (Cambridge, MA: Harvard University Press, 1937), 410.

2 A wonderful description of Pompey's triumph, along with the Plutarch quotation, can be found in Mary Beard, *The Roman Triumph* (Cambridge, MA: Harvard University Press, 2007), 7–14.

3 Quoted in Jean Henri Merle d'Aubigné, *History of the Reformation in the Sixteenth Century*, vol. 1, trans. Henry Beveridge (Glasgow: William Collins, 1845), 146.

4 Lucretius, *De Rerum Natura* 1.62–63, 1.66–75.

 Humana ante oculos foede cum vita iaceret
 in terris oppressa gravi sub religione . . .

primum Graius homo mortalis tollere contra
est oculos ausus primusque obsistere contra;
quem neque fama deum nec fulmina nec minitanti
murmure compressit caelum, sed eo magis acrem
inritat animi virtutem, effringere ut arta
naturae primus portarum claustra cupiret.
Ergo vivida vis animi pervicit et extra
processit longe flammantia moenia mundi
atque omne immensum peragravit mente animoque,
unde refert nobis victor . . .

Human before eyes revoltingly when life was-thrown-down
into the-earth crushed heavy under religion . . .
the-first of-Greece a-man mortal to-raise against [religion]
was eyes daring and-the-first to-make-a-stand against [religion];
whom neither rumor of-gods nor thunderbolts nor menacing
sound restrained of-heaven, but in-him more eager
encouraged of-his-soul the-virtue, to-break-down so-that the-confining
of-nature's first gates barriers he-should-desire.
Thus full-of-vigor the-will of-his-mind prevailed and beyond
advanced after-a-long-while the-flaming bulwarks of-the-world
and the-all immense he wandered with-mind and soul
whence he-brings-back to-us as-victor . . .

5 *Epicurea*, ed. Hermann Usener (Teubner: Leipzig, 1887), 168. Fragment 221.
6 A copy of this formula was found in the Villa of the Papyri in Herculaneum,
 which contained a collection of writings, carbonized in the famous eruption
 of Mount Vesuvius, by the Epicurean philosopher Philodemus.
7 Epicurus, *The Art of Happiness*, trans. George K. Strodach (New York: Penguin
 Books, 2012), ii–viii. This is a marvelous collection of Epicurus's writings
 that is interspersed with some Lucretius.
8 See Bernard Frischer, *The Sculpted Word: Epicureanism and Philosophical Recruit-
 ment in Ancient Greece* (Berkeley: University of California Press, 1982).
9 Most of the busts in the Hall of Philosophers are bearded. There's evidence
 to suggest that in the ancient world different styles of beards reflected
 different philosophies. For both moral and aesthetic reasons, I subscribe to
 the old dictum, *"Barba non facit philosophum"* (A beard does not a philosopher
 make).
10 See Karen Cokanye, *Experiencing Age in Ancient Rome* (New York: Routledge,
 2003).
11 Lucretius, *De Rerum Natura* 3.996–1002.
12 Lucretius, *De Rerum Natura* 3.957–58.

sed quia semper aves quod abest, praesentia temnis,
inperfecta tibi elapsast ingrataque vita.

13 Horace, Carmina 2.3.5–8.

> Seu maestus omni tempore vixeris,
> seu te in remote gramine per dies
> festos reclinatum bearis
> interiore nota Falerni.

> Whether gloomy all the-time you-live
> or yourself on a-remote patch-of-grass on days
> festive lounging you-treat
> from-your-cellar to-a-good bottle-of-Falernian.

14 Lucretius, *De Rerum Natura* 3.642–45.

> Falciferos memorant currus abscidere membra
> saepe ita de subito permixta caede calentis,
> ut tremere in terra videatur ab artubus id quod
> decidit abscisum . . .

> Equipped-with-scythes they-recount a-chariot cuts-off limbs
> often so suddenly mingled slaughter warm
> that trembling on earth seems from joints that which
> falls-away.

15 Lucretius, *De Rerum Natura* 2.29–31.

> cum tamen inter se prostrati in gramine molli
> propter aquae rivum sub ramis arboris altae
> non magis opibus iucunde corpora curant . . .

> when however among themselves they-lounge on grass soft
> by of-water a-stream below the-boughs of-a-tree tall
> not on-much outlay happily their-bodies they-care-for . . .

16 Alfred, Lord Tennyson, "Lucretius," lines 104–110. These lines are a loose translation of Lucretius, *De Rerum Natura* 3.18–22.

17 George Santayana, *The Works of George Santayana*, vol. 8, *Three Philosophical Poets: Lucretius, Dante, and Goethe*, ed. Kellie Dawson and David E. Spiech (Cambridge, MA: MIT Press, 2019), 24.

18 MATER NOMEN ERAM · MATER NON LEGE FUTURA · QUINQUE ETENIM SOLOS ANNOS VIXISSE FATEBOR · ET MENSES SEPTEM DIEBUS CUM VINTI DUOBOS · DUM DIXI LUSI · SUM CUNCTIS SEMPER AMATA.

19 OSSA POMPONIAE·C·L·PLATVRAE. "C·L"—*Caii Libertae*—means "the freed woman of Gaius."

20 I found this in Brian K. Harvey, *Daily Life in Ancient Rome: A Sourcebook* (Indianapolis: Hackett, 2016), 256. The translation is mine. Here's the Latin (with the abbreviations filled in).

> V(ixit) an(nos) LII
> d(is) M(anibus)
> Ti(beri) Claudi Secundi
> hic secum habet omnia
> balnea vina Venus
> corrumpunt corpora
> nostra set vitam faciunt
> b(alnea) v(ina) V(enus)
> karo contubernal(i)
> fec(it) Merope Caes(aris)
> et sibi et suis p(osterisque) e(orum)

21 See Donald Phillip Verene, *The Science of Cookery and the Art of Eating Well* (Stuttgart: ibidem-Verlag, 2018), 86.

22 Verene, *The Science of Cookery and the Art of Eating Well*, 28.

23 Verene, *The Science of Cookery and the Art of Eating Well*, 89.

24 Marcella Hazan, *Marcella Says* (New York: HarperCollins Publishers, 2004), 7.

CHAPTER SEVEN

1 Horace, *Epistularum* 2.1.

> Graecia capta ferum victorem cepit.

> Greece captive as-prey its-victor captured.

2 Horace, *Carmina* 2.7.13–14.

> me per hostis Mercurius celer
> denso paventem sustulit aere . . .

> me through the-enemy Mercury quickly
> in-a-dense frightened carried cloud . . .

3 Horace, *Carmina* 1.4.13–14.

> pallida Mors aequo pulsat pede pauperum tabernas
> regumque turris.

> pallid Death with-impartial pounds (his-)foot of-the-poor at-the-hovels
> and-of-kings at-the-towers.

4 "Dare to be wise" or "dare to know" (*sapere aude*) is from Horace's *Epistle*
 1.2.40. Kant declares it "the motto of the Enlightenment."

5 Horace, *Carmina* 3.29.

> ille potens sui
> laetusque deget, cui licet in diem
> dixisse "vixi."

> that-one master of-oneself
> and-joyful spends-one's-time, who is-able each day
> to-have-said, "I-have-lived."

6 Horace, *Sermones* 1.5.44.

> nil ego contulerim iucundo sanus amico.

> Nothing I rank pleasing when-sane [above-]a-friend.

7 Horace, *Epistularum* 2.1.258–59.

> nec meus audet
> rem temptare pudor quam vires ferre recusent.

> not my dares
> the-thing to-try modesty which [my-]strength to-bear refuses.

8 Horace, *Epistularum* 2.2.19.

> eximit virtus populum.

> banishes virtue what's-popular.

9 Horace, *Carmina* 1.33.10–12.

> Sic visum Veneri, cui placet imparis
> formas atque animos sub iuga aenea
> saevo mittere cum ioco.

> Such it-seems-[good] to-Venus, who enjoys mismatched
> physiques and minds beneath yoke her-bronze
> savage placing for joke.

10 The rumormonger is Suetonius in *The Lives of Caesars*, vol. 2, trans. J. C. Rolfe
 (Cambridge, MA: Harvard University Press, 1914), 469.

11 Horace, *Epistularum* 1.16.66.

qui metuens vivet, liber mihi non erit umquam.

who anxiously lives free to-me not will-be ever.

12 Horace, *Carmina* 1.7.17–19.

tu sapiens finire memento
tristitiam vitaeque labores
molli, Plance, mero . . .

you wisely to-put-an-end remember
to-the-sorrow and-of-life-and to-labors
with-soft, Plancus, unmixed-wine . . .

Lucius Munatius Plancus, the addressee, surrounded by "soft" (*molli*) "wine" (*mero*), is known to history as a political fair-weather friend, his allegiance flapping from one cause to another during Rome's transition from republic to empire. It's probably worth pointing out that Horace's injunction to get drunk is especially good advice for dangerous overachievers.

13 Horace, *Carmina* 4.12.27.

Misce stultitiam consiliis brevem.
Dulce est desipere in loco.

Mix folly with-planning a-little.
Sweet it-is to-fool-around in-its-place.

14 I've borrowed this precept from the modern Horatian W. H. Auden, who says, "Irreverence / is a greater oaf than Superstition." "Moon Landing," in *Collected Poems*, ed. Edward Mendelson (New York: Modern Library, 2007), 844.

15 Horace, *Carmina* 1.34.2–3.

insanientis . . . sapientiae
consultus.

of-insane . . . theories
a-devotee.

16 Horace, *Carmen Saeculare* 2–3.

lucidum caeli decus, o colendi
semper et culti . . .

shining of-the-heavens grace, o [you] to-be-worshipped
always and cherished . . .

17 Horace, *Epistularum* 1.6.67–68.

> Vive, vale. Si quid novisti rectius istis,
> candidus imperti; si nil, his utere mecum.

> Live, good-bye. If something you've-figured-out better-than these [precepts],
> candid-one, share; if not, these use with-me.

18 Alfred North Whitehead, *The Aims of Education* (New York: The Free Press, 1929), 12.

19 Horace, *Ars Poetica* 240–43.

> ex noto fictum carmen sequar, ut sibi quivis
> speret idem, sudet multum frustraque laboret
> ausus idem: tantum series iuncturaque pollet,
> tantum de medio sumptis accredit honoris.

> from the-familiar made poetry I-aim-for, such-that anyone
> might-hope-for the-same, would-sweat a-lot and-in-vain would-labor
> venturing for-the-same: so-great order and-connection is-the-power-of,
> so-great from the-common drawn-up the-beauty approaches of-honor.

20 Friedrich Nietzsche, *Twilight of the Idols / The Anti-Christ*, trans. R. J. Hollingdale (London: Penguin Books, 1990), 115.

21 Horace, *Epistularum* 1.7.35–36.

> nec somnum plebis laudo satur altilium nec
> otia divitiis Arabum liberrima muto . . .

> neither the-sleep of-the-pleb I-praise sated on-chickens nor
> leisures for-the-riches of-Arabia very-free I'd-trade . . .

22 Horace, *Carmina* 1.20.1–8.

> Vile potabis modicis Sabinum
> cantharis, Graeca quod ego ipse testa
> conditum levi, datus in theatro
> cum tibi plausus,
> clare Maecenas eques, ut paterni
> fluminis ripae simul et iocosa
> redderet laudes tibi Vaticani
> montis imago.

> Inferior you-will-drink modest Sabine
> drinking-cups, Greek that I myself in-jars

preserved sealed, having-been-given in the-theater
when for-you applause,
distinguished Maecenas lord, that ancestral
of-the-river banks together and joyful
returned praise of you Vatican
hill echo.

23 Suetonius. *"Horati Flacci ut mei memo resto."*
24 Horace, *Carmen Saeculare* 1–4.

Phoebe silvarumque potens Diana,
lucidum caeli decus, o colendi
semper et culti, date quae precamur
tempore sacro.

Phoebus and-of-the-woods the-mistress Diana,
shining of-the-heavens grace, o [you] now-to-be-worshipped
always and will-to-be-worshipped, grant what we-pray-for
in-this-time holy.

25 Horace, *Carmen Saeculare* 9–12.

alme sol, curru nitido diem qui
promis et celas aliusque et idem
nasceris, possis nihil urbe Roma
visere maius.

nourishing sun, on-a-chariot gleaming the-day who
leads-forth and hides and-another and the-same
are-reborn, may-you nothing the-city of-Rome
see greater-than.

26 Horace, *Carmen Saeculare* 57–60.

iam Fides et Pax et Honos Pudorque
priscus et neglecta redire Virtus
audit adparetque beata pleno
copia cornu.

now Faith and Peace and Honor also-Modesty
ancient and neglected to-return Virtue
dare, and-appears blessed with-full
plenty horn.

27 See Michael C. J. Putnam, *Horace's* Carmen Saeculare: *Ritual Magic and the Poet's
 Art* (New Haven, CT: Yale University Press, 2000), 68.

28 Karl Barth, *Wolfgang Amadeus Mozart*, trans. Clarence K. Pott (Eugene: Wipf and Stock, 1986), 55. I've modified the translation a bit.

29 *The Great Beauty*, directed by Paolo Sorrentino (2013; Criterion Collection, 2014), 2:11:45–2:13:02, DVD.

30 Cardinal Bernardino Spada, whose Palazzo contains Borromini's forced perspective corridor, draws a metaphysical lesson from Rome's many tricks, "Great only in appearance, all things are small for whoever takes a closer look. On earth, greatness is nothing but illusion." Quoted in Marco Lodoli, *Islands—New Islands*, trans. Hope Campbell Gustafson (Rome: Fontanella Press, 2019), 7.

31 The whole exchange is on the extra called "Maestro Cinema" in *The Great Beauty*.

32 Quoted in *The Great Beauty*, 1:21–1:39.

33 Gilbert Highet, *Poets in a Landscape* (London: Hamish Hamilton, 1957), 120.

34 Georgina Masson, *The Companion Guide to Rome*, revised by John Fort (Suffolk: Companion Guides, 2009), 361.

CHAPTER EIGHT

1 Keith Hopkins and Mary Beard, *The Colosseum* (Cambridge, MA: Harvard University Press, 2005), 86–94.

2 Seneca, "On Providence," in *The Stoic Philosophy of Seneca: Essays and Letters*, trans. Moses Hadas (New York: W. W. Norton, 1958), 36.

3 Seneca, *Letters on Ethics*, trans. Margaret Graver and A. A. Long (Chicago: University of Chicago Press, 2015), 35.

4 Seneca, *Letters on Ethics*, 35.

5 Seneca, *Letters on Ethics*, 373.

6 Seneca, *Letters on Ethics*, 35.

7 Seneca, "Thyestes," in *Six Tragedies*, trans. Emily Wilson (Oxford: Oxford University Press, 2010), 186–87.

8 Emily Wilson, *The Greatest Empire: A Life of Seneca* (Oxford: University of Oxford Press, 2014), 154.

9 Seneca, *On Benefits*, trans. Miriam Griffin and Brad Inwood (Chicago: University of Chicago Press, 2011), 20.

10 Seneca, *On Benefits*, 94.

11 *The Godfather*, directed by Francis Ford Coppola (1972; Paramount, 2001), 6:25–6.33, DVD.

12 Seneca, *On Benefits*, 17.

13 Seneca, *On Benefits*, 24.

14 Seneca, *On Benefits*, 20–21.

15 Plato, *Republic*, trans. Robin Waterfield (Oxford: Oxford University Press, 1993), 361 (607b).

16 Augustine, *Confessions*, trans. Henry Chadwick (Oxford: Oxford University Press, 1991), 101 (6.8).

17 Augustine, *Confessions*, 29 (2.4).

18 James Curtis, *W. C. Fields: A Biography* (New York: Alfred A. Knopf, 2003), 393.

19 Augustine, *Confessions*, 148 (8.10).

20 Augustine, *Confessions*, 106 (6.11).

21 Augustine, *Confessions*, 145 (8.7).

22 The book that engagingly makes this case is Sarah Ruden, *Paul Among the People* (New York: Image Books, 2010).

23 Rom. 13:13–14. See Augustine, *Confessions*, 153 (8.12).

24 Matt. 22:35–40, Mark 12:28–34, Luke 10:27.

25 Augustine, *Homilies on the First Epistle of John*, trans. Boniface Ramsey (Hyde Park: New York City Press, 2008), 110. Ramsey translates the phrase, "Love, and do what you want."

26 Augustine, *Confessions*, 201 (10.27).

27 Augustine, *Confessions*, 191 (10.14).

28 *The Apostolic Fathers*, vol. 1, trans. Bart D. Ehrman (Cambridge, MA: Harvard University Press, 2003), 104.

29 The word generally translated here as Colosseum is *Colyseus*, which likely refers to the Colossus. "*Quandiu stabit Colyseus—stabit et Roma; quando cadet Colyseus—cadet et Roma; quando cadet Roma—cadet et mundus.*"

30 Seneca, *Letters on Ethics*, 377.

31 Ovid, *Tristia* 2.207.

> Perdiderint cum me duo crimina, carmen et error.

> Have-brought-ruin on me two crimes, a-song and a-mistake.

32 Ovid, *Ars Amatoria* 1.613.

> Sibi quaeque videtur amanda.

> Herself any-woman perceives as-someone-to-be-loved.

33 Here I use the splendid version by Peter Green: Ovid, *The Erotic Poems*, trans. Peter Green (London: Penguin Books, 1982), 211. Ovid, *Ars Amatoria* 2.682–84.

> Quod iuvet ex aequo femina virque ferant.
> Odi concubitus qui non utrumque resolvunt;
> hoc est, cur pueri tangar amore minus.

> What delights by equality woman and-man let-experience
> I-hate a-sexual-encounter that not for-each reaches-climax;
> which is why for-a-boy I-am-touched by-love less.

34 Ovid, *The Erotic Poems*, 205. *Ars Amatoria* 2.461–63.

> Cum bene saevierit, cum certa videbitur hostis,
> tum pete concubitus foedera, mitis erit.
> Illic depositis habitat Concordia telis.

When finely she's-been-raging, when certainly she-seems an-enemy,
then seek sexual treaties, calm she-will-be.
In-that-place set-down dwells Concordia with-weapons.

35 Ovid, *The Erotic Poems*, 246–47. *Remedia Amoris* 251 and 290.

Ista veneficii vetus est via.

That of-witchcraft outdated is the-way.

Deme veneficiis carminibusque fidem.

Take-away in-witchcraft and-spells faith.

It should be noted that the Latin word for "magic spell" is *carmen* (the source of our word "charm"), which is also the word for song or poem. Maybe we shouldn't trust Ovid either!

CHAPTER NINE

1 Joseph Mullooly, *Saint Clement: Pope and Martyr; And His Basilica in Rome*, 2nd ed. (Rome: G. Barbera, 1873), 186.
2 "It was startling to find in this Christian crypt a cave for the celebration of the Mithraic mysteries." Mullooly, *Saint Clement*, 214.
3 Sigmund Freud, *Civilization and Its Discontents*, trans. Joan Riviere (London: Hogarth Press, 1955), 15. Besides San Clemente, Freud's thought experiment also puts me in mind of those laser light shows, like the one in the Forum of Augustus, where you put on goggles to see visuals of reconstructed buildings projected in the midst of their wreckage. By yoking his view of the mind to the reality of Rome, did Freud accidentally invent virtual reality?
4 Lila Yawn, "Clement's New Clothes: The Destruction of Old S. Clemente in Rome, the Eleventh Century Frescoes, and the Cult of (Anti)Pope Clement III," *Reti Medievalia Revista* 13, no. 1 (2012): 31.
5 Walter Burkert, *Ancient Mystery Cults* (Cambridge, MA: Harvard University Press, 1987), 5.
6 Ovid, *Metamorphoses* 3.657–58.

nec enim praesentior illo
est deus . . .

nor therefore more-present-than-this
there-is a-god . . .

7 Apuleius, *The Golden Ass*, trans. Sarah Ruden (New Haven, CT: Yale University Press, 2011), 266.
8 Apuleius, *The Golden Ass*, 264.

9 Michael Pollan, *How to Change Your Mind: What the New Science of Psychedelics Teaches Us about Consciousness, Dying, Addiction, Depression, and Transcendence* (New York: Penguin Press, 2018), 68.

10 Cicero, *The Republic and the Laws*, trans. Niall Rudd (Oxford: Oxford University Press, 1998), 136.

11 In *Eleusis: Archetypal Image of Mother and Daughter*, Carl Kerényi suggests that the ingredient drunk in the Eleusinian mysteries was hallucinogenic. That book was published in 1967—surprise, surprise. More recently, Brian Muraseku in *The Immortality Key: The Secret History of the Religion with No Name* (2020) makes the case for the use of hallucinogenic substances among the ancient Greek mystery cults. Walter Burkert is not impressed by such arguments: see *Ancient Mystery Cults*, 108–9.

12 All quoted by Pollan, *How to Change Your Mind* on pages 222, 71, and 251 respectively.

13 Quoted in Burkert, *Ancient Mystery Cults*, iii.

14 Pollan, *How to Change Your Mind*, 251.

15 Manfred Clauss, *The Roman Cult of Mithras: The God and His Mysteries*, trans. Richard Gordon (New York: Routledge, 2001), 81.

16 Cited in Clauss, *The Roman Cult of Mithras*, 66.

17 "*Uno itinere non potest perveniri ad tam grande secretum.*" Symmachus, *Relationes* 3:10. Quoted in G. W. Bowersock, *Mosaics as History* (Cambridge, MA: Harvard University Press, 2006), 6.

18 John 14:6.

19 ECCLESIAM CRISTI VITI SIMILABIMUS ISTI + DE LIGNO CRUCIS JACOBI DENS IGNATIIQ(ue) + IN SUPRASCRIPTI REQUIESCUNT CORPORE CRISTI + QUAM LEX ARENTEM SET CRUS FACIT E(ss)E VIRENTE(m).

20 Lines 1–2 and 4–7 of "The Dream of the Rood," trans. Jonathan and Teresa Glenn, Lightspill.com, modified March 9, 2020, https://lightspill.com /poetry/oe/rood.html.

21 "The situation is akin to that of one who, confined to surveying a single section of a mosaic floor, looked at it too closely, and then blamed the artisan for being ignorant of order and composition. In reality it is he himself who, in concentrating on an apparently disordered variety of small colored cubes, failed to notice the larger mosaic work." Augustine, *On Order*, trans. Silvano Borruso (South Bend: St. Augustine's Press, 2007), 5.

22 Mullooly, *Saint Clement*, 422.

23 Mullooly, *Saint Clement*, 426.

24 Mullooly, *Saint Clement*, 427.

25 William James, *The Varieties of Religious Experience: A Study in Human Nature* (New York: Modern Library, 1902), 220.

26 Thomas Merton, *The Labyrinth* (unpublished manuscript), Thomas Merton Center, Bellarmine University, Louisville, Kentucky, 45.

27 Quoted in Susan McCaslin, "Merton's Mystical Visions: A Widening Circle," in *Thomas Merton: Monk on the Edge*, ed. Ross Labrie and Angus Stuart (North Vancouver: Thomas Merton Society of Canada, 2012), 28.

28 William Carlos Williams, *A Voyage to Pagany* (New York: New Directions, 1970), 118.

CHAPTER TEN

1 Though I have nothing reassuring to say about the link between suffering and beauty, I did write a book that deals with the subject: *Seven Ways of Looking at Pointless Suffering* (Chicago: University of Chicago Press, 2018).

2 Ingrid D. Rowland, *The Roman Garden of Agostino Chigi* (Groningen: The Gerson Lectures Foundation, 2005), 12. This book, based on a lecture, has been invaluable to this chapter.

3 Ingrid D. Rowland, *The Culture of the High Renaissance: Ancients and Moderns in Sixteenth-Century Rome* (Cambridge: Cambridge University Press, 1998), 242. In some versions of the story, the plates are silver.

4 Montaigne makes a good point about wild stories: "Whether they have happened or no, in Paris or Rome, to John or Peter, they exemplify, at all events, some human potentiality, and thus their telling imparts useful information to me. I see it and profit from it just as well in shadow as in substance." *The Complete Essays of Montaigne*, trans. Donald M. Frame (Stanford, CA: Stanford University Press, 1965), 75.

5 I know the Housman quotation from Philip Larkin, "All Right When You Knew Him," in *Required Writing: Miscellaneous Pieces, 1955–1982* (London: Faber and Faber, 1983), 264–65. The other quotation is from Radmila Lazić, "Sorry, My Lord," *A Wake for the Living*, trans. Charles Simic (St. Paul: Graywolf Press, 2003), 19.

6 Georgina Masson, *Courtesans of the Italian Renaissance* (New York: St. Martin's Press, 1975), 35.

7 Masson, *Courtesans of the Italian Renaissance*, 36.

8 Masson, *Courtesans of the Italian Renaissance*, 47.

9 Apuleius, *The Golden Ass*, trans. Sarah Ruden (New Haven, CT: Yale University Press, 2011), 98.

10 Apuleius, *The Golden Ass*, 119. The site no longer exists. According to Livy, it was at the foot of the Aventine, next to the Circus Maximus.

11 Apuleius, *The Golden Ass*, 93.

12 Rowland, *The Roman Garden of Agostino Chigi*, 21.

13 See Rowland, *The Culture of the High Renaissance*, 6.

14 Eleanor Clark agrees with me—really, I with her—about both the Ludovisi Throne and the bas-relief of Orpheus. See Eleanor Clark, *Rome and a Villa* (New York: Harper Perennial, 1992), 122.

15 *Odi et amo. Quare id faciam fortasse requiris. / Nescio, sed fieri sentio et excrucior.* (I-hate and I-love. Why it I-do perhaps you-might-ask. / I-don't-know, but it-happening I-feel and I-am-tortured.)

CHAPTER ELEVEN

1 Wilhelm Dilthey, *Selected Works*, vol. 6, *Ethical and World-View Philosophy*, ed. Rudolf A. Makkreel and Frithjof Rodi (Princeton, NJ: Princeton University Press, 2019), 167.

2 Ingrid Rowland, *From Heaven to Arcadia: The Sacred and the Profane in the Renaissance* (New York: New York Review of Books, 2008), xix.

3 *The Collected Works of Samuel Taylor Coleridge*, vol. 14, part 2, ed. Carl Woodring (Princeton, NJ: Princeton University Press, 1990), 111. The remark is from a conversation on July 2, 1830.

4 Vasari claimed that the figure now accepted to be Pythagoras was the Evangelist Matthew. He might have been mentally blending the *School of Athens* with the *Disputation*. It's easy to pick on a guy who was working from memory.

5 For an informative and amusing account of the scholarly tradition, see Marcia Hall, "Introduction," in *Masterpieces of Western Painting: Raphael's School of Athens*, ed. Marcia Hall (Cambridge: Cambridge University Press, 1997), 32–37.

6 The reading of this group as illustrating the stages of learning is widely noted. As usual, my goal is the opposite from the standard scholarly goal of saying original things in an unoriginal way. I strive to say unoriginal things in an original way.

7 Robert Williams, *Raphael and the Redefinition of Art in Renaissance Italy* (Cambridge: Cambridge University Press, 2017), 77–83.

8 Williams, *Raphael and the Redefinition of Art*, 168.

9 Williams, *Raphael and the Redefinition of Art*, 16–17.

10 Dilthey, *Selected Works*, vol. 6, *Ethical and World-View Philosophy*, 170.

11 Charles Wright, *Negative Blue: Selected Later Poems* (New York: Farrar, Straus and Giroux, 2000), 13.

12 Friedrich Nietzsche, "On the Uses and Disadvantages of History for Life," in *Untimely Meditations*, trans. R. J. Hollingdale (Cambridge: Cambridge University Press, 1983), 69.

CHAPTER TWELVE

1 Heather McHugh, "What He Thought," *Hinge & Sign: Poems, 1968–1993* (Middletown: Wesleyan University Press, 1994), 3–4.

2 Cicero, *On the Orator*, trans. E. W. Sutton and H. Rackham (Cambridge, MA: Harvard University Press, 1948), 354–55 (2.86). I've slightly modified the translation. The word Cicero uses is *locus*, which I've rendered as "place" instead of the overly-abstract "locality."

3 Frances Yates, *The Art of Memory* (Chicago: University of Chicago Press, 1966), 79.

4 Ingrid D. Rowland, *Giordano Bruno: Philosopher/Heretic* (Chicago: University of Chicago Press, 2009), 145–46.

5 See the editor's introduction to Giordano Bruno, *The Expulsion of the Triumphant Beast*, trans. Arthur D. Imerti (New Brunswick: Rutgers University Press, 1964), 8.

6 Bruno, *The Expulsion of the Triumphant Beast*, 238.

7 Bruno, *The Expulsion of the Triumphant Beast*, 240.

8 Giordano Bruno, *The Ash Wednesday Supper*, trans. Edward A. Gosselin and Lawrence S. Lerner (Toronto: University of Toronto Press, 1995), 90–91.

9 Quoted in Rowland, *Giordano Bruno*, 281

10 Virgil, *Eclogue* 3.60.

11 Giordano Bruno, *The Heroic Frenzies*, trans. Paul Eugene Memmo Jr. (Chapel Hill: University of North Carolina Press, 1966), 61.

12 Bruno, *The Heroic Frenzies*, 237.

13 Jacques Mercanton, "The Hours of James Joyce," in *Portraits of the Artist in Exile: Recollections of James Joyce by Europeans*, ed. Willard Potts (New York: Harcourt Brace Jovanovich, 1986), 213.

14 Frances Yates, *Giordano Bruno and the Hermetic Tradition* (London: Routledge Classics, 2002), 342.

15 See Rowland, *Giordano Bruno*, 247–48.

16 See Rowland, *Giordano Bruno*, 236. In point of fact, what he'd yell at God was, "Traitor! Take that, wretched dog-fucked cuckold! Look how you run the world!"

17 Rowland, *Giordano Bruno*, 10. *Maiori forsan cum timore sententiam in me fertis quam ego accipiam.*

18 Czesław Miłosz, "Campo dei Fiori," in *New and Collected Poems: 1931–2001* (New York: Ecco, 2001), 33.

19 Yates, *The Art of Memory*, 305.

20 M[arcus]·AGRIPPA·L[ucii]·F[ilius]·CO[n]S[ul]·TERTIVM·FECIT.

21 Though the standard story, which I use here, is that Hadrian commissioned and possibly helped to design the Pantheon, it has been recently argued, on the basis of the stamps on its bricks, that it was built under Trajan, Hadrian's predecessor. For this argument, see Lise M. Hetland, "Dating the Pantheon," *Journal of Roman Archaeology* 20 (2007), 95–112. I think my argument makes sense whether one plugs in Trajan or Hadrian. Perhaps it works even better to plug in both!

22 Marguerite Yourcenar, *Memoirs of Hadrian*, trans. Grace Frick and Marguerite Yourcenar (New York: Farrar, Straus and Giroux, 1954), 167.

23 Yourcenar, *Memoirs of Hadrian*, 167.

24 Yourcenar, *Memoirs of Hadrian*, 293.

25 Little-soul, wandering, charming, / guest and-companion of-the-body, / what now are-you-going-off to places, / pale, rigid, naked, / not as you-once-did you'll-be-making jokes?

26 Yourcenar, *Memoirs of Hadrian*, 295.

CONCLUSION

1 Mick Heaney, "My Father's Famous Last Words," *Irish Times*, September 12, 2015, https://www.irishtimes.com/life-and-style/people/mick-heaney-my -father-s-famous-last-words-1.2348525.

2 Seamus Heaney, "Du Bellay in Rome," *New England Review* 34 (2013–14), http://www.nereview.com/back-issues/vol-34-2013-2014/vol-34-no-2-2013 /seamus-heaney-du-bellay-in-rome/. If you're into this sort of thing, notice that the word "Rome" is used fourteen times in the sonnet, a poem that's governed by the number fourteen. The poem is used with kind permission from Faber and Faber Ltd.

3 Here are seven other versions of the couplet. Do they prove or contradict its message? Janus Vitalis (1485–1560): *"Disce hinc possit Fortuna: immota labascunt, / quae perpetuo sunt agitata manent."* Joachim du Bellay (1522–60): *"Ce qui est ferme est par le temps détruit, / Et ce qui fuit au temps fait résistance."* Edmund Spenser (1552–99): "That which is firm, doth flit and fall away; / And that is flitting, doth abide and stay." Francisco de Quevedo (1580–1645): *"Huyó lo que era firme, y solamente / lo fugitivo permanece y dura."* Ezra Pound (1885–1972): "That which stands firm in thee Time batters down, / And that which fleeteth doth outrun swift Time." Robert Lowell (1917–77): "Whatever once was firm has fled . . . what once / was fugitive maintains its permanence." J. V. Cunningham (1911–85): "Learn hence what Fortune can: the unmoved falls, / And the ever-moving will remain forever."

4 Carlo Levi, *Fleeting Rome: In Search of la Dolce Vita*, trans. Antony Shugaar (Chichester, West Sussex: John Wiley and Sons, 2005), 7. "And it all ends in hell" is a quotation from Giuseppe Belli, the great—and extremely naughty and blunt—poet of Trastevere, who's commemorated there with a statue and a tram stop.

ACKNOWLEDGMENTS

1 *"Numquam se plus agere quam nihil cum ageret, numquam minus solum esse quam cum solum esset."* Cicero, *The Republic and The Laws*, trans. Niall Rudd (Oxford: Oxford University Press, 1998), 14.

APPENDIX

1 Quoted in Scott Newstok, *How to Think Like Shakespeare* (Princeton, NJ: Princeton University Press, 2020), 107.

2 Elizabeth Bowen, *A Time in Rome* (New York: Vintage Books, 2003), 242.

INDEX